Picturing the Invisible

Picturing the Invisible

Exploring interdisciplinary synergies
from the arts and the sciences

Edited by

Paul Coldwell and Ruth M. Morgan

First published in 2022 by
UCL Press
University College London
Gower Street
London WC1E 6BT

Available to download free: www.uclpress.co.uk

ISBN: 978-1-80008-105-5 (Hbk.)
ISBN: 978-1-80008-104-8 (Pbk.)
ISBN: 978-1-80008-103-1 (PDF)
ISBN: 978-1-80008-106-2 (epub)
ISBN: 978-1-80008-107-9 (mobi)
DOI: https://doi.org/10.14324/111.9781800081031

Contents

List of figures

List of contributors

Professor Paul Coldwell is an artist and Professor in Fine Art at the University of the Arts London. His practice includes printmaking, sculpture and installation; his work has been exhibited widely and is held in numerous collections both in the UK and abroad. His published work includes *Printmaking: A contemporary perspective* and *Giorgio Morandi: Influences on British art*.

Professor Stephan Doering, MD, is a psychiatrist and psychoanalyst. He is chair and Professor of Psychoanalysis and Psychotherapy and head of the Department of Psychoanalysis and Psychotherapy at the Medical University of Vienna, Austria. His main research foci are psychotherapy research, diagnosis and treatment of personality disorders, and psychosomatic medicine.

Professor Mark Emberton is Professor of Intervention Oncology within the Division of Surgery and Dean of the Faculty of Medical Science at UCL. He is clinically active and holds the position of Honorary Consultant Urologist at UCL Hospitals NHS Trust where he works as a specialist in prostate cancer. He is a founding Pioneer of the charity Prostate Cancer UK.

Professor Adam Gibson is Professor of Medical Physics and Professor of Heritage Science at UCL. His research interests are medical imaging (mainly optical imaging of the newborn brain and breast cancer) and heritage imaging, such as that described in his chapter.

Owen Hopkins is a curator and writer specialising in architecture and its histories. He is currently Director of the Farrell Centre at Newcastle University. Previously, he was Senior Curator of Exhibitions and Education at Sir John Soane's Museum and, prior to that, Architecture Programme Curator at the Royal Academy of Arts.

Dr Cerys Jones is a postdoctoral researcher with the ARTICT project at UCL. She received her MMath degree in mathematics from Cardiff University in 2015, and her MRes degree in science and engineering in art, heritage and archaeology and PhD in multispectral imaging at UCL in 2016 and 2020, respectively.

Katy Makin is an Archivist at UCL Special Collections, where she manages donated and deposited modern archive collections as well as medieval and early modern manuscripts. Her particular collection interests are medieval manuscript fragments and archives relating to the history of science.

Dr Jo Melvin is Reader in Fine Art, Archives and Special Collections, Chelsea College of Art, London, UK, and Director of the Barry Flanagan Estate. Her practice focuses on artists' and institutional archives and oral histories, curatorial strategy with a particular interest in relationships between the archive, documentation and performativity.

Professor Ruth M. Morgan is Professor of Crime and Forensic Science. She is also Vice Dean (Interdisciplinarity Entrepreneurship) in the UCL Faculty of Engineering Sciences, and a World Economic Forum Young Scientist. Her research is focused on the interpretation of forensic science evidence and she is the three times winner of the PW Allen award from the Chartered Society for the Forensic Sciences.

Joseph Norris is a Specialist Registrar in Urology in the London Deanery. He currently holds a Medical Research Council (MRC) PhD Fellowship at UCL. His research centres around improving delivery of prostate magnetic resonance imaging (MRI), in particular, elucidating features of invisible cancer. He has recently been awarded a Fellowship with the European Society of Surgical Research.

Professor Tanja Staehler is Professor of European Philosophy at the University of Sussex. Her research interests include Phenomenology, Aesthetics, Philosophy of Pregnancy and Childbirth and Philosophy of Art and Dance. She has written monographs entitled *Hegel, Husserl, and the Phenomenology of Historical Worlds* (2016) and *Plato and Levinas: The ambiguous out-side of ethics* (2010).

Jieran Sun is a medical engineering student with interests in imaging technologies. In 2019, he received a scholarship to work with UCL Special

Collections on historical document digitalisation. He is now completing his bachelor's degree in Hong Kong and moving forward to the invisible realm ahead.

Susan Tallman is an art historian educated at Columbia and Wesleyan Universities. A regular contributor to *New York Review of Books*, she is the author and co-author of numerous books and museum catalogues, including the British Museum's *American Dream: Pop to the present* (2017).

Professor Melissa Terras is the Professor of Digital Cultural Heritage at the University of Edinburgh's College of Arts, Humanities, and Social Sciences, directing the Edinburgh Centre for Data, Culture and Society. She previously directed the UCL Centre for Digital Humanities in UCL Department of Information Studies, where she was employed from 2003 to 2017.

Professor Irene Tracey FMedSci, MAE is Professor of Anaesthetic Neuroscience, Pro-Vice Chancellor and Warden of Merton College, her alma mater, at the University of Oxford. Using neuroimaging, Irene's multidisciplinary research team has made fundamental discoveries into how we construct the experience of pain, its relief and how analgesics and anaesthetics work.

Professor Roberto Trotta is Professor of Astrostatistics at Imperial College London, currently on leave of absence to the International School of Advanced Studies in Trieste, Italy, where he is leading a new data science group. He is also a Visiting Professor of Cosmology at Gresham College, London. His research focuses on cosmology, machine learning and data science. An award-winning author and science communicator, he is the recipient of the Annie Maunder Medal 2020 of the Royal Astronomical Society for his public engagement work.

Dr Tabitha Tuckett is Rare-Books Librarian at UCL. She has a D.Phil. in Elizabethan literature and was a junior research fellow at New College, Oxford before training as a librarian. Her academic background is in book history research, and Classics and Renaissance literature and philosophy. She currently teaches postgraduate librarianship and collaborates on imaging research.

Foreword

Paul Coldwell

The capacity to speak to an audience beyond our individual disciplines is essential if we are genuinely interested in communication. While the modern world requires high-level specialism and subject knowledge, in order to address complex issues, a capacity to communicate and engage across disciplines is necessary for progress. Today's problems cannot be resolved within a narrow range of references.

This volume is the result of a one-year network supported by the AHRC, in which a group of academics both in the UK and abroad, from a range of disciplines, set aside time to engage with blue sky thinking and engage with one another around the subject of picturing the invisible.

The project developed from my ongoing concerns in both my studio practice and my academic work where I kept returning to questions of presence and absence. Furthermore, parallel to my ongoing studio practice, I have sought out museums and collections as opportunities to engage in practice-based research resulting in exhibitions and bodies of work, including at Kettle's Yard and the Scott Polar Research Institute, both in Cambridge and most recently with the Freud Museums in both Vienna and London. Invariably, this led me to consider my practice as a fine artist, alongside other disciplines and methodologies. The opportunity to talk across disciplines became a way for me to understand my own position more clearly and this project was conceived to formalise and expand on this experience.

As the project began to form, I had begun discussions with Owen Hopkins at the Sir John Soane's Museum about the possibility of developing an exhibition of my work in response to their collection. When this was agreed in principle, it provided a focus from which to begin to shape the wider project. At an early stage, I was fortunate to have Prof. Ruth M. Morgan as my co-applicant and throughout the process of writing the grant application and its subsequent implementation it has

been both a pleasure and inspiration to work alongside her. Together we approached a number of leading academics with the invitation to join our network and were gratified with the number of enthusiastic acceptances confirming our belief that the subject had a common currency.

The one-year network was conceived to create different modes of exchange. We brought the network members together in an initial two-day workshop at the Soane Museum to share perspectives from our own disciplines. Curiously, most meetings in academia are held in sterile rooms where the business is clearly set out through agenda. The rich environment of the Soane Museum and how the workshop was framed (like cricket) around intervals for lunch, afternoon tea and supper, engendered a relaxed opportunity to develop a conversation. From this conversation a number of core themes emerged which frame the structure of this book.

Further explorations followed with my exhibition *Picturing the Invisible: The house seen from below* in the kitchens of the Soane Museum curated by Owen Hopkins, and the production of a special edition of *Art in Print* with Susan Tallman as Editor in Chief.

The network culminated in a two-day conference at Chelsea College of Arts, University of the Arts London, which brought together network members and invited speakers to develop their reflections, created spaces for broader discussions throughout each session with the delegate body (a rare occurrence in traditional academic conferences), and a pop-up exhibition from UAL students on the theme of Picturing the Invisible.

This book is a product of the discussions and reflections that have taken place through the year and we hope it offers insights that can act as a springboard into further interdisciplinary thinking and reflection.

Acknowledgements

We would like to acknowledge the support of the AHRC in the form of an AHRC Network Award.

We would like to thank all members of the *Picturing the Invisible Network*, for your commitment, positivity, curiosity and willingness to explore with us:

Professor Stephan Doering (Medical University of Vienna)

Professor Mark Emberton (UCL)

Professor Adam Gibson (UCL)

Professor Paul Goodwin (UAL)

Owen Hopkins (Sir John Soane's Museum)

Professor Roger Kneebone (Imperial College, London)

Professor Tanja Staehler (University of Sussex)

Susan Tallman (Art in Print and School of the Art Institute of Chicago)

Professor Irene Tracey (University of Oxford)

Professor Roberto Trotta (Imperial College London).

We would also like to thank Cerys Jones, Katy Makin, Jo Melville, Joseph Norris, Jieran Sun, Melissa Terras and Tabitha Tuckett for their contributions to this volume.

Throughout the project, we have been greatly assisted by our research administrator, Gabriele Grigorjeva, and would like to thank her for her vision, eye for detail and engagement with every aspect of the project. We would also like to thank Catherine Long for proofreading and editing the final chapters.

We would like to acknowledge the help and support of Professor Malcolm Quinn, Chris To and Nick Tatchell and staff from Research Management and Awards (RMA) at UAL. We would like to thank

The Sir John Soane's Museum for staging both the initial workshop and the exhibition *Picturing the Invisible: The house seen from below.*

We would like to thank Abbi Fletcher for curating a pop-up exhibition at Chelsea College of Arts to complement the conference, featuring the work of Lizzie Cardozo, Rachael Causer, Elin Karlsson, Maria Clara Lorusso, Lara Orawski, Zoe Prichard, Camila Quintero, Stephanie Spindler, Parichat Tanapiwattanakul, Anna Tsuda and Altea Grau Vidal.

Finally, we would like to thank UCL Press for publishing this volume.

<div align="right">

Professor Paul Coldwell and
Professor Ruth M. Morgan

</div>

Introduction

Ruth M. Morgan

'We can draw conclusions about the invisible; we can postulate its existence with relative certainty. But all we can represent is an analogy, which stands for the invisible but is not it'

(Gerhard Richter 2009: 14).

Complex challenges are often very visible from the 'outside'. The symptoms of the challenges are usually apparent, and they are often the indicators that the challenge exists. However, the components of the complexity that arguably creates that challenge are often invisible. It is this that makes these challenges so difficult to address and resolve. The symptom is often clear and in plain sight (such as glaciers melting), but the causes are often multiple, hidden or obfuscated to some degree by other factors that can mislead our attempts to address root causes and alleviate the symptom(s).

Why we need to picture the invisible

A problem for all disciplines is how to articulate the invisible, which we define here as 'that which is not known or that which is not provable'. The challenge for academics is how to articulate these concepts, first to those within their academic field and then beyond, to other disciplines and the wider world. Indeed, as our understanding of the complexity of the world grows incrementally as technologies and new means of viewing emerge and develop, our realisation that issues and problems can rarely be resolved within neatly demarcated disciplinary boundaries only propagates. Therefore, the importance of finding means of communicating across disciplines and fields has never been such a pressing priority. We acknowledge the essential importance of the specialist academic in driving disciplines forward. However, in addition we need to ensure that

within the wider community we are developing the capacity to understand how to communicate our own discipline with an informed appreciation of other disciplines, their priorities, methodologies and even the language used. This ability is becoming increasingly crucial to being an effective instrument for change.

This book brings together a range of perspectives from different disciplines seeking to picture the invisible in order to build a 'greater than the sum of its parts' expression for the invisible or unknown. It is our hope that by bringing together insights from a range of seemingly disparate disciplines from Art and Design, Heritage Science, Curatorial Practice, Literature, Forensic Science, Medical Science and Imaging, Psychoanalysis and Psychotherapy, Philosophy, Astrophysics and Architecture, this volume can act as a springboard for developing truly interdisciplinary thinking. This collection is designed to create the space for each discipline to articulate how the invisible is pictured and where picturing the invisible creates challenges in a specific domain. In so doing, we seek to create a platform for reflection and a pathway to growing our capability to articulate a more coherent and synthesised approach to picturing the invisible that draws from the approaches and challenges identified in each discipline.

If the challenges we face do not have distinct solutions that can be drawn from a single discipline, developing a more coherent and synthesised vision of complexity offers the chance to bring together high-level specialisms and expertise. It also crucially brings that expertise together in concert with the tools that we need to cross the traditional boundaries, by incorporating different and contrasting perspectives, identifying where difference provides opportunities to think creatively and disruptively, and ultimately the opportunities to create common ground. There are many different layers to picturing the invisible within this complexity, but exploring the different lenses of traditionally disparate disciplines on this foundational challenge promises new insights. It also has the potential to put us on the right pathway for identifying creative steps forward in identifying solutions to the big complex challenges of our world.

Therefore, we believe that this is a timely contribution. The world has never been more complex and that complexity is only growing as technologies and increasing capacities for connectivity propel us forward into new territories that are, as yet, unnavigated. Much of this new world is invisible. It is also increasingly complex as each year passes and each new scientific breakthrough emerges, laying the foundations for a world where things that we cannot even imagine today will be possible and will become the fabric of communities.

By incorporating a highly diverse disparate range of disciplines that span the arts, sciences and humanities, this book is designed to offer the reader an opportunity to consider their own discipline and its approaches to picturing the invisible or unknown, and then draw comparisons and contrasts from other disciplines. As such, this volume offers a conduit to further thinking, and links within chapters that inspire curiosity and further exploration. This book provides the opportunity for chance encounters with other ways of seeing, and creates a fertile ground for creative innovative thinking. It is this kind of approach that offers a key to breaking down siloed thinking within traditional disciplinary boundaries, and ultimately creating pathways for innovation in and across disciplines that can be inroads into the complex global challenges. Each chapter focuses on very specific ideas and issues, rather than trying to speak on behalf of their academic community. Through this approach, they offer insights into how problem-solving, methodologies and practical considerations are approached, and so highlight both what is distinct and shared.

We hope this book offers insights for a broad readership. We hope that it challenges, and offers space to grapple with new ideas that lead to new ways of seeing and connecting. We hope that it is a book that accompanies a journey, that offers helpful and valuable food for thought in different seasons, and ultimately fosters curiosity and excitement.

The core themes

This book represents the journey of a team of representatives from a broad range of disciplines that span the arts, sciences and humanities. Through sharing ideas, and exploring different challenges that arise in these different disciplines, four core themes have emerged that transcend the traditional disciplinary boundaries: interdisciplinarity, communication and language, interpretation, and absences and voids.

Each of these themes provides a different lens and offers insights into where the challenges may lie in terms of picturing the invisible in different disciplines. They also offer a means of seeing the often tacit connections that exist between those disciplines and identifying new perspectives. These new perspectives offer novel approaches within a single discipline, and also, very importantly, lift out broad overarching themes that offer insights into approaches that we can take to tackle the complex global challenges that we are increasingly confronting in the

world. These themes are by no means exhaustive, nor are they mutually exclusive, but we hope that they offer a starting point for considering the invisible in your own discipline and insights that go beyond.

Interdisciplinarity

The term 'interdisciplinary' is widely used in varying and disparate ways; it is used often and liberally. However, interdisciplinary approaches often promise much but do not appear to ultimately deliver. It is not uncommon to be working on an 'interdisciplinary' project where there is a pre-dominant discipline framing the project with at best some minor contributions on the periphery from other fields. Ultimately, this cannot be the coherent approach that 'interdisciplinary' promises, or that truly complex challenges require, and it is not going to create the truly innovative solutions we need.

To create the truly interdisciplinary, we need to consider infrastructure, mindset and a common language. First, there will need to be some modification to the existing infrastructures within which we work, the traditional silos. This will require better pathways and connectivity within those infrastructures and across disciplines, and a commitment to valuing and recognising efforts and successes that make the 'greater than the sum of its parts' value of interdisciplinarity.

Second, and perhaps even more importantly, we also need a changed mindset of individuals and organisations to embrace a truly realised interdisciplinarity. Unless this can be fostered and nurtured, we risk continuing to take established approaches that bring the 'same old solutions' and that means we will keep the 'same old problems'. Ultimately, we cannot solve our problems with the same thinking we used when we created them. Ultimately, an interdisciplinary approach needs to be synthesised to such an extent in its development and formation that it is distinct from each of those individual contributing disciplines. This is the challenge of 'interdisciplinary'.

Third, we also need to be developing in an ongoing manner, a common language. In many disciplines there are terms and phrases that are used extensively. These terms can be used in many different disciplines and domains, but often these terms have very different meanings, which can create barriers to seeing the invisible.

Chapter 1 addresses forensic science and Chapter 2 addresses heritage science. These chapters present the challenges of working in idealistically interdisciplinary fields, and the steps that can be taken as we picture the invisible to overcome these challenges. Elements of this theme

can also be seen in subsequent chapters and the opportunities for new bridges to be built, for example between art (Chapter 3) and neuroscience (Chapter 6), psychoanalysis (Chapter 4) and cosmology (Chapter 5), and medicine (Chapter 7) and architecture (Chapter 8), all offer exciting avenues for future exploration.

Communication and language

Knowledge is dynamic, and ways of seeing are constantly developing. Therefore, to develop a deeper understanding and appreciation of the different approaches and tools that grapple with the invisible (known and unknown), there needs to be an ongoing conversation. A conversation can be considered to be a form of communication that requires at least two (or more) parties, a willingness to engage and cooperate, an intention to listen, contribute, ask questions, and commitment to engaging with an open-ended exchange that creates space to follow ideas and thoughts that were not set out at the start. A conversation as means of communication has great power to allow links to become visible that were previously unseen between different ideas or viewpoints. Conversations also create an environment where different viewpoints and ways of seeing can coexist. This can lead to the exploration of serendipitous topics and new connections being identified as interesting (and different to the status quo) ways of exploring new ground.

A conversation that transcends disciplinary boundaries requires a common language (both verbal and non-verbal) to explore how different approaches and conceptual constructs can be applied in non-traditional ways in different disciplines. Chapter 12 offers an exploration of the language that we use in different disciplines, identifying common terms and disparate meanings. It offers a springboard for thinking more deeply about the opportunities that could exist for building a common language that transcends disciplinary silos and enables ever deeper and interesting conversations. When presented to the network, it proved to be a catalyst for exploring the very challenges of language and the assumptions we have for language and communication.

The way we communicate across boundaries also needs to be considered with different audiences in mind. When considering how we communicate the invisible, the terms we use and the pre-requisite knowledge that is required need consideration if we are to effectively bridge the gaps and create new approaches and ways of seeing. When considering studio practice in the arts (Chapter 3), psychoanalysis (Chapter 4) and cosmology (Chapter 5), as well as other fields such as

neuroscience (Chapter 6) and philosophy (Chapter 10), it is clear that the effort to derive language for communication is a core foundation. It is in our efforts to convey and express the invisible that language (verbal and non-verbal) becomes critical. Understanding the audience we seek to communicate and engage with is, therefore, paramount. This not only needs a common language but also a consideration of context that the communication is delivered into. More than this, we also need to consider the context of the audience in terms of their prior experiences and beliefs that shape viewpoints and impact what it is possible to 'see'.

Interpretation

How we interpret what we can and cannot see is an underlying theme that connects across each discipline within the volume. Where there is invisibility, there is ambiguity of meaning, which presents opportunities for exploration and curiosity but also the need for conversation.

Art and science are often juxtaposed, setting creativity in contrast to analysis, picturing in contrast to imaging. Yet this is an artificial construct, and a core theme that has developed throughout the engagement with the topic of 'picturing the invisible' is that of symbiosis. No discipline can operate within a vacuum, and making connections across different fields and viewpoints (ways of seeing) is integral to understanding better the unknowns and ambiguities that are observed or predicted. Developing connections and a way of articulating ambiguity is a foundation for being able to see the context and consider a topic in a holistic way. In addition, we should avoid characterising a discipline and understand that, for example, the imagination is not the sole domain of the arts while rational analysis is not the exclusive preserve of the sciences.

Addressing uncertainty is also a key attribute of interpretation. Creating space for exploration and observation where it is possible to be comfortable with uncertainty, or at least agree a threshold for it, is relevant for all disciplines, and key to taking the holistic approach to 'seeing'. It also opens up new opportunities to consider what is created by uncertainty in different domains. A consideration of the interpretation of images is a theme that connects neuroscience (Chapter 6) and diagnostic medicine (Chapter 7) as it represents a literal expression of interpreting that which is not known and that which cannot be seen by the naked eye. The importance of interpretation is also clear across the volume with insights into the importance of interpretation and establishing meaning in almost every other chapter within the volume. If we can picture the invisible, we are one step closer to being able to extract meaning.

The fourth core idea that has emerged within this collection is that of the information that is embedded in absence. This is perhaps most clearly demonstrated in the practice of prediction in astrophysics (Chapter 5), and the value of voids in architecture (Chapter 8), history (Chapter 9) and art (Chapters 3 and 11). This is connected to the observation that it is often necessary to peel back layers and remove certain things in order to reveal the invisible. One particular example of this is in the field of imaging (Chapters 2, 6 and 7) where imaging technologies create a visualisation of physical entities that the human eye cannot see. However, in so doing, it is almost always necessary to filter, to remove certain parts of the image in order to see what is sought. The technologies that allow this are sophisticated and create an ability to reveal what has been previously hidden from view. They also create a world of increasing ability to develop cures for diseases and recreate past environments that were previously unknown. Yet what we choose to see is often decided in advance, and the value of that which is removed can be missed. The impact of this can be expressed in the voids that are apparent and explored in art and history (Chapters 3, 9 and 12).

This leads to the important consideration of what is lost when things are removed. It also highlights that what we see and reveal is a product of a complex environment of what is considered to be valuable. It is therefore important to be considering how we select, abstract and re-present what is observed. We also need to be mindful of what we value implicitly and explicitly, and the impact that has on what is preserved. Ultimately, considering the absences and voids can enable an appreciation of reflecting on how a change of focus can bring new attributes into view.

Summary

It is often said that innovation needs a challenge, but perhaps we need to go one step further. Innovation in our ever more complex and interconnected world needs a truly coherent, dynamic and evolving interdisciplinary approach to address the big multifaceted challenges we are looking to find solutions for. An approach is needed that is able to deal with the breadth and interconnectivity of the big picture within which a specific challenge sits, to bring hybridised approaches that are greater than the sum of their parts to ask the most insightful questions, and to draw on a wide range of expertise that is needed in a coherent, broad yet

focused way. Ultimately, picturing the invisible is a foundational pillar of stepping out into our complex world, and creating opportunities to re-think and re-imagine the world.

Our hope is that this volume offers an opportunity to step out of the comfort zone, to critically think about the infrastructures that can impede this kind of approach, and be curious about how other fields view and tackle challenges in their own disciplines. An adventure awaits with potentially great rewards. Picturing the invisible offers us ideas and a pathway to finding the innovative creative solutions to the truly complex challenges we face at the global scale.

References

Richter, Gerhard. 2009. 'Notes, 1962', in *Gerhard Richter: Text: Writings, interviews and letters, 1961– 2007*, edited by Dietmar Elger and Hans Ulrich Obrist, 14. London: Thames and Hudson.

Interdisciplinarity

1
Forensic science, revealing the unseen and the unknown

Ruth M. Morgan

Introduction

Forensic science is an interdisciplinary endeavour that synthesises approaches from the sciences, social sciences and humanities. Forensic science is then considered to be the application of this interdisciplinary approach to the reconstruction of events and to provide insights into questions of 'who?', 'what?', 'when?' and 'how?' In forensic science, we grapple with rarely ever truly knowing what actually happened at a particular crime scene, and therefore our scientific approaches face the challenge of reconstructing events from the inferences we can make from the clues that are recovered.

Forensic science also brings together the physical, digital and human worlds in a highly distinctive manner, and this leads to additional complex challenges. Technological advances have been significant and it is now possible to 'see' smaller and smaller (physical) traces or more and more (digital) data, to greater degrees of accuracy, more quickly than ever before. This has led to a preoccupation with answering the 'what' and 'who' questions (such as, what is this substance? Who did this trace originate from?), an endeavour often proliferated by the representations of forensic investigations in popular culture and the media, and the strong drivers to provide metric measures of advancement (such as an increased detection rate). This has led to a situation where it is increasingly possible to 'see' what a trace is and who it belongs to, but the foundational understanding and evidence base that is needed to 'see what that trace means' in the context of a specific case has been severely neglected.

As a result, the challenge of misinterpreted evidence is both an issue of being able to see more than ever before, but at the same time not being able to see what a trace or material means. Therefore, in many situations, we do not have all that is needed to effectively communicate an accurate reconstruction of the crime event. To see the invisible, we not only need to be able to visualise that which is not readily seen (in the case of forensic science, detect and classify a material or clue), but we also need to understand what that material means in the context of a case. This requires visualising the often invisible complex interactions of different factors that form that context. Thus, achieving robust, reliable and reproducible interpretations of what we can and cannot see is critical to the future of forensic science and the role of science in the justice system.

The challenge of complexity and uncertainty and how we can 'see' in forensic science

Forensic science is a complex interdisciplinary field for four main reasons:

1. The matrix environment of multiple institutional stakeholders within which forensic science must operate.
2. The multiple stages of the forensic science process (starting at the crime scene and then incorporating the detection, analysis and interpretation of materials, followed by the presentation of those materials as intelligence to investigators and evidence to a court).
3. The different forms of evidence that must be considered to develop a holistic reconstruction of pertinent events.
4. The individuals that make critical decisions at each stage of the forensic science process and within key stakeholder institutions.

One of the challenges of complexity is that it can render connections between different parts of a system difficult to 'see' and therefore articulate. In some cases, this can lead to obfuscation to the degree that those relationships can themselves become invisible. Figure 1.1 provides a preliminary and basic visualisation that seeks to capture a conceptual understanding of the complexity of forensic science. By articulating this context, which is invisible in a way that seeks to capture the holistic system, it becomes possible to set a course for developing more meaningful approaches to the key challenges within forensic science such as the (mis) interpretation of science evidence within the justice system.

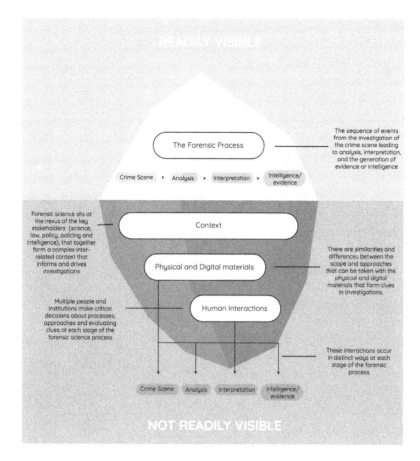

Figure 1.1 Picturing the visible and less visible components of the forensic science.

Credit: Ruth M. Morgan and Emma Levin.

The matrix environment

Forensic science sits at the nexus of the spheres of science, policing, policy and the law (Morgan 2017a). At the institutional level, each of these different spheres has different areas of primary focus and core aims it seeks to deliver (e.g. investigators seek to gather evidence and establish a reconstruction of events pertinent to a particular crime, the law seeks to provide a framework within which justice can be secured and upheld to protect citizens). Each sphere will have different drivers, some of which may be shared (such as identifying a suspect and collecting evidence),

and others that are distinctive to a specific sphere (in science, the primary aim is to disprove a theory and conclusions are necessarily probabilistic, whereas in law there is a need to establish 'truth' beyond reasonable doubt). Each sphere creates, retains and shares knowledge in different ways (Morgan 2017b). It is also important to acknowledge that each sphere is made up of individuals. These individuals create and communicate knowledge in different ways, and also have different drivers and responses to different pressures that are exerted by the infrastructure of a specific institution. Therefore, forensic science engages the justice system at the intersection of this complex matrix environment, which introduces many (often competing) factors and needs that forensic science seeks to absorb and incorporate into the interdisciplinary science that is produced and applied in casework.

The forensic science process

Forensic science is made up of four key stages that encompass each of the key activities required to achieve a crime reconstruction (Morgan et al. 2020). These stages comprise the crime scene where clues are found, collected and preserved; the analysis stage where clues are examined and classified; the interpretation stage where that analysis is evaluated and interpreted; and then the presentation of those findings to investigators (as intelligence) or to a court (as evidence). Each of these stages is connected to the preceding stage(s) in a broadly linear progression, although there are feedback loops within that system (such as the requirements of the law with regard to admissibility impacting the manner in which a clue is identified, collected and preserved at a crime scene).

The nature of different forms of evidence

At each stage of the forensic science process there are two broad forms of clue that may be present and valuable to the endeavour of reconstructing pertinent events of a crime. Physical materials, which are often present as visible items or invisible traces (to the naked eye), can offer insights about the identity of individuals (such as DNA and fingerprints) or the nature and source of a relevant material (such as glass, fibres and sediments). Digital materials, while distinct to physical materials in substance, share many similar characteristics in terms of the insights that they can offer in regard to the identity of an individual (such

as facial recognition) and the movements, interactions and connections that individual has with the physical and cyber environments (such as online activities and phone data). While there are clear similarities between these different forms of evidence (such as the need to identify, preserve and maintain the integrity of a clue), there are also some distinct differences (such as the quantity of material that is possible to identify and gather) that need to be taken into account at every stage of the forensic science process (OSAC 2018).

Different actors and critical decision-making

At each stage of the forensic science process there are key individuals who are working within different stakeholder institutions, such as crime scene managers at the crime scene, scientists within the laboratory and lawyers within the courts (Almazrouei et al. 2019). Each of these individuals is required to make decisions that can impact the forensic science process. For example, a crime scene manager must set the priorities for managing a crime scene, which may mean that certain types of clues are searched for in favour of others. Depending on the charge against a defendant, a lawyer may choose to lead their case with one particular piece of the body of evidence to provide a clearer argument and stronger case to prosecute or defend the defendant. All human decision-making brings together both explicit knowledge (that which can be codified or can be 'seen') and tacit knowledge (that which is not tangible and that is often 'invisible'), and introduces a further degree of complexity, particularly when it comes to evaluating the clues that have been detected and made visible, and then discerning what the clues mean (Morgan 2017a).

It is increasingly recognised that the complexity of the forensic science ecosystem, and the degree to which that complexity has not been fully appreciated, articulated and made visible, has contributed to many of the challenges that forensic science has faced in the last 20 years. Forensic science has been identified to be a highly fragmented system (House of Lords Science and Technology Select Committee 2019), therefore developing a conceptual understanding of forensic science and the different components of the system is the first step to being able to articulate and make visible how that system works and is connected. By making the complexity more visible, it is possible to open up a path to address the most severe challenge that forensic science has faced to date, including the pressing issue of the (mis)interpretation of forensic science evidence.

Increased capabilities in seeing (detecting) leads to a greater challenge of understanding what the evidence means: the importance of interpretation

Technological capabilities have been increasing significantly in the last decade and new capabilities are consistently emerging, such as artificial intelligence and machine learning approaches that can be applied to facial recognition; the enhanced sensitivity and accuracy of DNA analysis that can now detect and profile even smaller traces of biological material; and the dramatic increase in the quantity and quality of digital data that it is now possible to capture, retain and search. As these capabilities have grown, there has been a strong focus on developing detection techniques that are enabling us to 'see' more than ever before in terms of finding clues that may have been too small to identify in the past, or being able to classify those materials at greater degrees of resolution than ever before. At the same time, there has been strong commitments made to ensuring the quality standards of those forms of analysis and detection in order to ensure consistency, integrity, reproducibility and accuracy (Forensic Science Regulator 2017). However, as the ability to 'see' more and more of the previously 'invisible' has grown, there has not been a concomitant focus on ensuring that the approaches needed to achieve robust interpretations of what a detected trace means when a particular type of material (physical or digital) is found and identified. Therefore, a key stage of the forensic science process, that of interpretation, has been neglected (Morgan 2018).

The interpretation of what the clues mean in the context of a crime reconstruction relies not only on being able to 'see' those clues within the wider context of the whole system (figure 1.1) but also on a consideration of two core elements; the knowledge base and the evidence base (figure 1.2).

The knowledge base

The knowledge base for forensic science is generally well established, often in the parent disciplines such as analytical chemistry or genetics. The body of knowledge within these disciplines underpins many fields within forensic science, for example, core theories within fluid mechanics, analytical chemistry and genetics enable the analysis of blood patterns, explosive residues and DNA respectively. These knowledge bases address

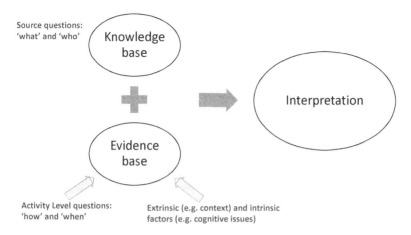

Figure 1.2 The two core elements of interpreting science evidence for forensic applications; the knowledge base and the evidence base.

Credit: Ruth M. Morgan.

the questions about what a substance is and who or where it may have originated from.

While the knowledge base is generally very well established, it is dynamic and continues to grow and develop at a significant rate. As the capabilities in detection (seeing) increase, new challenges emerge for understanding what a clue may mean. More data can provide significant potential for greater insights, but it also introduces changes to thresholds of uncertainty. For example, when DNA analysis was first introduced, the amount of biological material required to produce a full profile was far greater than the current technologies require (Meakin and Jamieson 2013). This means that we can now detect DNA in situations when previously it was not possible to generate a full profile, which has many benefits. However, it also means that mixed source profiles are now far more common and our ability to interpret those mixtures is still nascent and, in many cases, problematic (Butler 2018). The more we can 'see' does not necessarily increase what we can 'know', in some situations it can actually lead to invisibility.

The evidence base

The evidence base in forensic science, in contrast to the knowledge base, is relatively sparse and lacks a coherent body of knowledge. The evidence

base provides the context that is necessary to evaluate the clues that are identified. This context is relevant in two ways: understanding the trace itself and understanding the decisions that are made by human actors during the forensic science process. To understand and interpret what a trace means, it is important to have a foundational understanding of how a trace may interact with a specific environment. For example, understanding how and when a trace material such as a fibre transfers from an item of clothing onto an exhibit of interest, or pollen grains transfer onto footwear, can be critical for evaluating whether the fibre or pollen grain is relevant. In a similar way, it is very important to know how long different types of trace can persist on different recipient mediums (such as clothing, vehicles or footwear) to be able to interpret whether the trace is present due to its transfer at the time of the crime or days, weeks or even months before (Chisum and Turvey 2007; Roux et al. 2015; Morgan et al. 2020).

The evidence base also has the capacity to provide a foundational understanding of how critical human actors within the forensic science process observe clues, the factors that can influence the inferences and decisions made, and ultimately the conclusions that are reached regarding what a trace means. Human decision-making is generally highly logical and is able to engage with both explicit forms of knowledge (such as following agreed processes), and also tacit forms of knowledge (which draw in experience and expertise that is developed through practice and mentorship). It is also subject to implicit factors that can influence decisions at an unconscious level, which can introduce sources of uncertainty in some situations (Edmond et al. 2017; Dror 2018; Dror and Langenburg 2019).

The evidence base is fundamental to robust interpretation because it can offer greater understanding of how traces may behave within certain parameters. It also provides insights into how critical human decision-making may have been influenced by context, and offers ways to incorporate thresholds of risk and uncertainty into the evaluation of the conclusions that are reached (Earwaker et al. 2020). A key challenge for forensic science is ensuring that the value of establishing the evidence base is recognised within each of the main contributing spheres of influence (science, policy, law, policing and intelligence), so that appropriate investment is made in developing the evidence base. This is critical for the future because understanding what the evidence means must be underpinned by a strong knowledge base in combination with a strong evidence base.

Some examples of revealing the invisible in forensic science

There are different types of research taking place within forensic science that seek to contribute and develop the knowledge base and the evidence base. Traditionally, the focus and value has been placed on research that grows the knowledge base, often in other disciplines, with a view to potentially applying new discoveries to forensic science questions (Morgan and Levin 2019). However, increasingly research is beginning to be undertaken that is designed to answer research questions that are directly relevant and framed by the needs of forensic science. This research still predominantly focuses on addressing the detection and analysis of physical and digital materials. Studies that address the gaps in the evidence base have been steadily growing and fall into two main categories: those that address the interaction of different types of evidence within an environment (evidence dynamics) and those that address the human decision-making at each step of the forensic science process, and the roles of context and cognition on those decisions and the conclusions that are drawn.

Revealing the invisible: answering the questions of what and who?

The developments in fingerprint research offer a good example of the progress being made in developing the capabilities to detect and analyse greater amounts of intelligence from a clue. Traditionally, fingerprints have had a strong role in investigations to identify individuals and to inform crime reconstructions in terms of who handled a specific item, and sometimes how they handled it. Studies are now exploring how greater detection capabilities within the field of mass spectrometry can detect the biological materials that are excreted when a fingermark is deposited. These can identify other indicators about the individual who left the mark, such as what prescription or illicit drugs the individual may have taken (Groeneveld et al. 2015; Bailey et al. 2015; Costa et al. 2020). Similar work is taking place within the field of DNA in terms of deriving additional intelligence from the profiles identified from samples, such as developing approaches to infer appearance characteristics from the genetic profile (Kayser 2015) to provide additional information about an unknown individual from a deposit of trace DNA.

Revealing the invisible: answering the questions of how and when?

The importance of being able to understand how and when a clue may have transferred onto the surface where it was then detected and collected for analysis can be critical to understanding and revealing what that clue really means. For example, if we find the DNA profile of a suspect on the handle of a weapon, what does that really mean? Georgina Meakin et al. developed a study to contribute to the evidence base to assess the degree to which trace DNA could transfer onto knives (2017). The study was designed to have a series of 'regular users' who used a knife regularly over a period of two consecutive days. Each regular user then shook hands with a new participant for 10 seconds, and then the regular user picked up their knife and stabbed a foam block repeatedly for 60 seconds. When the handles of the knives were swabbed and analysed, it was found that the majority of the DNA on the knife handles was consistent with the DNA profile of the regular user. However, on some of the knives a small amount of DNA consistent with the handshaker (who had never touched the knife) was also found on the handles, and in some runs, the DNA from an unknown donor was identified. This study therefore demonstrates that while it is possible to reveal the invisible and identify DNA present on an item, it is absolutely critical to understand how trace DNA transfers between individuals and then in what circumstances it can be transferred onto exhibits, if it is going to be possible to evaluate what the presence of that DNA means when it is detected.

Revealing the invisible: ensuring an understanding of the impact of context and cognition in decision-making

It has been well documented in the published literature in many different disciplines that human decision-making can be influenced at the subconscious level and can influence what is seen. It has been identified that if the same clue is provided to an expert, but in different circumstances, the interpretation of that clue can be altered (Dror et al. 2006). One study in forensic science was designed to address the issue of whether context at the crime scene could influence what was seen by scientists at later stages of the forensic science process (during the analysis of materials in the lab). The experiment used a male skeleton cast that was buried in graves with 'female clothing' and in graves with more 'neutral clothing' (Nakhaeizadeh et al. 2018). The graves were then excavated and the remains recovered and brought to a lab where the

skeletons were laid out in order to undertake a sex assessment to establish whether the skeleton was from a male or female. The first group excavated the skeletons buried with female clothing and a second group excavated the skeletons buried with neutral clothing. Once back in the laboratory, both groups were asked to assess whether the skeleton they had recovered was male or female.

The majority of the group that excavated the skeleton with female clothing concluded that it was not possible to determine whether the skeleton was from a male or female. In contrast, the majority of the group that excavated the skeleton with neutral clothing concluded that the skeleton was male. The control group (who just saw the skeletal remains in the laboratory) all concluded that the skeleton was male. Therefore, the findings from this study indicate that context at earlier stages of the forensic science process may influence the decisions that are made at later stages.

The value of studies such as these are clear. It is really important to establish the explicit and implicit factors that can influence decisions, and when and to what degree these factors are present. In so doing, it will be possible to record the context of a decision more consistently, and incorporate this context into the interpretation of what a clue means and how that decision was reached. Incorporating greater transparency of context, and the potential impact of those factors on decisions and the ultimate conclusions reached, is a critical step for offering insights to investigators and the courts to assist investigations and use of evidence within the justice system.

Ongoing challenges in forensic science: moving from the visible challenges (symptoms) to seeing the invisible root causes to find solutions

Being able to articulate, and so make visible, the whole system within which forensic science operates, brings significant opportunities for the development of forensic science and the ability of science to assist the justice system. Revealing the complexity of the system that forensic science operates within – the multiple stakeholders (both institutional and individual actors) and factors (types of evidence, forms of decision-making) – as well as developing the capacity of both the knowledge base and the evidence base, is critical. There have been many significant challenges identified in forensic science such as miscarriages of justice, quality standard failures, the lack of an evidence base to underpin the

science and the interpretation of what a clue means in the context of a case. These are often symptoms of underlying challenges. These symptoms are what is visible, but the root causes of the symptoms have up until now remained invisible. Only by taking steps to reveal the complexity of the system, and the interconnections and relationships within that system as a whole, will it be possible to make the root causes of critical challenges visible. Only by making these root causes visible will it be possible to develop solutions that can address them in a sustainable way.

The challenge in forensic science has moved on from the need to reveal previously invisible clues. The value of making the whole system visible is a foundational step to being able to harness the capabilities that technology is providing. Forensic science must not only remain committed to revealing the hidden clues to address the 'what' and the 'who' questions, but also to revealing the system within which clues are found and decisions are made. Doing so will identify the gaps in the knowledge base and the evidence base that need to be addressed, in order to be able to reveal what those clues mean.

Conclusion

The importance of making the invisible visible is clear. However, at the same time we need to be willing to engage with what is not possible to 'see' (that which is not knowable). If science offers probabilistic conclusions that are reliant on what cannot (yet) be falsified, it is important for forensic science to be consistent and incorporate uncertainty into the conclusions that are reached when investigating clues to develop a crime reconstruction. There will always be known unknowns, and unknown unknowns, and these must be built into our understandings of the forensic science system.

This is why the models that we develop of that system to 'reveal it' need to incorporate both explicit and tacit forms of knowledge in order to provide resilience and a capacity to be clear about what is known and knowable, and that which is (as yet) not knowable or invisible. Other fields can offer valuable insights. Music, magic, medicine and many of the arts bring together established processes, skills and methods of analysis, which can be codified and communicated explicitly (made visible). They also crucially incorporate the development of experience expertise and a culture of performance that is nuanced and draws on tacit forms of knowledge that can often be difficult to make visible but are still knowable.

This is, of course, easier said than done, but an appreciation that forensic science operates within a holistic system where there will always be some parts of that system that will remain invisible will actually transform what we can see, and what we search to see better. Taking this approach offers a pathway to seeing more than we currently can, and ensuring that science can offer even more to the justice system by continuing to reveal that which is not currently visible, but also developing greater transparency in what remains invisible.

References

Almazrouei, Mohammed A., Itiel E. Dror and Ruth M. Morgan. 2019. 'Forensic disclosure: What should be disclosed to and by forensic experts?' *International Journal of Law, Crime and Justice* 59: https://doi.org/10.1016/j.ijlcj.2019.05.003.

Bailey, Melanie J., Robert Bradshaw, Simona Francese, Tara L. Salter, Catia Costa, Mahado Ismail, Roger Webb, Ingrid Bosman, Kim Wolff and Marcel de Puit. 2015. 'Rapid detection of cocaine, benzoylecgonine and methylecgonine in fingerprints using surface mass spectrometry', *Analyst* 140(18): 6254–9.

Butler, John M., Margaret C. Kline and Michael D. Coble. 2018. 'NIST interlaboratory studies involving DNA mixtures (MIX05 and MIX13): Variation observed and lessons learned', *Forensic Science International: Genetics* 37: 81–94.

Chisum, W. Jerry and Brent Turvey. 2007. *Crime Reconstruction*. USA: Academic Press.

Costa, Catia, Mahado Ismail, Derek Stevenson, Brian Gibson, Roger Webb and Melanie Bailey. 2020. 'Distinguishing between contact and administration of heroin from a single fingerprint using high resolution mass spectrometry', *Journal of Analytical Toxicology* 44(3): 218–25. https://doi.org/10.1093/jat/bkz088.

Dror, Itiel E. 2018. 'Biases in forensic experts', *Science* 360(6386): 243.

Dror, Itiel E., David Charlton and Ailsa E. Péron. 2006. 'Contextual information renders experts vulnerable to making erroneous identifications', *Forensic Science International* 156(1): 74–8.

Dror, Itiel E. and Glenn Langenburg. 2019. '"Cannot decide": The fine line between appropriate inconclusive determinations versus unjustifiably deciding not to decide', *Journal of Forensic Sciences* 64(1): 10–15.

Earwaker, Helen, Sherry Nakhaeizadeh, Nadine M. Smit and Ruth M. Morgan. 2020. 'A cultural change to enable improved decision-making in forensic science: a six phased approach', *Science and Justice* 60(1): 9–19.

Edmond, Gary, Alice Towler, Bethany Growns, Gianni Ribeiro, Bryan Found, David White, Kaye Ballantyne, Rachel A. Searston, Matthew B. Thompson, Jason M. Tangen, Richard I. Kemp and Kristy Martire. 2017. 'Thinking forensics: Cognitive science for forensic practitioners', *Science and Justice* 57(2): 144–54.

Groeneveld, Gino, Marcel de Puit, Stephen Bleay, Robert Bradshaw and Simona Francese. 2015. 'Detection and mapping of illicit drugs and their metabolites in fingermarks by MALDI MS and compatibility with forensic techniques', *Scientific Reports* 5: https://doi.org/10.1038/srep11716.

House of Lords Science and Technology Select Committee. 2019. 'Forensic science and the criminal justice system: A blueprint for change'. Accessed 29 April 2020. https://publications.parliament.uk/pa/ld201719/ldselect/ldsctech/333/333.pdf.

Kayser, Manfred. 2015. 'Forensic DNA phenotyping: Predicting human appearance from crime scene material for investigative purposes.' *Forensic Science International: Genetics* 18: 33–48.

Meakin, Georgina E., Emma V. Butcher, Roland A.H. van Oorschot and Ruth M. Morgan. 2017. 'The deposition and persistence of directly- and indirectly-transferred DNA on regularly used knives', *Forensic Science International: Genetics* 29: 38–47.

Meakin, Georgina and Allan Jamieson. 2013. 'DNA transfer: Review and implications for casework', *Forensic Science International: Genetics* 7(4): 434–43.

Morgan, Ruth M. 2017a. 'Conceptualising forensic science and forensic reconstruction; Part I: a conceptual model', *Science and Justice* 57(6): 455–9.

Morgan, Ruth M. 2017b. 'Conceptualising forensic science and forensic reconstruction; Part II: the critical interaction between research, policy/law and practice', *Science and Justice* 57(6): 460–7.

Morgan, Ruth M. 2018. 'Forensic science needs the "hedgehog" and the "fox"', *Forensic Science International* 292: https://doi.org/10.1016/j.forsciint.2018.08.026.

Morgan, Ruth M. and E. Levin. 2019. 'A crisis for the future of forensic science: Lessons from the UK for the importance of epistemology for funding research and development', *Forensic Science International: Synergy* 1: 243–52.

Morgan, Ruth M., Georgina E. Meakin, James C. French and Sherry Nakhaeizadeh. 2020. 'Crime reconstruction and the role of trace materials from crime scene to court', *WIREs Forensic Science*: https://doi.org/10.1002/wfs2.1364.

Nakhaeizadeh, Sherry, Ruth M. Morgan, Carolyn Rando and Itiel E. Dror. 2018. 'Cascading bias of initial exposure to information at the crime scene to the subsequent evaluation of skeletal remains', *Journal of Forensic Sciences* 63(2): 403–11.

Organization of Scientific Area Committees for Forensic Science (OSAC). 2018. 'A framework for harmonizing forensic science practices and digital/multimedia evidence', OSAC Technical Series 0002. https://www.nist.gov/system/files/documents/2018/01/10/osac_ts_0002.pdf.

Roux, Claude, Benjamin Talbot-Wright, James Robertson, Frank Crispino and Olivier Ribaux. 2015. 'The end of the (forensic science) world as we know it? The example of trace evidence', *Philosophical Transactions of the Royal Society B* 370(1674): https://doi.org/10.1098/rstb.2014.0260.

The Forensic Science Regulator. 2017. 'Annual report'. Accessed 29 April 2020. https://www.gov.uk/government/publications/forensic-science-regulator-annual-report-2017.

2
Revealing the invisible and inaudible in UCL Special Collections

Adam Gibson, Tabitha Tuckett, Katy Makin, Cerys Jones, Jieran Sun and Melissa Terras

Introduction

Rare books, manuscripts and archives housed in libraries and institutions are often perceived as invisible to all but a privileged few. Whether this perception is accurate or not, it has begun to be challenged over the last few decades by the powerful combination of digital photography and the internet, which together enable images of some of the most fragile and carefully preserved material to be easily viewed and disseminated. However, the increased visibility of collections is now balanced by a range of advanced imaging techniques addressing what has so far remained invisible in standard digitisation and to the naked eye. This chapter surveys some of these techniques, and how we have used them to attempt to picture otherwise invisible text and materiality in medieval manuscripts and early printed books.

Many libraries and archives now routinely digitise as much of their special collections as resources permit, and copyright and data restrictions allow. One of the reasons they do this is to improve access for readers, who indeed often expect historic material to be accessible digitally. Digitisation allows researchers to access collections without the need to travel, it facilitates linking data so that objects in different collections may be studied together, it offers access for less well-funded researchers, and it can open up collections to new opportunities for outreach and crowdsourcing, including through social media (Terras 2015, 63). Most major collections in the UK now have well-developed digitisation

strategies and programmes that are addressing the complex issues of copyright, ownership, metadata, storage, access, increased visitor numbers (resulting from increased online presence) and the impact of photography on the physical originals.

However, advanced imaging and computational techniques that use scientific approaches to reveal further details about objects and artefacts not visible to the naked eye and come under activities now known as heritage science, are not yet routinely deployed in this sector, despite these approaches being able to recover otherwise illegible text, detect underwriting or inform conservation practices. This is partly due to limited access to expertise and the high cost: they often require expensive equipment and intensive image processing. It may perhaps also be due to an assumption that the appeal of imaging special collections lies only in transmitting text rather than examining its materiality – an assumption that pervades our language across digital contexts, where we describe the written word and its referent as 'content', 'information' and 'data' rather than using the range of language associated with physical books or manuscripts.

The slow adoption of advanced imaging in heritage science is also partly because it is relatively unusual to have the opportunity to carry out sustained, joint approaches to imaging library and archive materials, involving colleagues both from special collections and the growing field of heritage science. Advanced imaging is usually undertaken as part of a multidisciplinary team of imaging scientists and computer scientists, librarians, curators and conservators, and historians and other humanities scholars (Dillon et al. 2014). The expense, time and broad range of skills required means that it is frequently outside the scope of most libraries and archives.

In this chapter, we describe such a collaboration that brought together imaging scientists based in the UCL Digitisation Suite with staff from UCL Special Collections. The UCL Digitisation Suite is co-located with UCL Special Collections, allowing the close working relationship to develop that is necessary for such projects. The Suite is supported by both UCL Faculty of Engineering and UCL Faculty of Arts and Humanities as well as UCL Library Services, and aims to provide a space in which people can learn, research and experiment with digitisation and heritage science technologies.

A range of non-invasive digital-imaging investigations was undertaken on materials held in UCL Special Collections. We demonstrate that the use of non-invasive imaging methods such as multispectral imaging and reflectance transformation imaging can provide further

information that can help in identifying and understanding library and archive objects, and enhancing catalogue information and description, ultimately helping in discovery and research. However, there remain issues about resourcing, retention of data and information and informed interpretation of results, that need to be addressed before this type of digitisation becomes more commonplace in special collections.

Introduction to the collections

UCL Special Collections[1] is part of UCL Library Services and is one of the foremost university collections of manuscripts, archives and rare books in the UK. It holds extensive collections of medieval manuscripts and early printed books, as well as significant holdings of eighteenth-century works, and highly important nineteenth- and twentieth-century collections of personal papers, archival material, books on the history of science and literature, notably Jewish collections and the George Orwell Archive.

Some of the items described in this chapter form part of an extremely varied collection of around 150 fragments of medieval and early modern manuscripts in a variety of languages, predominantly Latin. They are primarily leaves from Christian liturgical texts such as missals, breviaries, psalters, bibles, antiphonals and graduals, but there are also several fragments from popular medieval textbooks such as the *Codex Justinianus* (a legal text originally put together in the sixth century CE, but translated and transformed many times during the medieval period). The early provenance of the UCL fragments is obscure, but most appear to have been removed from the bindings of other manuscripts or early printed books, where they had generally been used as pastedowns or outer coverings. This method of recycling was increasingly common from the late fifteenth century onwards where manuscript copies on parchment of texts that were no longer used were recycled as decorative covers and endpapers or to reinforce the binding of new printed works. The origins of some items in this collection can be traced to Germany, particularly the music fragments, which have distinctive German or Bohemian musical notation. A small number of texts, such as fragments of works by Justinian, are clearly Italian in their script and decoration, and they may have originated in Bologna, where the university was a centre of legal studies in the medieval period.

Some of the fragments were purchased by Professor Robert Priebsch (Professor of German at University College London, 1898–1931) at a sale

in Bonn in the early 1920s in order to give his students practical experience of medieval palaeography. It is not known precisely how many he purchased, but surviving records indicate that this number is likely to be small and therefore does not account for the whole collection that has since been accrued.

The rare books in this study indicate the wide range of provenance of UCL's historic collections. Although founded in the early nineteenth century, the College's library has acquired significant earlier holdings. One of the books discussed below belongs to the library of Charles Kay Ogden, and was acquired in 1953 with funding from the Nuffield Foundation.[2] Ogden, who founded the Basic English movement, collected medieval, early modern and later books and manuscripts related to writing, language, communication, cryptography, written signatures, annotations, palimpsests and what he described as 'word magic' (Ogden 1937, 234). He was interested in the marks people make on the page and how we interact with books physically. The example below is typical, and one of a number of books in the Ogden Collection that may have been formerly owned by Ben Jonson. Another book used in our project comes from the rich historical collections of the Hertfordshire Natural History Society, whose rare botanical books were deposited with UCL in 1935. We invited the Royal College of Physicians to contribute the third printed book in this project from their historic collections.[3] Their rare books include a number formerly owned by the sixteenth-century mathematician and astrologer John Dee, one of which was imaged as part of this work.

Multispectral imaging

For the work described in this chapter, we used two different methods of imaging to reveal the invisible, which highlight some of the various advanced imaging methods that have been applied to books and manuscripts. For example, we have previously used eight different imaging methods in an attempt to read writing in the papyrus that constitute Egyptian mummy cartonnage and masks, and all of these methods have also been applied to documents and manuscripts (Gibson et al. 2018). Here, we concentrate on two methods: multispectral imaging (MSI) and reflectance transformation imaging (RTI). We outline the techniques here and then describe their application to a range of documents and manuscripts later in the chapter.

The human eye is an extraordinarily effective system for detecting light. There are three different light sensitive cells in the retina, which can

detect wavelengths of light between about 400 nm, which are seen as blue, and about 700 nm, which are perceived as red. As there are only three different detector cells, much of the processing that allows different colours to be distinguished occurs in the brain. By dilating or contracting the pupil, it is possible to see in bright light and faint light. Indeed, when the eye is dark adapted, we can see in conditions that can be 10 billion times darker than full sunshine. In humans, two eyes are arranged to give overlapping views that give some sense of depth perception. In comparison, a standard digital camera has a detector that is based on silicon and is sensitive to a wider range of wavelengths than the eye, allowing sensitivity to the ultraviolet (to about 350 nm) and the near infrared (about 950 nm). Such a camera usually has a filter that excludes near infrared light, so that its spectral response is matched to that of the eye.

In multispectral imaging, it is possible to exploit the increased spectral range, excellent spatial resolution and controllable lighting conditions that are available with a digital photography system to produce images that show features that are invisible to the naked eye (Liang 2012, 309–11). The increased spectral range allows the visualisation of features under ultraviolet and near infrared illumination. A particular advantage of this is that the longer infrared wavelengths tend to penetrate a medium such as paper or parchment deeper than shorter wavelengths. These advantages allow the detection of specific pigments with increased clarity, and also allow us to see through the outer surface and expose under-drawings or writing that has been overwritten. The excellent spatial resolution allows fine detail to be seen, but perhaps more important is the ability to control the illumination. In particular, if we illuminate in a certain wavelength but then use a filter to prevent that wavelength from being detected by the camera, it is possible to detect fluorescence. Fluorescence occurs when an object is illuminated by short-wavelength light (typically ultraviolet or blue) and then re-emits the light as a different colour (often blue or green). Under certain conditions, fluorescence can be seen by eye, for example, when white clothing glows in a night club.

Multispectral imaging is now widely used to image heritage objects following initial success of imaging the Dead Sea Scrolls (Bearman and Spiro 1996), artworks (Casini et al. 1999) and the Archimedes Palimpsest (Easton et al. 2003). For example, MSI can be used for condition monitoring (Marengo et al. 2011), to detect traces of ink and distinguish between different pigments (Cosentino 2014), and highlight faded text (Giacometti et al. 2017). Two general approaches are taken. One is to

illuminate with white light and use the camera to distinguish between the wavelengths, perhaps using wavelength filters or some other method to split the white light into its colour components. The other method is to illuminate with different wavelengths (Jones et al. 2020). For example, the illumination used in this work generates light at 16 different wavelengths, giving better wavelength sensitivity compared to the three available in the eye. MSI is usually assumed to be safe for collection items as the illumination is approximately equivalent to that which an object would receive in a few days on display, although it is possible that the light levels could damage particularly light-sensitive pigments.

The system used in this work was provided by R. B. Toth Associates LLC (VA, USA) and is based around a PhaseOne 60 megapixel, 16-bit monochrome IQ260 digital back with a 120 mm apochromatic lens (PhaseOne, Denmark) and lighting and filter wheel provided by Equipoise Imaging LLC (MD, USA). The lighting consists of two panels, each able to illuminate at 12 wavelengths from 370 nm to 940 nm, and a filter wheel, which is able to insert a long-pass filter in front of the camera lens to exclude the illumination light (figure 2.1).

As an early test of the system, a fragment of a liturgical manuscript containing music (probably a noted missal) held by UCL Special Collections (MS FRAG/MUSIC/5) was imaged. It is believed to be from the thirteenth century and contains Catholic songs, prayers and chants

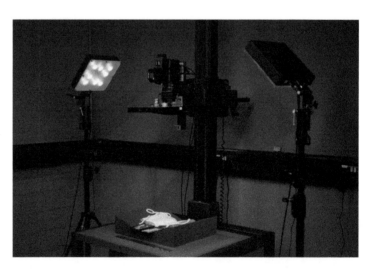

Figure 2.1 The UCL Multispectral Imaging System, showing camera, filterwheel, lighting panels and copy stand.

Credit: Adam Gibson.

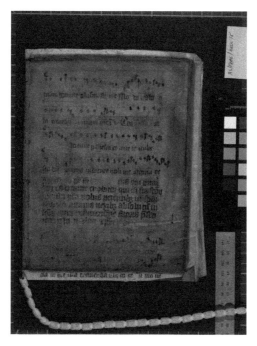

Figure 2.2 Music fragment MS FRAG/MUSIC/5.

Credit: UCL Special Collections/Adam Gibson.

(figure 2.2). The musical notation at the bottom of the document is unclear and it was imaged using the multispectral imaging system in an attempt to provide clarification. Images were obtained using 12 wavelengths, some augmented with filters, to give 16 images in total. A set of images like this is difficult to view and analyse in a natural way, so some image processing is generally necessary to interpret them. Often, this is just a simple subtraction of one image from another but in this case, principal component analysis (PCA) was employed (Tonazzini et al. 2019). This method takes a series of data (in this case images, arranged by wavelength) and generates a new set of images with the same total information content, but restructured so that the first image contains as much information as possible and each subsequent image contains decreasing amounts of information (mathematically, they are uncorrelated, meaning that each subsequent image is independent of the others). PCA has a number of advantages: by maximising the information in a few images, it can allow the information to be compressed into fewer images; images with less information tend to contain more noise and can be rejected to suppress noise; and certain features sometimes appear

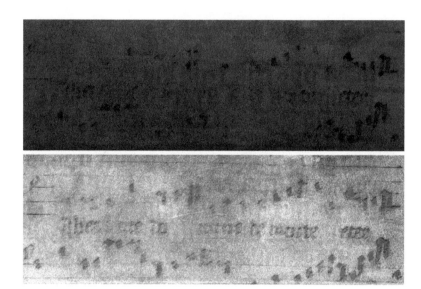

Figure 2.3 Part of music fragment MS FRAG/MUSIC/5 imaged under visible lights (top) and following principal component analysis to maximise the legibility of the musical notation (bottom).

Credit: UCL Special Collections/Adam Gibson.

more strongly in some of the images' output from the PCA analysis than they do in the original image set. In this particular case, we chose three PCA images that showed the musical notation most strongly and assigned them to the red, green and blue channels of a standard digital image. Figure 2.3 shows that the notation is more clearly visible in the false colour, processed image than in the original full colour image. The text can be read as '*Libera me, Domine, de morte æterna*', the opening of a responsory from the Office for the Dead.

Reflectance transformation imaging

MSI can highlight changes due to different wavelengths of illumination but pays no attention to the surface shape of the object. Manuscripts and the printed page are often assumed to be flat, 2D objects with no surface structure and, indeed, it is sometimes assumed that the legibility of the writing is the only consideration. They are, however, real physical objects and their physicality is important. Concentrating on making the text visible may by implication make the physical structure invisible, and methods that recover both structure and legibility can enhance the

visibility of both. For example, the structure of paper or parchment is important to conservators and can be useful to curators and researchers for dating, provenance and general book history, as well as indicating what animal the parchment came from, how the paper was made, or how either was treated or coated, or ink or pigments applied. Folds and creases can reveal how the document was used, and any impressions in the surface of a printed page could give indications as to what printing technology was used.

Reflectance transformation imaging (also called polynomial texture mapping) is used to highlight surface texture in a document or other object (Malzbender et al. 2006). This technique, a type of computational photography, is now commonly used in heritage applications; for example, to image graffiti (DiBiasie Sammons 2018) and similar features (Earl et al. 2010). A camera is mounted in a fixed position and a number of photographs, typically around 50, are taken of the object with a flash being used to light it from different angles. Some researchers use a dome to hold the camera and flashes in fixed positions (MacDonald et al. 2018), but for maximum flexibility we use a camera on a copystand and a hand-held flash, along with various calibration targets. In raking light photography, photographs are taken with illumination from a position almost parallel to the surface. By taking many photographs at raking light angles and higher angles, and processing them, a virtual surface can be generated where every pixel shows the intensity of the reflected light and the angle of the surface. This is visualised in an interactive viewer, allowing the user to control a 'virtual light source' and explore the surface shape of the object. The spatial resolution of RTI is the same as that of each photograph, so with a high performance camera and lens, it is quite easy to relight individual letters, allowing extremely detailed analysis. The interactivity of the virtual light source can be attractive to an end-user as they can interact actively with the image rather than just viewing it passively.

Revealing a Hebrew text

Our work on a Hebrew manuscript fragment gives a more detailed indication of what these techniques can achieve. This manuscript (MS FRAG/HEB/1) consists of two folios (i.e. two sheets, so four sides of writing) on parchment. The two folios are believed to come from the same manuscript. Some text on the first folio is legible and has been identified as coming from the Book of Genesis. It is arranged in two

Figure 2.4 Part of MS FRAG/HEB/1 illuminated under natural lighting, showing how faded the writing is to the eye.

Credit: UCL Special Collections/Jieran Sun.

columns, with each verse in Hebrew followed by an Aramaic translation. Much of Folio 2 is faded and blurred, so the aim of the work was to image the manuscript to see if it was possible to increase the contrast to reveal more detail and make the writing legible. The edges of the manuscripts are damaged and have been heavily restored, and there is some evidence of annotation by a Hebrew scribe (figure 2.4).

For MS FRAG/HEB/1, because the aim was to enhance legibility, we chose to image with MSI. An upgraded multispectral imaging system was used that could illuminate at 16 wavelengths, which, with filters, gave a total of 23 photographs. Ultraviolet and blue wavelengths were found to give most contrast as the parchment fluoresced and so became brighter at shorter wavelengths while the ink did not. Indeed, simply viewing the unprocessed images acquired under shorter wavelengths appeared to give better contrast than viewing under room lights. Principal component analysis enhanced contrast further (figure 2.5), particularly when supported by more image processing such as inversion (converting black to white and vice versa), normalisation (increasing the intensity of the brightest pixel to maximum and decreasing that of the darkest pixel to

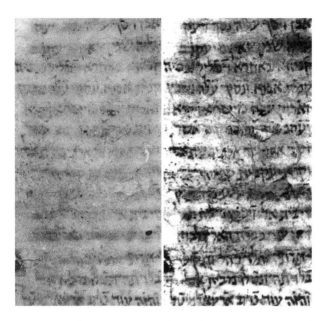

Figure 2.5 Principal Component Analysis of MS FRAG/HEB/1, showing part of the sheet illuminated under room lighting (left) and the increased legibility offered by PCA (right).

Credit: UCL Special Collections/Jieran Sun and Cerys Jones.

minimum) and histogram equalisation (distributing the intensity values equally). These post-processing techniques can all improve apparent visual contrast but may need to be optimised for each individual case.

The improved contrast has allowed Vanessa Freedman, the Hebrew & Jewish Studies Subject Liaison Librarian at UCL, to read the text of the second folio, which she identified as Genesis 35: 11–17. It is arranged in the same way as the first folio, with each Hebrew verse followed by an Aramaic translation taken from a second century translation of the Torah known as *Targum Onkelos*. We are now confident that the two folios are indeed from the same manuscript but are not consecutive. Revealing this previously unknown connection will change the way that the two folios are stored and described in the catalogue.

This case study demonstrates how MSI, with the associated image processing, may enhance the contrast and enable a reader to decipher illegible text – and so picture the invisible – but it also illustrates the breadth of multidisciplinary skills required to embark on a study like this. It is necessary to assemble a team not only of imaging scientists and archivists, but also historians who can advise on the date and context of

the document, and scholars who can read and understand the language, in this case Hebrew and Aramaic. Each discipline brings a different lens of viewing and insight, which together can reveal that which was previously unknown or invisible.

Revealing writing that has been overwritten

Medieval and early modern scholars treated reading as an interactive process, annotating books with enthusiasm. It is not unusual to see a manuscript or an early printed book with numerous notes written in different hands. Indeed, books were often written or printed with a generous margin to facilitate this. Similarly, it was common for an owner to write inscriptions, which could be as simple as a signature or something more complex, to show ownership. As a book passed between owners, the new owner might overwrite or scribble over the previous owner's signature. This left a trace of the passage of ownership that now provides an important contemporary record of the use and history of a book (Jackson 2001).

It is possible to image overwritten signatures using multispectral imaging, and two representative samples are described here. First, a copy of Otto van Veen's *Amorum Emblemata*, a book of emblems (each consisting of image, quotation and verse) about love, printed in 1608, which is believed to have been owned by the Elizabethan and Jacobean playwright Ben Jonson. It has three areas on the title page where previous inscriptions have been overwritten (figure 2.6). One is believed to include Ben Jonson's name and the other two have not previously been deciphered. Second is a copy of a short treatise on parts of Pliny's *Naturalis Historia*, printed in 1548 and owned by the Royal College of Physicians (Ryff 1548). It has an inscription reading 'Nicolaus Saunderus' dated 1584, which is clearly written on top of a previous inscription that is now illegible.

Both books were imaged using multispectral imaging, with image processing carried out as described previously. Where possible, both sides of a sheet are imaged to identify any instances where text that is printed on the back side is visible from the front (as was the case in the music manuscript described in the introduction).

It was possible to recover the three areas of overwriting on *Amorum Emblemata*. The underwriting is still difficult to decipher, but given knowledge of the context, the first is believed to read '*tamquam explorator*', a quotation from Seneca meaning 'as an explorer' and written by

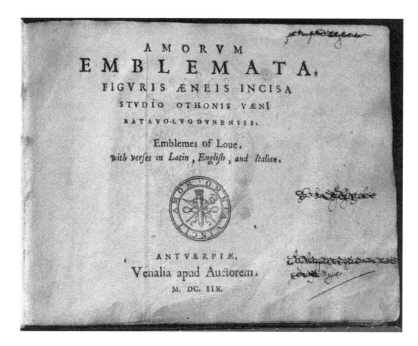

Figure 2.6 A photograph of the title page of *Amorum Emblemata* (OGDEN A 292) showing three different overwritten inscriptions.

Credit UCL Special Collections/Cerys Jones.

Ben Jonson as a motto in several of his books to indicate his ownership. The second is likely to say '*Sum Ben Jonsonij Liber*', or '*I am Ben Jonson's book*' (figure 2.7).

The third is more challenging, but with knowledge that the author's dedication, printed on the following pages, is to Philip Herbert, Earl of Montgomery (1584–1650), and his older brother William Herbert, 3rd Earl of Pembroke (1580–1630),[4] both of whom provided patronage to Jonson in many ways (and that a manuscript inscription in an early modern hand has been added following the statement of dedication to read '& of thy noble vou[ch]sake'), it is possible to surmise that it says:

D.
ex Philippi {.}o{.}i{.}iss{.} comitis Mont-
gomerij Musaeo.

or '[Gift] from the library / study / collection[5] of Philip {…} Earl of Montgomery' (figure 2.8). *Mont-gomerij* is split across two lines, and the

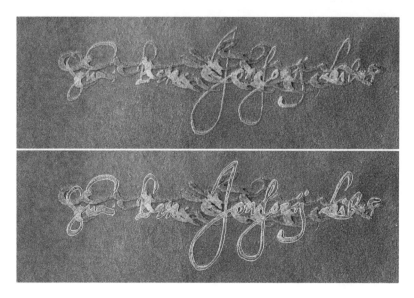

Figure 2.7 Principal component analysis revealing inscription '*Sum Ben Jonsonij Liber*' that has been overwritten (top), with underwriting highlighted by outlining it (below).

Credit: UCL Special Collections/Cerys Jones.

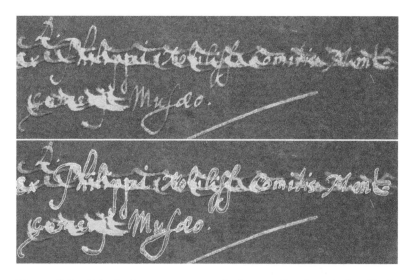

Figure 2.8 Principal component analysis revealing inscription '*D. Ex Philippi Comitis Mont-Gomerij Musaeo*' that has been overwritten (top), with underwriting highlighted by outlining it (below).

Credit: UCL Special Collections/Cerys Jones.

missing word may be 'nobiliss.' or a similar abbreviation for 'nobilissimi', giving 'Philip, most noble Earl of Montgomery'. The improved visibility of the inscriptions suggests that all three are in the same hand. Matching this with known inscriptions by Ben Jonson, we are now more confident that the book was indeed owned by him and contains his motto as well as his name. We may also have revealed evidence that this copy was a gift to, or purchase for, Jonson from Philip of Montgomery (Jonson's *Timber; or discoveries made upon men and matter*, published posthumously in 1641, notes that William's patronage included £20 a year to buy books for Jonson). While the three inscriptions discussed here are crossed through (with the exception of the word 'musæo'), the lines 'the gyfte of one whose death I moane' are copied repeatedly into the book elsewhere, in an early modern hand, and are not crossed through. Might these refer to the death of William, or later death of Jonson, or the even later death of Montgomery?

The undertext beneath 'Nicolaus Saunderus' on *Naturalis Historiae Commentarius* was also difficult to read after enhancement (figure 2.9), but after discussion with Katie Birkwood, Rare Books and Special Collections Librarian at the Royal College of Physicians, we believe the underwriting says '*Joannes Dee 1562 Antwerpiæ*'. This supports the belief that the book was owned by John Dee (1527–1608/9), an Elizabethan and Jacobean scientist and astrologer. The Royal College of Physicians holds several books of his that bear his partially erased or overwritten signature, often overwritten by the name of Nicolas Saunder who obtained books from Dee, possibly by theft (Jones 2016). Imaging was able to support other evidence, including annotations in his hand

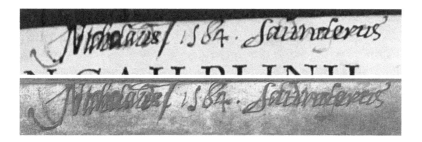

Figure 2.9 Photograph of title page showing area where '*Nicolaus Saunderus*' has been written over an earlier inscription (top) and principal component analysis that attempts to enhance the earlier inscription (below).

Credit: UCL Special Collections/Jieran Sun.

elsewhere in the book, that this copy of *Naturalis Historiae* was part of Dee's collection, either stolen or received by Saunder.

It is notable that the successful recovery of the underwriting on *Amorum Emblemata* and *Naturalis Historiae Commentarius* was not due to principal component analysis or even multispectral imaging per se. It was due to the excellent spatial resolution (32.5 pixels/mm) and the additional perceived contrast offered by false colour imaging. This, together with the relative lack of success of recovering the writing on other examples, is likely to be due to the ubiquitous use of iron gall ink. Iron gall ink, made from the galls of oak trees, was the most widely used ink in Europe for manuscripts from Roman times until the twentieth century. It darkens from light blue to brown-black over a few decades, but once darkened, the spectral signature of all types of iron gall ink is similar. We would not therefore expect the response of the under-writing to be significantly different from that of the ink used to obscure it, and, therefore, we would not expect multispectral imaging to be particularly successful at separating the undertext from the overtext.

Imaging the binding of a book

Exoticorum libri decem (Clusius 1605) is a book compiled by the pioneering sixteenth-century botanist Carolus Clusius, including both his own works and new editions of other key works on natural history. It is an exhaustive description of animals and plants, illustrated throughout by woodcut prints. The full title is *Exoticorum libri decem: quibus animalium, plantarum, aromatum, aliorumque peregrinorum fructuum historiæ describuntur*, or 'Ten books of exotica: giving accounts of animals, plants, spices and other fruits from distant lands'. The copy held by Special Collections is the first edition, printed in 1605, and has a contemporary half-binding of unstained vellum and stained re-used parchment over boards (figure 2.10). There is very faint evidence of writing on the binding and we used multispectral imaging to try to reveal more of the writing and determine what it says.

The standard imaging process described earlier was used with 17 images, followed by principal component analysis and some other image enhancement techniques. Unprocessed images offered some visible improvement in contrast, but not enough improvement that the writing became legible. Some of the principal components did significantly improve legibility and certainly uncovered more writing that was invisible to the eye. We generated false-colour images by selecting three principal

Figure 2.10 A photograph showing the binding of *Exoticorum libri decem*, with a barely visible handwritten inscription.

Credit: UCL Special Collections/Cerys Jones.

component images and assigning them to the red, green and blue channels of a standard image and processed these further using a program called DStretch, which can increase colour contrast.[6] These did show more of the writing and had indications that some of the capitals were written in a different colour from the rest of the writing (figure 2.11). On both the front and back covers, we were able to detect a greater extent of writing than had previously been suspected, to identify the language as Latin, to identify the presence of different colour or ink and to begin to make out some letters and words (such as '*paschalia*' at the top and '*Deus*' at the bottom of the image on the left). However, to read, understand, date and identify the manuscript text will need a palaeographer who is familiar with writing of that period.

Even though we have so far been unable to read and identify the writing on the binding of the book, we have been able to determine that the book was bound in an earlier manuscript. This was suspected but as the writing is almost imperceptible to the eye, our confirmation is valuable. Revealing this previously unconfirmed history of the book has changed the way that it is handled and cared for. By growing our understanding of the history and provenance of the book, it is possible to

Figure 2.11 Principal component analysis, allowing some of the inscription to be read, and showing that more than one ink is present.

Credit: UCL Special Collections/Cerys Jones.

identify opportunities for further research directions to reveal more of the (currently) 'invisible'.

This example also further demonstrates the importance of bringing together a multidisciplinary team to tackle questions around these objects. In this case, librarians and archivists who understand the books and their context, imaging scientists who can create the clearest possible images of the writing, and classical, medieval or early modern scholars such as palaeographers and historians who can read and interpret the writing all had important roles to play. Even then, palaeography and history offer alternative contextual and interpretative insights, and pooling interpretations and discussing openly what each discipline enables us to see in the images has proved central to the work revealing more of the invisible.

Imaging illuminations

Illuminated letters were used in high-profile medieval manuscripts, especially religious texts. MS FRAG/LAT/28 is a fourteenth-century

psalter, or psalm book, written on parchment. Only the bottom half of the leaf remains and includes parts of Psalms 48 and 49. It is believed to have been used for private devotional use and has faint marginal annotations. The text is in Latin, mainly in iron gall ink, with some letters in red to denote the start of a new line of the psalm. However, the most striking feature of the fragment is an illuminated initial 'D' in gold leaf, the height of three lines of text, with some faded ink decorations around it, indicating the start of the 49th Psalm. The gold leaf is extensively degraded, with the underlying parchment visible in places. It was about to be restored and we were asked to image it beforehand in the hope that imaging would help to guide the restoration process.

One might expect gold leaf to be bright and reflective. However, the lighting for the multispectral imaging system is arranged so that the manuscript is illuminated from a 45-degree angle, so that any direct, specular reflections would also occur at 45 degrees and therefore not be detected by the camera. Such reflections might be unusually bright, but would carry information about the wavelength of the illuminating lights rather than the material of the object itself. The gold leaf therefore appeared dark in the images, especially at shorter wavelengths where the parchment fluoresced and so appeared light. Other than providing high-resolution images, there was little additional information provided by multispectral imaging.

However, the flaking surface of the gold leaf offered some 3D surface structure, suitable for reflectance transformation imaging, so we carried out this imaging modality on the illuminated letter 'D' as well as multispectral imaging. The interactive viewer (RTIViewer, available from http://culturalheritageimaging.org) allows the virtual light source to be moved over the surface of the image, enabling the viewer to enhance the shadows and therefore the visualisation of the surface interactively. It also offers different viewing options, one of which is 'specular enhancement', which emphasises the areas that reflect light most strongly such as the gold (figure 2.12).

The images we obtained will be useful during the restoration process. We will train the conservators in the use of RTIViewer, so that they can interact with the RTI image themselves. The multispectral images gave excellent delineation of the edges of the remaining gold leaf flakes, mainly due to the fluorescence of the underlying parchment. The interactivity allowed by RTI enables the user to explore the surface structure of the gold leaf in detail, to gain an impression of the level of damage and an indication of how well the remaining gold flakes are adhered to the surface. We aim to repeat the imaging following the

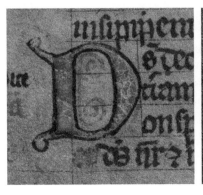

Figure 2.12 Reflectance transformation image of the gold illuminated letter 'D'. This shows two snapshots taken from the interactive viewer, visualised using two of the standard options available in RTIViewer, 'Default' (left) and 'specular enhancement' (right).

Credit: UCL Special Collections/Jieran Sun.

conservation treatment so that we can compare multispectral and RTI images of the illuminated letter before and after restoration.

Conclusion

In this chapter, two examples of advanced imaging methods applied to rare books and archival documents have been presented, together with a number of different case studies where these techniques have been used to image manuscripts and books. This work has revealed previously unknown attributes and insights, which have increased our knowledge of these objects and informed their curation, storage and interpretation. Most commonly, advanced imaging is used to examine iconic objects (e.g. Bearman and Spiro 1996; Easton et al. 2003; Earl et al. 2010), whereas here we use it to examine less high-profile items in a university's historic collection, thereby gaining insights into new pieces and further revealing that which has been invisible.

However, it is clear that imaging in these cases has not been transformative. In most cases, it has confirmed information that already existed or added incrementally to existing information and understanding. This should not be surprising, as the time, effort and resources required to image items means that advanced imaging tends to be applied to items

that are already considered important and so have been previously studied.

The co-location of the Digitisation Suite with Special Collections at UCL has allowed a degree of experimentation that might be difficult to achieve otherwise. Working together in a university setting has meant that students have been able to carry out imaging, which means that costs are significantly reduced. Even so, access to advanced imaging is still limited, so choices need to be made about the allocation of resources. Sometimes, indeed often, imaging might not lead to new knowledge and it must be accepted that speculative studies will not always lead to successful outcomes and might be perceived by some, in this respect, as wasted effort. To maximise the likelihood of success, it is necessary to build relationships based on trust, and for imaging scientists, librarians and archivists to have detailed, open discussions about the imaging. In our experience, a multi-disciplinary collaboration such as this is only successful when both parties gain from the project and when both parties are willing to attempt to understand the whole of the challenge.

Reports on advanced imaging tend to emphasise new discoveries about the text of a document, but we have found that equally important is information that is of value to conservators. Imaging could be used to establish the condition of an item prior to conservation and provide a robust record of the effect of conservation. It can also guide the conservator, but again this needs close collaboration between imager and conservator.

Even when imaging does generate new and useful information, it is not straightforward to integrate it into standard library catalogues so that it can be found by users searching the system. Images, especially complex, multi-dimensional images such as those generated by MSI and RTI, cannot easily be stored, recovered, viewed and examined using standard library and archives software. This problem becomes even more intractable when the images are associated with complex metadata. This remains an unsolved problem, despite the development of some standard image interfaces such as IIIF.[7] This is not only a problem for advanced imaging, but also for more routine digitisation. We hope that any solution that is developed, which allows digitised images and updatable metadata to be integrated with their physical objects' updatable catalogue records, is sufficiently flexible to also allow more complex image types to be recorded. It is likely that the demand for systems for flexible archiving that can handle a wide range of potentially user-defined datatypes will increase, requiring a step increase in digital storage and presentation

requirements. Such a system should offer the user information not only about the history and content of a document, but also its materiality and physical attributes. As with the physical collection, building a rich collection of images of the physical is a way of building information whose relevance may only be identified and understood far in the future, or by researchers from very different disciplines. Because the visual, verbal and material amass to inform us about heritage objects, there is value in picturing the invisible even when we cannot read it.

We believe that advanced imaging can play a role in smaller museums and archives, by providing information about the history of an item, its curation and its cataloguing. However, the resource requirements are significant and the techniques must be used realistically. We suggest that if a library or archive was to have access to advanced imaging, the imaging would be deployed most effectively following discussion between the curator and imaging scientist, when the imaging is aimed at answering specific questions and when staff responsible for cataloguing are fully involved at an early stage.

Acknowledgements

We are very grateful to Vanessa Freedman, Subject Liaison Librarian for Hebrew & Jewish Studies and Information Studies at UCL Library Services, Katie Birkwood, Rare Books and Special Collections Librarian at the Royal College of Physicians and Angela Warren-Thomas, Senior Conservator at UCL Special Collections, for discussion and advice on the objects described in this article.

Notes

1 https://www.ucl.ac.uk/library/special-collections/.
2 https://www.ucl.ac.uk/library/special-collections/a-z/ogden-library.
3 https://www.rcplondon.ac.uk/education-practice/library/historical-research-materials.
4 We are grateful to Lucie Grange-François, UCL BASc visiting student, for linking dedication and inscription as part of an undergraduate project.
5 Literally, 'place dedicated to the muses' and used in particular of the Hellenistic library and scholarly academy at Alexandria, but here most likely Anglicised Neo-Latin for 'museum' used in sense 2.a. ('collection') or 1.b. suggested in the *Oxford English Dictionary* (3rd edition 2003): 'a scholar's study', for which the dictionary's first quotation comes from letters published in 1645 by a former acquaintance of Jonson: 'To my honoured friend and fa. Mr. B. Johnson ... I thank you for the last *regalo* you gave me at your *Musæum*, and for the good company'.
6 Available from https://www.dstretch.com
7 https://iiif.io/.

References

Bearman, Gregory H. and Sheila I. Spiro. 1996. 'Archaeological applications of advanced imaging techniques', *Biblical Archaeologist* 59: 56–66.

Casini, Andrea, Franco Lotti, Marcello Picollo, Lorenzo Stefani and Ezio Buzzegoli. 1999. 'Image spectroscopy mapping technique for noninvasive analysis of paintings', *Studies in Conservation* 44: 39–48.

Cosentino, Antonino. 2014. 'Identification of pigments by multispectral imaging: A flowchart method', *Heritage Science* 2: 8.

DiBiasie Sammons, Jacqueline F. 2018. 'Application of Reflectance Transformation Imaging (RTI) to the study of ancient graffiti from Herculaneum, Italy', *Journal of Archaeology Science: Reports* 17: 184–94.

Dillon, Catherine, Nancy Bell, Kalliopi Fouseki, Pip Laurenson, Andrew Thompson and Matija Strlič. 2014. 'Mind the gap: Rigour and relevance in collaborative heritage science research', *Heritage Science* 2: 11.

Earl, Graeme, Kirk Martinez and Tom Malzbender. 2010. 'Archaeological applications of polynomial texture mapping: Analysis, conservation and representation', *Journal of Archaeology Science* 37: 2040–50.

Easton, Roger L., Keith T. Knox and William A. Christens-Barry. 2003. 'Multispectral imaging of the Archimedes palimpsest'. In: *32nd Applied Imagery Pattern Recognition Workshop, 2003. Proceedings*, 111–16. Washington DC: IEEE.

Giacometti, Alejandro, Alberto Campagnolo, Lindsay MacDonald, Simon Mahony, Stuart Robson, Tim Weyrich, Melissa Terras and Adam Gibson. 2017. 'The value of critical destruction: Evaluating multispectral image processing methods for the analysis of primary historical texts', *Digital Scholarship in the Humanities* 32(1): 101–22.

Gibson, Adam, Kathryn E. Piquette, Uwe Bergmann, William Christens-Barry, Graham Davis, Marco Endrizzi, Shuting Fan, Sina Farsiu, Anthony Fitzgerald, Jennifer Griffiths, Cerys Jones, Guorong Li, Phillip L. Manning, Charlotte Maughan Jones, Roberta Mazza, David Mills, Peter Modregger, Peter R. T. Munro, Alessandro Olivo, Alice Stevenson, Bindia Venugopal, Vincent Wallace, Roy A. Wogelius, Michael B. Toth and Melissa Terras. 2018. 'An assessment of multimodal imaging of subsurface text in mummy cartonnage using surrogate papyrus phantoms', *Heritage Science* 6: 7.

Jackson, H. J. 2001. *Marginalia: Readers writing in books*. New Haven; London: Yale University Press.

Jones, Cerys, Christina Duffy, Adam Gibson and Melissa Terras. 2020. 'Understanding multispectral imaging of cultural heritage: Determining best practice in MSI analysis of historical artefacts', *Journal of Cultural Heritage* 45: 339–50. https://doi.org/10.1016/j.culher.2020.03.004

Jones, Roger. 2016. 'Exhibition: Scholar, courtier, magician: The lost library of John Dee: Master of divine secrets', *British Journal of General Practice* 66(647): 317.

Liang, Haida. 2012. 'Advances in multispectral and hyperspectral imaging for archaeology and art conservation', *Applied Physics A* 106: 309–23.

MacDonald, Lindsay W., Erica Nocerino, Stuart Robson and Mona Hess. 2018. '3D reconstruction in an illumination dome', *Electronic Visualisation and the Arts*: 18–25.

Malzbender, Tom, Bennett Wilburn, Dan Gelb and Bill Ambrisco. 2006. 'Surface enhancement using real-time photometric stereo and reflectance transformation', 17th *Eurographics Symposium on Rendering Techniques*: 245–50.

Marengo, Emilio, Marcello Manfredi, Orfeo Zerbinati, Elisa Robotti, Eleonora Mazzucco, Fabio Gosetti, Greg Bearman, Fenella France and Pnina Shor. 2011. 'Technique based on LED multispectral imaging and multivariate analysis for monitoring the conservation state of the Dead Sea Scrolls', *Analytical Chemistry* 83: 6609–18.

Ogden, Charles. 1937. *Basic English and Grammatical Reform*. Cambridge: Orthological Institute.

Terras, Melissa. 2015. 'Cultural heritage information: Artefacts and digitization technologies'. In: *Cultural Heritage Information*, edited by G. Chowdhury and Ian Ruthven, 63–88. London: Facet.

Tonazzini, Anna, Emanuele Salerno, Zienab A. Abdel-Salam, Mohamed Abdel Harith, Luciano Marras, Asia Botto, Beatrice Campanella, Stefano Legnaioli, Stefano Pagnotta, Francesco

Poggialini and Vincenzo Palleschi. 2019. 'Analytical and mathematical methods for revealing hidden details in ancient manuscripts and paintings: A review', *Journal of Advanced Research* 17: 31–42.

Collection items

Clusius, Carolus. 1605. *Caroli Clusii Atrebatis … Exoticorum libri decem quibus animalium, plantarum, aromatum, aliorumque peregrinorum fructuum historiæ describuntur* ([Leiden?]: Ex officinâ Plantinianâ Raphelengii). London, UCL Special Collections, STRONG ROOM HNHS FOLIO 1605 L2 (barcode UCL0015382).

Ryff, W. H. 1548. *In Caii Plinii Secvndi Natvralis historiæ argutissimi scriptoris I. & II. cap: libri XXX. commentarius … cvi praeterea adiecta est de fascinationibus disputatio elegans & erudita* (Wurzburg: per Ioannem Mylium). London, Royal College of Physicians, D1/19-c-27 (barcode 9978).

van Veen, Otto. 1608. *Amorum emblemata* (Antwerp: venalia apud autorem) London, UCL Special Collections, STRONG ROOM OGDEN A 292 (barcode UCL0013661).

Fragment of a noted missal. Thirteenth century. Manuscript on parchment. London, UCL Special Collections, MS FRAG/MUSIC/5.

Fragment of a Psalter. Fourteenth century. Manuscript on parchment. London, UCL Special Collections, MS FRAG/LAT/28.

Two fragments of a Hebrew manuscript. Unknown date. Manuscript on parchment. London, UCL Special Collections, MS FRAG/HEB/1.

Communication and language

3
Picturing the invisible in site-responsive art practice

Paul Coldwell

Introduction

The presentation of art can never be conducted in a neutral space. All locations carry with them histories and associations against which the artist's work is read and interpreted. However, the notion of the 'white cube' as a space supposedly stripped of external references has become synonymous with contemporary art. But an alternative scenario is offered by the increasing willingness of museums and collections to open their doors to the interpretation of contemporary artists and the staging of their work within these contested settings. This chapter focuses on a number of projects of mine, which have been the result of research within specific collections, and the presentation of the resulting work in exhibitions, intentionally setting up a dialogue with the museum and its collection, making invisible presences visible. The projects include: *I Called When You Were Out* (2008–9), a series of interventions in the house at Kettle's Yard, Cambridge, suggesting how family life had been edited out in favour of a pure aesthetic; *Temporarily Accessioned* (2016–17), a project with the Freud Museums in Vienna and London, conjuring the absent presence of Freud and how his exile could serve as a means to make visible the plight of the migrant; and, most recently, *Picturing the Invisible – the house seen from below* for the Sir John Soane Museum (2019), where I viewed the house from the often invisible perspective of those below stairs.

The white cube and beyond

The concept of the white cube as a place for the display and interpretation of contemporary art has become firmly established in the language of art and curatorial practice. The advent of abstraction and, in particular, colour field painting with its discarding of the convention of the picture frame in the late 1950s, favoured the supposedly neutral space of the purpose-built gallery, a space stripped of anything from the outside world that might be seen to distract from the experience of viewing art. The picture frame that had served to distinguish art from life was now replaced by the perimeters of the gallery itself. In 1976, the artist and writer Brian O'Doherty wrote a series of essays published in *Artforum* (later published as a book entitled *Inside the White Cube*) in which he articulated the contemporary obsession with the white space, arguing that 'A gallery is constructed along laws as vigorous as those for building a medieval church. The outside must not come in, so windows are usually sealed off. Walls are painted white. The ceiling becomes the source of light' (1999, 15).

However, as with Newton's third law of motion, which states that for every action (force) in nature there is an equal and opposite reaction, artists began to look beyond these designated spaces for alternative venues. At the same time, with the growing interest in contemporary art, a number of museums and country houses began to open their doors to artists both as spaces to show their work alongside their collections or to make interventions. This strategy both served to capitalise on the new audiences for contemporary art and to offer fresh ways of viewing and interpretation. This was particularly beneficial for those museums and houses whose collections were fixed or that had limited resources to reframe their collections. Furthermore, the radical nature of how some of the collections had come into being could become lost over time as Michael Harrison, the former director of Kettle's Yard, observed: 'the danger is that Kettle's Yard becomes an enjoyable and comfortable period piece' (2009, 2).

The practice of inviting artists to make work in response to collections has now become commonplace with many institutions regularly timetabling such opportunities into their calendar. The National Gallery Associate Artist Scheme was introduced to demonstrate the continuing inspiration of the Old Master tradition on today's artists and has hosted artists on a regular basis, beginning with Paula Rego in 1989–90. The scheme, which includes a studio at the National Gallery, serves to offer the artist an opportunity to also open up their studio for visitors,

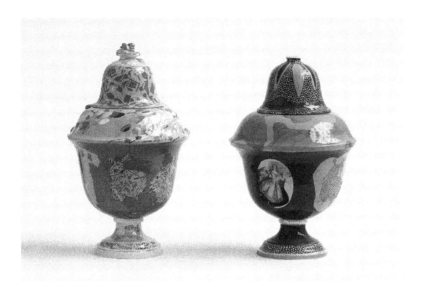

Figure 3.1 Charlotte Hodes, *Pink Reflections* (left), *Vase for Mademoiselle de Camargo* (right), 2006. Colour slip, enamel transfer, sprigs on earthenware, @ 40 × 28 cm.

Credit: © Charlotte Hodes. Photograph: Peter Abrahams.

revealing the hidden practices behind the making of art. Undoubtedly inspired by the success of this scheme, other galleries have followed. The Wallace Collection invited Charlotte Hodes as their first Associate Artist in 2007, whose resulting exhibition responded to the Fête Galante paintings of Watteau and the collection of Sèvres porcelain through the contemporary prism of collage (figure 3.1). More recently, Michael Eden's collaboration with the Waddesdon's collections in 2018 set his technologically innovative vessels against the traditional sense of craftsmanship evident in the Rothschild collections.

These are just a few examples and while these can be seen as mutually beneficial both for the artist and institution, a riskier strategy was taken when Hans Haacke was invited to critique the V&A in his exhibition *Give & Take* in 2001. As Adrian Searle (2019) wrote:

> Can any such institution avoid looking at its holdings in a guilty light? The climate at the V&A might well be controlled, the air purified, the lighting kind, but all this seeks to do is to nullify, to omit and suppress, to prevent larger stories being told. In part, Haacke's show is a rescue attempt, a way of giving voice to multiple meanings, multiple readings.

While each project carries with it its own agenda, all offer the opportunity for an outsider's view of both the institution and the collection to be seen. While a gallery's curatorial staff rightly focuses on the work in their collection and its conservation, the artist as the detached observer can provide valuable insights into what might be missing and how by viewing the collection through an alternative perspective, it can reveal that which was otherwise invisible.

Site-responsive projects

Over a number of years, running parallel with exhibiting in more traditional gallery situations, I have sought out museums and collections as alternatives to the white cube. Joanne Morra describes this practice as site-responsive, that being 'a new category within artistic and curatorial practice, which is produced when contemporary art enters a space that is not primarily a site for exhibiting artwork: a space that is not a white cube gallery' (2018, 14). In each case, I have adopted a research methodology, which has involved a deep engagement with each institution, resulting in new bodies of work made both for precise locations within the museums and in direct response to the collections themselves and the stories they embody. Through this embodied approach, I have been drawn to consider that which is absent as well as that which is present, along with narratives that are hidden or concealed. By attempting to picture the invisible, I hope to unsettle a singular reading and make clear that all presentations are interpretations rather than implicit truth. Three examples, each very different in nature, offer insights into this way of picturing: Kettle's Yard in Cambridge, The Freud Museums in Vienna and London and, most recently, the Sir John Soane's Museum in London.

Kettle's Yard, Cambridge

In 2008, I was invited by the then director, Michael Harrison, to make an intervention in the house at Kettle's Yard, and, over a period of months, made regular visits to conduct archive research, make on-site drawings and notes, take photographs as well as conduct conversations with the curatorial staff and those engaged in invigilating. With no pre-existing plan, it required an open-ended commitment to the project from the director who had to rely on trust that a cohesive exhibition or installation would result. This high-risk strategy requires close

communication, in this case with the director, in order to ensure that there is a clear understanding of the direction being taken and to anticipate problems.

The house at Kettle's Yard can be best understood as the masterwork of Jim Ede. Formed by joining four small cottages in Cambridge in 1958, Kettle's Yard was the home of Ede and housed his collection, and he lived there with his wife, Helen. Each object in the house is precisely placed and located to set up specific relationships with other objects and the space as a whole. The house would be open to visitors each afternoon when Ede would give a personal tour and discuss the collection. Now owned by the University of Cambridge, visitors are allowed to sit in the chairs (rare for a museum), which both encourages a meditative experience through inviting the visitor to dwell there as well as serving as a reminder that it was originally a home. The collection brings together fine examples of British modernism, including works by Ben Nicholson and others from the St Ives School, sculptures and drawings by Gaudier-Brzeska, and numerous works by the naive artist Alfred Wallis along with porcelain jugs, glass decanters and natural found objects such as shells and pebbles. It is an idiosyncratic collection, where value is placed on the object's aesthetic quality rather than on its intrinsic monetary value.[1]

While the refined aesthetic of Ede is self-evident in the precision in which the collection is arranged, I soon became aware that this was at the expense of editing out evidence of the day-to-day activity of a house. I sensed that the mundane activity of living and being lived in had been removed in order to foreground the requirement to view the house from an aesthetic and spiritual perspective. Ede, writing in *A Way of Life* with the intensity suggestive of that of a mystic or visionary, observes 'as I look at these floorboards in the photograph they become intensely a part of myself; cracks, notches, joins, the passages of darkness and the transparency of shadow, here perceived, create something which I had not reached when I walked across them' (1984, 122). Here there is no place for the merely practical. The house and collection have the sense of having been curated, with no trace left exposed of that which might contradict such a singular reading. The more often I visited, the more I speculated on what was absent. I gradually shaped an overall narrative for my intervention. I wanted to imagine visiting the house when the owners were away, a direct reference to the missing presence of Jim and his wife. This, of course, also brings in a certain voyeuristic experience, of examining a house without meeting the eye of the owner. It occurred to me later, that when we view a house as a potential buyer, we are often in that position, being shown round by the agent and subconsciously

building up a picture of the inhabitants and house we might in due course inhabit.

The first piece I realised and which set the tone of the exhibition was a series of photography frames that I made and cast in clear glass to surround the solitary *Head of Prometheus* by Brancusi that was positioned on the grand piano (figure 3.2). When I first visited the house, the lack of photographs of family life was striking and my intention was for my glass frames to draw attention to this absence. I had rarely seen a piano in a family home that did not also serve as a surface to display photographs of family and loved ones. Here, in Kettle's Yard, the personal and sentimental had been substituted for a very pure aesthetic experience, the solid bronze form of the Brancusi perfectly reflected in the black sheen of the piano. My frames surrounded the piece and I hoped they would set up a dialogue with the Brancusi, the transparency of the frames in contrast to the solid form, the lack of specific detail in the frames, echoed by the reduced form of the head.

The feeling of restraint and austerity was continued in the Ede's rather sparse separate bedrooms and the monastic quality of their single beds. I made a bronze skeletal hot water bottle for Helen Ede's bed, to be

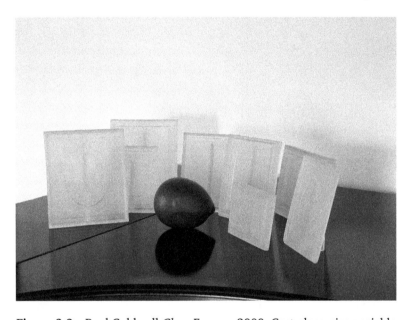

Figure 3.2 Paul Coldwell *Glass Frames*, 2008. Cast glass, size variable (Constantin Brancusi *Prometheus* in foreground). *I Called While You Were Out*, 2008–09, Kettle's Yard, University of Cambridge.

Credit: © Paul Coldwell. Photograph: Paul Allitt.

Figure 3.3　Paul Coldwell, *Hot Water Bottle,* 2007. Bronze 32 × 22 × 10 cm. *I Called While You Were Out*, 2008–09, Kettle's Yard, University of Cambridge.

Credit: © Paul Coldwell. Photograph: Paul Allitt.

positioned where her rib cage would have lain in an obvious reference to the absent body, but also to the need for warmth (figure 3.3). In another instance, I made a short film featuring one of my poems *I called but you were out*, set against images of seagulls and the incoming tide, evoking the collections of pebbles from various beaches arranged on some of the tables and as a reference to the description of Kettle's Yard by Ian Hamilton Finlay as being 'the louvre of the pebble'.[2] In another piece, I made a small bronze sailing boat with paper sail on a base of a 12 inch record to be located on the French chest in which Ede had concealed his record player, as if a guilty pleasure (figure 3.4).

My interventions were part of a programme in which artists, at different times, were invited to temporarily disrupt the tranquillity of the house. My intervention was quite discreet. More dramatic was Michael Craig-Martin's, when, in 1995 for *Open House*, the artist took one room and painted it an intense garish pink onto which was painted a life-size image of a chair. For many, this disrupted the tranquil serenity of the

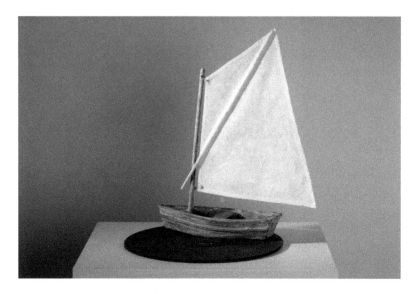

Figure 3.4 Paul Coldwell, *Small Boat (His Master's Voice)*, 2008. Bronze, paper, rubber, 40 × 32 × 30 cm.

Credit: © Paul Coldwell. Photograph: Peter Abrahams.

house but as Craig-Martin wrote, 'by confronting the existing aesthetic of Kettle's Yard with another, I have sought to revitalise the sense of challenge that was the original characteristic of this unique place' (Harrison 2009, 9).

Freud Museums, Vienna and London

While Kettle's Yard is a conscious construct and preserved like a time capsule, the Freud museums in Vienna and London present a more complex multi-layered proposition. The Freud Museum in London was one of the first museums to understand the benefits of inviting artists, and for a period of over 25 years the museum has been established as a significant venue for contemporary art. The two museums are, however, very separate; Monika Pessler, director of the museum in Vienna, describes them as being 'like two sides of the same coin' (2016, 4). The museum in Vienna is in the apartments that Freud occupied between 1891 and 1938 before the family escaped to London. Ironically, when the Freuds left, the apartments were then used as temporary accommodation for Jews awaiting deportation. The Freuds, supported by influential friends and following the payment of tax, were fortunate enough to be

granted the right to take their belongings with them, including Sigmund's now famous couch, his desk and chair, as well as his formidable collection of more than two thousand antiquities. In contrast, 20 Maresfield Gardens is the house where Freud finally settled in London but only lived for a year before his death in 1939. The house remained the family home until Anna Freud's death in 1982 and then opened to the public in 1986. So, while the apartment in Vienna where Freud did all his major work is empty of Freud's possessions, the house in London where he only lived for a year is full, complete with Freud's study and consulting room preserved as if Freud had just left the room.

While Kettle's Yard is set within the intellectual development of English modernism, the Freud museums have to be seen against the backdrop of the onset of the Second World War, the rise of fascism and, of course, Freud's own exploration of the inner workings of the mind, an altogether more complex set of issues. One of the principal challenges was to make work that would resonate in both locations. As I conducted my research, Freud's flight and subsequent exile became the overriding theme and this was personified for me by the coat that Freud had purchased for his migration, now on display in the hallway of the museum in London. I had discovered the coat 20 years previously when I first became involved with the museum and was shown it in storage by the then director Erica Davies. This became the basis for an artist's book entitled *Freud's Coat* (Coldwell 1996). The invitation by the current director, Carol Seigel, was to revisit the museum, now 20 years later, and produce a new body of work. I kept returning to the idea of the coat and began to explore the possibilities of having the coat X-rayed as if it were a precious relic (figure 3.5).

The decision to have the coat X-rayed represented an attempt to reference and bring together a number of ideas. First, that Freud was himself a doctor and would have been familiar with X-rays in his training; second, as a patient, he was regularly X-rayed as part of his treatment for cancer; third, I imagined it would result in a life-size image reminiscent of the Turin shroud with its indexical relationship to the body. Finally, it was a means to transform the coat into a cultural object worthy of study in the way that Old Master paintings are X-rayed and examined for hidden truths. The process did reveal in one of the pockets the plastic rain hat that Anna wore when gardening, therefore proving that she was wearing her father's coat after he died. I also hoped that it might serve to symbolically represent the process of psychoanalysis with its search for meaning within layers of experience. As Stephan Doering observed, 'Like the real Freud, the coat will not return – in its stead Coldwell provides

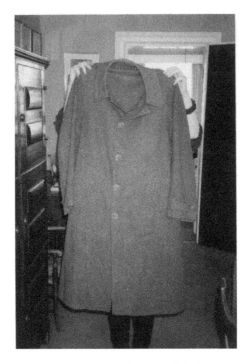

Figure 3.5 Freud's coat purchased by Freud for his migration to London in 1938.

Credit: © Paul Coldwell.

a materialisation of our internalised image: a picture of the invisible' (Doering 2019, 6). The final image was the result of 14 A3 X-rays that were digitally stitched together to form the whole coat while retaining the structural evidence of its making (figure 3.6). From this file an edition of five inkjet prints were made, each with a one-to-one scale relationship to the original coat (figure 3.7).[3]

Alongside the coat, I also wanted to find a way of returning all the objects on Freud's desk to Vienna as a ghost, again a reminder of what was absent (figure 3.8). Freud arranged his collection of antiquities, statuettes and other selected objects, 'his old and grubby gods' (Bourke 2006, 155), in organised rows on his writing desk as if ready for battle or the beginning of a chess match.[4] Freud would have looked at these objects every day, and I imagined them as a cultural net through which his thoughts might be filtered. Of course, working in museums means adopting the highest protocols in ensuring no damage is done to the objects and I eventually settled on 3D scanning all the objects, which, as with X-raying, is a

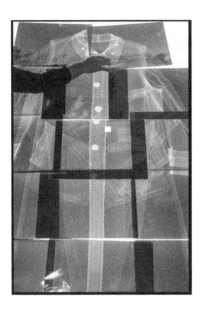

Figure 3.6 Paul Coldwell, page from bookwork *Temporarily Accessioned*, 2016.

Credit: © Paul Coldwell.

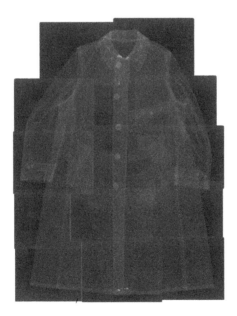

Figure 3.7 Paul Coldwell, *Temporarily Accessioned – X-Ray*, 2016. Inkjet, 115 × 152 cm.

Credit: © Paul Coldwell.

Figure 3.8 *Freud's Desk at 20 Maresfield Gardens*, 2015.

Credit: © Freud Museum London. Photographer: Karolina Urbaniak.

non-invasive process. Over a period of a week, working with my assistant, we scanned every object and then from these scans had 3D prints made in white nylon (figure 3.9). Each object was reduced by a third to suggest the miniaturisation that Bachelard associates with taking us back to

Figure 3.9 Paul Coldwell, *A Ghostly Return I*, 2016. Nylon SLS, 109 × 55 × 28 cm.

Credit: © Paul Coldwell. Photograph: Oliver Ottenschläger.

childhood, 'the tiny things we imagine simply take us back to childhood, to familiarity with toys and the reality of toys' (1998, 149), while also suggesting that which is lost through memory over time. Furthermore, the objects, now deprived of their colour and unified by the process and material, seemed to merge together to form a single apparition.

The Sir John Soane's Museum, London

Developing a body of work from the Sir John Soane's museum presented me with a very different set of problems. The museum, like Kettle's Yard, is again a time capsule, but in this case designated to be preserved as on Soane's death by Act of Parliament. Furthermore, the building itself is Grade I listed so there were restrictions on how my work could be presented. There could be no trace left on the fabric of the building. But most significant was to find a space within the museum. Early on in the project, it was proposed that I should use the kitchens as the space to present my work. This was pivotal for the way the work would develop since it led me to focus on the kitchen and its occupants, the invisible presence of the kitchen staff and those below stairs, and use this as a prism through which to engage with the house as whole.[5]

While for projects at Kettle's Yard and Freud museums it was the named occupants, Jim Ede and Sigmund Freud, that were central, here I was less interested in Soane himself but drawn to imagine the lives of the domestic staff below stairs. I began to imagine how they would have engaged with the collection as they went about their duties.[6] I speculated that living in a house so full of models, paintings and antiquities must have provided them with a singular landscape, which would have infiltrated their thoughts. Personality museums focus on the owner and the story is told with them as the principle protagonist. I wanted to reverse that and to view the house from the perspective of those below stairs, those responsible for the day-to-day functioning of the house. I wanted to image them as responding to the rich environment of the house and wanting to add their own interpretations. In imagining the house from the viewpoint of these now invisible presences, those figures below stairs engaged with the daily chores of cleaning, cooking and keeping the house warm and safe, I also wanted to draw attention to the daily actions and chores that leave no monument and little trace. If done well, their work would go unnoticed, drawing attention to itself only if something went wrong or was missing.

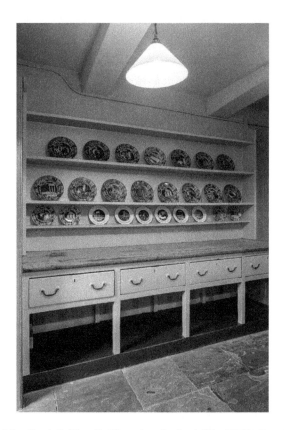

Figure 3.10 Paul Coldwell, *Picturing the Invisible*, 2019. Installation at
Sir John Soane's Museum.

Credit: © Paul Coldwell. Courtesy of Sir John Soane's Museum. Photograph: Gareth Gardner.

Responding directly to the kitchen dresser, the first piece I made
was a set of ceramic plates decorated with photographs of images of
classical columns and architectural ruins that I made using foodstuff
(figures 3.10 and 3.11). This was a reference to souvenirs from the grand
tour; here, places and ruins were reimagined using materials that would
be at hand in a kitchen. This idea of playing with food became a leitmotif
running through all the work I made. For the film *First Orders: Scenes from
the kitchen*, a time-lapse view of a model of the Temple of Vesta at Tivoli
is juxtaposed with scenes of cutting vegetables and attempting to use
the sections as components to construct columns and arches. There is an
element of endeavour and failure, something I associate with domestic
work. I also used these foodstuffs to make more complex structures,
which were either scanned and 3D prints made from them or used to cast

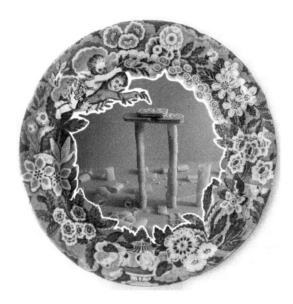

Figure 3.11 Paul Coldwell, *Scenes from the Kitchens*, 2019. Ceramic plate with transfer, 28 cm diameter.

Credit: © Paul Coldwell. Photograph: Peter Abrahams.

directly from in bronze. Why do this? The curator Ian Jeffrey (2001, 5) answers,

> Because art has always dealt in re-presentations. We like to inspect and to compare with the real thing, all of which takes more time than we would ever give to the objects themselves. As we linger we often begin to reflect on meaning, because it is in our nature to do so.

My pieces have their origins in the models throughout the museum, so, for example, *Scenes from the Kitchens – Columns* was made originally from pasta, bourbon biscuits, sugar lumps, topped by a scrubbing brush and is a reinterpretation of the model of the Temple of Castor and Pollux in Rome, while *Ghosts-Temple*, an assemblage of cast foodstuff in plaster, takes the cork model of the Temple of Fortuna Virilis as its starting point (figure 3.12). To further consolidate in the viewer's mind the idea of upstairs/downstairs, my sculptures were all presented close together on bases of differing levels in the middle of the kitchen in reference to the display in the Model Room at the top of the house, which includes

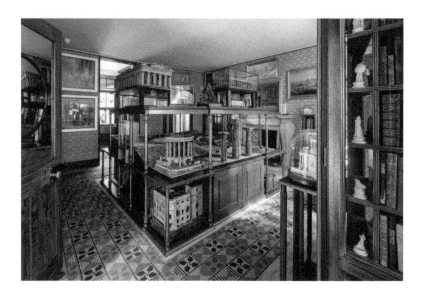

Figure 3.12 *Model Room, Sir John Soane's Museum.*

Credit: Courtesy of Sir John Soane's Museum. Photograph: Gareth Gardner.

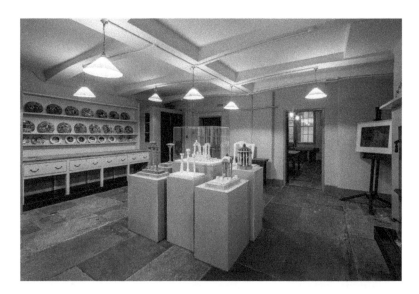

Figure 3.13 Paul Coldwell, *Picturing the Invisible*, 2019. Installation at Sir John Soane's Museum.

Credit: © Paul Coldwell. Courtesy of Sir John Soane's Museum. Photograph: Gareth Gardner.

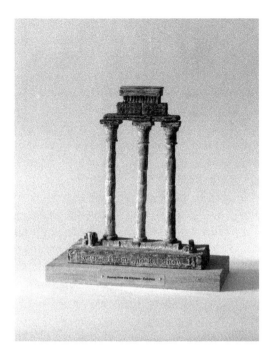

Figure 3.14 Paul Coldwell, *Scenes from the Kitchens – Columns*, 2018.
Bronze wood, brass, 43 × 23 × 48 cm.

Credit: © Paul Coldwell. Photograph: Peter Abrahams.

amongst others, a large panoramic cork model of the ruins of Pompei
(figures 3.12 and 3.13).

While the exhibition was relatively small in scale and compact, it
formed the first room of the visitor's tour, and my hope was that some of
the questions and propositions within the work would affect the
subsequent viewing of the whole house. This was certainly the case for
Ben Thomas who wrote in his review of the exhibition, 'the effect of
encountering Coldwell's work in the basement is that it transforms your
subsequent visit to the house, providing cues for contemplation, and
suggesting route maps for constellations of associations' (2020).

Conclusion

While I have focused on the benefits to museums of inviting artists to
introduce a temporary disruption to the way their collections are seen,
there are considerable advantages for the artist. Most obviously, the artist

on the gallery's existing audience. Over 18,000 visitors passed through my exhibition at the Soane Museum, a number way beyond that which I could expect from a conventional gallery space. Furthermore, it allows the work to be seen beyond the context of fine art, enabling comparisons and connections to be made with other disciplines and broader debates, as was the case in the Freud project where film-maker Susan Steinberg saw the work in the context of the politics of migration, while Professor Stephan Doering related it directly to psychoanalysis and in picturing how 'there always is the opportunity – and even the necessity – for a symbolic return' (Doering 2019, 6).

It is also important that museums and collections do not become ossified or merely preserved as time pieces. Museums and collections have a tendency to become fixed, both physically in a reluctance to rearrange themselves but also slow to view themselves against more contemporary issues and debates. 'It is not that they find these things hard to say per se, but that they sometimes find them hard to say through existing strategies for the curation of displays and objects' (Birchall 2019).

The museums and collections I have worked with would have originally been seen as provocative spaces – Kettle's Yard represents an attempt to create 'a refuge of peace and order' (Ede 1984, 18), 20 Maresfield Gardens as the focus of Sigmund and Anna Freud's work and theories complete with the physical evidence of his consulting room as it had been in Vienna, while the Sir John Soane's Museum is committed to preserve this personality museum complete with Egyptian sarcophagus, a folding Picture Gallery and a Monk's Parlour for future generations. By inviting artists in to see these spaces with fresh eyes, they can also ensure their continuing relevance in a broader cultural landscape and make visible that which is hidden or has simply been overlooked.

Notes

1 The Kettle's Yard website includes a virtual tour of the house and further details of the collection https://www.kettlesyard.co.uk/collection/the-house/.
2 Ian Hamilton Finlay was a sculptor and poet and creator of the internationally renowned garden, Little Sparta. Amongst his works is a stone on which he inscribed the words 'Kettle's Yard Cambridge England is the Louvre of the Pebble'. This work, made in 1995, is in the permanent collection of Kettle's Yard.
3 Of course, between the intention and execution there were numerous hurdles to overcome, the first being able to persuade the National Gallery to set aside time for the project. Once this was achieved, I commissioned the photographer Peter Abrahams to record the day's events, from packing the coat at the Freud Museum, transporting it by taxi accompanied by Bryony Davies (curator at Freud Museum), delivering the coat to the National Gallery, preparing and X-raying

the coat, before then being returned to the museum. From these photographs, I constructed a sequence of layered photographs, which became an artist book entitled *Temporarily Accessioned*. One striking aspect that was revealed through the photographs was how the coat assumed the role of a body and how we adopted the decorum associated with doctors or undertakers, and how the scanning table became synonymous with the hospital bed or the mortician's slab.

4 For more information of the objects on Freud's desk see Ro Spankie, *Sigmund Freud's Desk: An anecdoted guide*, Freud Museum London, 2015.

5 As with previous projects, I sought to immerse myself in the collection, spending many hours there, observing, gathering information in the form of drawings and notes, researching the online database, spending time in the library examining the albums of the prints of Piranesi and viewing works that were in store. The Soane Museum is also well known for the knowledgeable invigilators who oversee the visitors and I took full advantage of them on the occasions of my many visits.

6 For further details of the lives of the domestic staff see Susan Palmer, *The Soanes at Home: Domestic life at Lincoln's Inn Fields*, Sir John Soane Museum, London, 1997.

References

Bachelard, Gaston. 1998. *The Poetics of Space*. Boston: Beacon Press.

Birchall, Danny. 2019. 'Institution and intervention: Artists' projects in object-based museums'. Accessed 16 March 2020. https://museumcultures.files.wordpress.com/2012/12/dannybirchall_institutionandintervention.pdf.

Bourke, Janine. 2006, *The Gods of Freud*. New South Wales: Alfred A. Knopf.

Coldwell, Paul. 1996. *In Freud's Coat*. London: Freud Museum & Camberwell College of Arts.

Doering, Stephan. 2019. 'Paul Coldwell: Temporarily accessioned', *Art in Print* 9 (6): 6.

Ede, Jim. 1984. *A Way of Life – Kettle's Yard*. Cambridge: Cambridge University Press.

Harrison, Michael. 2009. *Upside Down/Inside Out*. Cambridge: Kettle's Yard, University of Cambridge.

Jeffrey, Ian. 2001. *The Language of Things*. Cambridge: Kettle's Yard University of Cambridge.

Morra, Joanne. 2018. *Inside the Freud Museums*. London: I. B. Taurus.

O'Doherty, Brian. 1999. *Inside the White Cube*. Berkeley: University of California Press.

Palmer, Susan. 1997. *The Soanes at Home: Domestic life at Lincoln's Inn Fields*. London: Sir John Soane Museum.

Pessler, Monica. 2016. *Setting Memory – Bettina von Zwehl & Paul Coldwell*. Vienna: Freud Museum Vienna.

Searle, Adrian. 2019. 'Art review: Multicoloured swap shop', *The Guardian*, 30 January 2019. https://www.theguardian.com/culture/2001/jan/30/artsfeatures.

Spankie, Ro. 2015. *Sigmund Freud's Desk: An anecdoted guide*. London: Freud Museum London.

Thomas, Ben. 2020. 'Review of *Picturing the Invisible*', *Impact Printmaking Journal* https://www.impactprintmaking.com/article/paul-coldwell-picturing-the-invisible/.

4

Implicit relationship experience and picturing the invisible in psychoanalysis

Stephan Doering

Introduction

Psychoanalysis pictures the invisible by finding words, metaphors and narratives for mental processes that have previously been unconscious. The basic assumption underlying this aim is that many psychiatric disorders are caused by unresolved intrapsychic conflicts. These conflicts are present on an unconscious level, that is, the person is not aware of the nature of the problem as well as of its manifold consequences, be it symptoms, relationship problems or simply suffering. In the very beginning of psychoanalysis, Freud assumed that bringing unconscious conflicts into consciousness would create a 'cathartic' resolution and help to overcome the symptom (Freud and Breuer [1895] 1952). To put it simply, the human mind appeared like a crossword that had to be solved by the psychoanalyst in order to cure the patient. The healing would be initiated by telling the patient the truth about his/her unconscious conflicts.

Soon, it turned out that things are not that easy: there seemed to be forces that counteract the enlightenment, factors from inside the patient. Freud understood that these forces need to be discovered, a deeper understanding of the reasons behind the conflicts need to be created, and all this needs to be worked through, that is, analysed together with the patient, again and again, before change can occur.

Another aspect was revealed to be highly relevant: patients show a tendency to repeat early relational experiences with the analyst. Freud called this phenomenon transference and explained: 'They are new editions or facsimiles of the impulses and phantasies which are aroused

and made conscious during the progress of the analysis; but they have this peculiarity, which is characteristic for their species, that they replace some earlier person by the person of the physician' (Freud [1905] 1942, 116). Later, Freud discovered that transference can be extremely helpful within the psychoanalysis:

> It cannot be disputed that controlling the phenomena of transference presents the psychoanalyst with the greatest difficulties. But it should not be forgotten that it is precisely they that do us the inestimable service of making the patient's hidden and forgotten erotic impulses immediate and manifest. For when all is said and done, it is impossible to destroy anyone *in absentia* or *in effigie*.
> (Freud [1912] 1943, 108)

To complicate things further, psychoanalysts show an emotional and behavioural reaction to the patient's transference. Freud called this counter-transference, 'which arises in him as a result of the patient's influence on his unconscious feelings, and we are almost inclined to insist that he shall recognize this counter-transference in himself and overcome it' ([1910] 1943, 144–5). Freud even invented training analysis (whereby every would-be psychoanalyst undergoes psychoanalysis as a 'patient') to prevent counter-transference occurring. It took 40 years before anyone dared to admit that he or she experienced counter-transference, until it was discovered that counter-transference is an extremely important tool within the psychoanalytic treatment.

It was Paula Heimann, a London psychoanalyst, who stated 'that the analyst's unconscious understands that of his patient. This rapport on the deep level comes to the surface in the form of feelings which the analyst notices in response to his patient, in his "countertransference"' (1950, 82).

Mirror mechanisms

In 1923, Freud stated that 'the ego is first and foremost a bodily ego' ([1923] 1940). Only 70 years later, his conceptual assumption was shown by experimental neuroscience to be true in many aspects. Vittoria Gallese et al. and Giacomo Rizzolatti et al. published their first papers on the so-called mirror neurons in 1996. The researchers could show that in monkeys the same brain regions were activated when they observed other monkeys grasping a banana, as if they were executing this

movement themselves. These mirror neurons were also shown to be activated when a person imagined a movement or heard someone carrying out an activity such as walking behind a door. Gallese and Cuccio termed this process 'embodied simulation' and hypothesised that something like a 'motor cognition' exists that allows us to understand and anticipate the action of others without language or cognition (2015). They called the mutual resonance of intentionally meaningful sensory behaviours 'intercorporeality' – a direct implicit modality of access to the meaning of other people's behaviour. The same effects have been demonstrated while observing other people's sensations (like being touched), observing other people's pain or witnessing other people's emotions (Gallese 2014). The latter was demonstrated in numerous experiments: if people are shown the emotionally activated faces of other people (smiling, looking angry, disgusted, sad, etc.), they subliminally activate the same facial muscles (Dimberg et al. 2000) and show the same activations in their brains as if they were experiencing the same affect themselves (Phillips et al. 1997).

As a consequence, it can be said that Gallese's embodied simulation not only takes place in motor action, but also involves the expression of affective states. Gallese suggests, 'Our social interactions become meaningful by means of *reusing our own* mental states or processes in functionally *attributing them to others*' (2014, 3). He emphasises that these processes take place non-consciously and pre-reflectively as a functional mechanism of the brain–body system. These mechanisms of intercorporeality play a central role in empathy. On an unconscious level, we are infected by other people's affects ('emotional contagion') and without any conscious recognition, we experience an internal state that 'mirrors' the state of the counterpart. Only after this occurrence do we become aware of our own internal state and then attribute it to the other person. We develop a cognitive understanding of the other person's situation and finally are able to identify with their needs (Preston and de Waal 2002). What we call mind reading, the theory of mind or mentalisation is, therefore, based on implicit bodily phenomena (mirror mechanisms).

Embodied memories

And soon, mechanically, weary after a dull day with the prospect of a depressing morrow, I raised to my lips a spoonful of the tea in which I had soaked a morsel of the cake. No sooner had the warm

liquid, and the crumbs with it, touched my palate, a shudder ran through my whole body, and I stopped, intent upon the extraordinary changes that were taking place. An exquisite pleasure had invaded my senses, but individual, detached, with no suggestion of its origin […]

And suddenly the memory returns. The taste was that of the little crumb of madeleine which on Sunday mornings at Combray (because on those mornings I did not go out before church-time), when I went to say good day to her in her bedroom, my aunt Léonie used to give me, dipping it first in her own cup of real or of lime-flower tea […]

And once I had recognized the taste of the crumb of madeleine soaked in her decoction of lime-flowers which my aunt used to give me (although I did not yet know and must long postpone the discovery of why this memory made me so happy) immediately the old grey house upon the street, where her room was, rose up like the scenery of a theatre to attach itself to the little pavilion, opening on to the garden, which had been built out behind it for my parents […]

(Proust [1913] 1928, 62)

This episode from Marcel Proust's first volume of *In Search of Lost Time* was published in 1913 and perfectly illustrates how early memories are stored implicitly without a conscious narrative and can be triggered implicitly by sensory perceptions that might provoke intense emotions.

We learn from research on infants that memories in the first year of age are encoded in a non-verbal and implicit mode of information, which is stored in perceptual channels as images, sounds, touch and temperature. This information may be inaccessible to attention or language but may, nevertheless, continue to operate and affect how we act and feel (Beebe and Lachmann 2002). Ed Tronick coined the term 'procedural knowledge of relationships' that is represented in the mind non-symbolically in the form of implicit relational knowing (2012). This can form a basis for much of what may later become symbolically represented and conscious knowledge.

Embodied communication

It is estimated that two-thirds of information in a face-to-face encounter is exchanged via non-verbal channels. These channels in one way or

another involve the body, for example, gestures and postures, rhythmic organisation of body movement and speech production, prosody (volume, sound and melody of speech), facial expression of emotions and chemo-sensory communication via smell (Wachsmuth et al. 2008). Since these channels of communication are embedded in the body, the term 'embodiment' was coined to stand for the rootedness of mental and interpersonal processes within the body. In the following, I will give a few empirical examples to demonstrate the subtlety and the relevance of bodily phenomena within relational experiences.

Facial expression of emotions

The influence of the interplay between the facial expression of emotions by patient and therapist on the success of psychotherapy has been studied repeatedly. Beutel et al. were able to predict the outcome of psychotherapy by using the facial expressions of both patient and therapist in the first session of the treatment (2005). If both smiled a lot during their initial session and the therapist failed to express sadness when the patient did, the treatment failed in the end. In contrast, a therapist who did not smile and showed more sadness than the patient, was very successful. The explanation for this 'reciprocity induced failure' (Krause 2016) is the following: patients tend to talk about very negative experiences and traumatisation with a smile that might help them to maintain their attitude and not be overwhelmed by negative feelings. If the therapist is smiling while the patient talks about trauma, this will most probably be inadequate. However, if the therapist expresses sadness instead of being influenced by the patient's smile, then the therapist expresses the patient's 'real feeling', and helps the patient to find access to his/her internal world, which is seen to be curative within many psychotherapeutic approaches.

Olfaction

A colleague of mine, a young psychoanalyst, told me this true story to illustrate the interpersonal relevance of smell.

> After I had given birth to my little children and after a very turbulent flight I was not comfortable with flying any more. I was on my way back home from a conference, waiting for the departure inside the airplane. I was alone and felt quite anxious. In that moment I noticed a smell – not intense – but I felt more calm, sheltered, and protected. Suddenly I thought: This is my analyst! – I didn't know

why. I wasn't aware that my analyst had 'a smell', but something within me unconsciously had recognized it. In fact, I turned around and looked behind me – and she was actually sitting there.

(2016)

The French psychoanalyst Didier Anzieu described the treatment of a patient who intermittently used to exude a disgusting smell ([1985] 2016). The smell disappeared after it had been possible to identify the causes and the unconscious interactional meaning of the smell. Anzieu hypothesised that 'it is possible that a psychoanalyst's intuition and empathy are largely based on the sense of smell, but this is difficult to establish'.

Since Anzieu published his book in 1985, the field has moved forward and what seemed to be far away in the 1980s is – at least in part – reality today. It has become possible to reliably assess the effect on mind and brain of olfactory stimuli. For these experiments, the odour from a donor's sweat is collected by means of cotton pads from the donor's axilla after he/she is stimulated affectively by watching funny, romantic, threatening or erotic movie clips. The cotton pads can be deep-frozen and stored, and then unfrozen so that, via a specific technical applicator, the recipient inhales the odour. After 'smelling' the odour, the recipient's brain activity as he/she responds to either questionnaires or computer tasks is recorded by means of functional magnetic resonance imaging (fMRI).

These experiments demonstrated that 'emotional odours' can be identified by the recipients with a much higher probability than just by chance. The highest hit rate occurred in women smelling male fearful odour (Chen and Haviland-Jones 2000). Not only can fear of others be identified olfactorily, but it also induces fearful emotions in the recipient. Twenty minutes after exposure to fearful sweat, in comparison to neutral (sports) sweat, recipients reported significantly higher levels of anxiety (Albrecht et al. 2011). Moreover, fMRI investigations demonstrated that in recipients, the brain regions involved in the processing of social emotional stimuli and empathy are activated, and this may indicate readiness for a social and empathic reaction towards a fearful person (keep in mind that there is no one else in the room with the odour recipient) (Prehn-Kirstensen et al. 2009). The experiments even demonstrated that recipients showed higher activation of brain regions connected to social perception and reward after smelling the body odours of socially liberal women compared to more inhibited women (Lübke et al. 2014). Socially liberal people, by means of their very body odour, might induce a higher reward in others and, thus, be regarded as more

likeable. Men were shown to be sexually aroused (in the specific brain region) in response to women's sexual sweat (Zhou and Chen 2008). Finally, male recipients reacted to women's tears of sadness that had been collected from the donors with a reduction of sexual arousal and reduced testosterone than of men who merely responded to pictures of women's faces (Gelstein et al. 2011).

Olfaction, which is mostly unconscious, guides our social relationships. Our body odours reveal our diet, indicate our physical health, our genetic compatibility with a potential mate, reveal our emotional status and personality traits, and can be correlated to such undesirable characteristics as being unfriendly or unpopular (Mahmut and Croy 2019). Women's menstrual cycle determines their emotional reaction to the effect of male body odours: women prefer dominant men during the fertile phase of their cycle, a preference that is much stronger in women in stable relationships than in those without (Havlicek et al. 2005). Moreover, women's conception risk in the cycle correlates with their preference for the body odours of men with higher testosterone levels and, surprisingly, more symmetrical bodies (Thornhill et al. 2013). Vice versa, men prefer women's scents when women are in the fertile phase of their cycle (Singh and Bronstad 2001). In view of these empirical results, we can confirm the saying that 'love goes through the nose' – this happens in an implicit and predominantly biological way. Thus, it is not surprising that a first attempt has been undertaken to create a dating platform based on smell (https://smell.dating/): people send t-shirts they have worn for a certain period of time to the provider, who cuts them into pieces and sends pieces to people looking for a partner. People whose judgement of the other person's smell match are then invited to meet face-to-face.

There is a simple neurobiological explanation for the relatedness of olfaction and emotional experience: the olfactory nerve that transfers our olfactory stimuli to the brain, where the experience of 'smell' is initiated, is part of the so-called limbic system, the brain area where emotions are processed. Thus, olfaction has a direct biological shortcut to our feelings, bypassing conscious cognitive processing.

Embodied communication in psychoanalysis

We have seen that the interpersonal processes within the relationship between psychoanalysts and their patients are not arbitrary but can be traced back to biological underpinnings. What the Boston Change Process Study Group called a 'moment of meeting' as a prerequisite for the

psychoanalyst's interpretation is mediated through embodied communication (2010). Another fascinating psychoanalytic model helps us to understand this process psychologically: the 'containment', as it was described by Wilfred Bion (1962). Bion's concept initially referred to the normal interaction between mother and baby, whereby the baby experiences an unbearable feeling and projects this onto the mother, who functions as a container. For example, a cry of panic by the baby might induce a panic-like state in the mother, who then rushes to the baby and feels immediate relief when she sees that the baby is okay. The mother takes the baby into her arms and communicates non-verbally her relief to the baby (with the sweet and calming sound of her voice, 'don't worry, everything is okay, Mum is here and will feed you now'). By means of the prosody of the mother's voice, her body language and her touch, the baby will immediately be relieved and calms down. Bion would say, the mother has detoxified the projected part, so that the baby can now take it back without panic. However, this containment procedure only works if the mother is able to be affected by the baby's emotional experience and to convey her affection to the baby – a merely cognitive empathy and understanding would not have a similar soothing effect on the baby. In psychoanalysis, similar containment processes take place: the analyst is affected by the patient's experience, contains it and conveys affection to the patient. Only after this, can the analyst help the patient to find a conscious and cognitive understanding of what is going on internally. This is a joint process requiring the creation of metaphors, words and a narrative. The very last step of this process of picturing the invisible is the psychoanalyst's interpretation: the analyst gives a hypothetical explanation of how the events that have been symbolised and verbalised are related to the patient's past experiences and present unconscious processes. This process has been depicted beautifully by Rainer Krause (2016, figure 4.1).

Figure 4.1 The process of interpretation in psychoanalysis according to Krause (2016).

Credit: Krause, Rainer (2016), translated by Stephan Doering.

Conclusion

The core of psychoanalysis, the science of the unconscious, is to picture the invisible. Many of our early experiences in childhood remain unconsciously stored as embodied memories and in the form of implicit relational knowing. This is a natural human condition. However, if these early experiences have been adverse or even traumatising, they might elicit psychological symptoms or even psychiatric disorders. A curative way to overcome these conditions is provided by psychoanalysis, which aims at the conscious realisation, working through and resolving internal conflicts. The relationship with the psychoanalyst plays a crucial role within this process. As it has been shown, a merely cognitive interpretation of the relevant events and experiences is not enough for a change of a personality. The 'something else' can be found in the 'moment of meeting' (Boston Change Process Study Group 2010), which involves that which is emotionally and physically shared as well as through implicit and non-verbal communication with the psychoanalyst, the invisible. This complex process involving the creation of metaphors, symbols, words and narratives forms into an interpretation that ideally creates meaning, and fosters change and healing.

References

Albrecht, Jessica, Maria Demmel, Veronika Schöpf, Anna Maria Kleemann, Rainer Kopietz, Johanna May, Tatjana Schreder, Rebekka Zernecke, Hartmut Brückmann and Martin Wiesmann. 2011. 'Smelling chemosensory signals of males in anxious versus nonanxious condition increases state anxiety of female subjects', *Chemical Senses and Flavor* 36: 19–27.

Anzieu, Didier. [1985] 2016. *The Skin-Ego*. London: Routledge.

Beebe, Beatrice and Frank M. Lachmann. 2002. *Infant Research and Adult Treatment*. London: The Analytic Press.

Beutel, Manfred, Karin Ademmer and Marcus Rasting. 2005. 'Affektive Interaktion zwischen Patienten und Therapeuten,' *Psychotherapeut* 50: 100–6.

Bion, Wilfred. 1962. *Learning from Experience*. New York: Jason Aronson.

Boston Change Process Study Group. 2010. *Change in Psychotherapy. A unifying paradigm*. New York: Norton.

Chen, Denise and Jeanette Haviland-Jones. 2000. 'Human olfactory communication of emotion', *Perceptual and Motor Skills* 91: 771–81.

Dimberg, Ulf, Monika Thunberg and Kurt Elmehed. 2000. 'Unconscious facial reactions to emotional facial expressions', *Psychological Science* 11(1): 86–9.

Freud, Sigmund and Joseph Breuer. [1895] 1952. *Studies on Hysteria*. London: Imago Publishing.

Freud, Sigmund. [1905] 1942. *Fragment of an Analysis of a Case of Hysteria*. London: Imago Publishing.

Freud, Sigmund. [1910] 1943. *The Future Prospects of Psychoanalytic Therapy*. London: Imago Publishing.

Freud, Sigmund. [1912] 1943. *The Dynamics of Transference*. London: Imago Publishing.

Freud, Sigmund [1923] 1940. *The Ego and the Id*. London: Imago Publishing.

Gallese, Vittorio. 2014. 'Bodily selves in relation: Embodied simulation as second-person perspective on intersubjectivity', *Philosophical Transactions of the Royal Society B* 369(1644): http://dx.doi.org/10.1098/rstb.2013.0177.

Gallese, Vittorio and Valentina Cuccio. 2015. 'The paradigmatic body. Embodied simulation, intersubjectivity, the bodily self, and language'. In: *Open Mind*, edited by Thomas Metzinger and Jennifer M. Windt. Frankfurt am Main: MIND Group. https://open-mind.net/DOI?isbn=9783958570269.

Gallese, Vittorio, Luciano Fadiga, Leonardo Fogassi and Giacomo Rizzolatti. 1996. 'Action recognition in the premotor cortex', *Brain* 119: 593–609.

Gelstein, Shani, Yaara Yeshurun, Liron Rozenkrantz, Sagit Shushan, Idan Frumin, Yehuda Roth and Noam Sobel. 2011. 'Human tears contain a chemosignal', *Science* 331: 226–30.

Havlicek, Jan, S. Craig Roberts and Jaroslav Flegr. 2005. 'Women's preference for dominant male odor: Effects of menstrual cycle and relationship status', *Biology Letters* 1(3): 256–9.

Heimann, Paula. 1950. 'On counter-transference', *International Journal of Psychoanalysis* 31: 81–4.

Krause, Rainer. 2016. 'Auf der Suche nach dem »missing link« zwischen Analytiker und Analysand, ihren Körpern und ihrer gemeinsamen Seele'. In: *Zum Phänomen der Rührung in Psychoanalyse und Musik*, edited by Karin Nohr and Sebastian Leikert, 61–74. Giessen: Psychosozial Verlag.

Lübke, Katrin, Ilona Croy, Matthias Hoenen, Johannes Gerber, Bettina M. Pause and Thomas Hummel. 2014. 'Does human body odor represent a significant and rewarding social signal to individuals' high social openness', *PloS ONE* 9(4): e94314. https://doi.org/10.1371/journal.pone.0094314.

Mahmut, Mehmet K. and Ilona Croy. 2019. 'The role of body odors and olfactory ability in the initiation, maintenance and breakdown of romantic relationships – A review', *Physiology & Behavior* 207: 179–84.

Phillips, M. L., A. W. Young, C. Senior, M. Brammer, C. Andrew, A. J. Calder, E. T. Bullmore, D. I. Perrett, D. Rowland, S. C. R. Williams, J. A. Gray and A. S. David. 1997. 'A specific neural substrate for perceiving facial expressions of disgust', *Nature* 389: 495–8.

Prehn-Kirstensen, Alexander, Christian Wiesner, Til Ole Bergmann, Stephan Wolff, Olav Jansen, Hubertus Maximilian Mehdorn, Roman Ferstl and Bettina M. Pause. 2009. 'Induction of empathy by the smell of anxiety', *PloS ONE* 4(6): e5987. https://doi.org/10.1371/journal.pone.0005987.

Preston Stephanie D., and Frans B. M. de Waal. 2002. 'Empathy: Its ultimate and proximate bases', *Behavioral and Brain Sciences* 25: 1–72.

Proust, Marcel [1913] 1928. *Swann's Way*. New York: The Modern Library, Inc.

Rizzolatti, Giacomo, Luciano Fadiga, Vittoria Gallese and Leonardo Fogassi. 1996. 'Premotor cortex and the recognition of motor actions', *Cognitive Brain Research* 3: 131–41.

Singh, Devendra and P. Matthew Bronstad. 2001. 'Female body odour is a potential cue to ovulation', *Proceedings. Biological Sciences* 268(1469): 797–801.

Thornhill, Randy, Judith Flynn Chapman and Steven W. Gangetsad. 2013. 'Women's preferences for men's scents associated with testosterone and cortisol levels: Patterns across the ovulatory cycle', *Evolution and Human Behavior* 34: 216–21.

Tronick, Ed. 2012. *The Neurobehavioral and Social-Emotional Development of Infants and Children*. New York: Norton.

Wachsmuth, Ipke, Manuela Lenzen and Günther Knoblich. 2008. 'Introduction to embodied communication: Why communication needs the body'. In: *Embodied Communication in Humans and Machines*, edited by Ipke Wachsmuth, Manuela Lenzen and Günther Knoblich, 1–28. Oxford: Oxford University Press.

Zhou, Wen, and Denise Chen. 2008. 'Encoding human sexual chemosensory cues in the orbitofrontal and fusiform cortices', *The Journal of Neuroscience* 28(53): 14416–21.

5

The invisible universe

Roberto Trotta

Physics and the invisible

Physicists have always been cavalier in their dealings with the invisible. Explaining the observed motions of apples falling from trees and planets orbiting the sun requires the introduction of an invisible force, gravity. The gravitational force is described mathematically as the rate of spatial change of another invisible construct, the gravitational potential, which itself is the amount of work that needs to be expended by an external force to bring in a test mass from infinity to the point being considered. Invisibles, invisibles, invisibles.

Physicists have always been reckless in their dealings with the invisible. When, in 1911, Ernest Rutherford observed that most of the alpha particles he shot at a thin gold foil went through unimpeded, with only a few scattered at large angles, he concluded that the atom must be mostly empty. When, in 1913, Niels Bohr could not explain the hydrogen atom as a miniature solar system, he invented the quantisation of orbits – the idea that electrons could only jump between a discrete set of orbits around the nucleus, but never be in-between them. When, in 1930, Wolfgang Pauli could not save the sacred principle of conservation of energy in certain radioactive decays, he turned to a 'desperate remedy': he invented a new particle that he thought nobody could ever discover. In 1956, this invisible neutrino was detected for the first time. Invisibles, invisibles, invisibles.

Physicists have always been bold in their dealings with the invisible. Buoyed by their unshakeable belief in the 'unreasonable effectiveness of mathematics' (Wigner 1960, 1), physicists used the predictive power of mathematics to make inroads into the realm of the invisible, slashing

and burning along the way. Coaxed into the straitjacket of ordinary differential equations, constrained by the unforgiving simplicity of symmetries, adorned by the shrinking error bars of better and better measurements, the invisible was brought into the light.

Today, the triumphs of physics explain the unconceivably small realm of quantum particles, with predictions from quantum electrodynamics agreeing with experiments to better than ten parts in a billion; they chart the history of the cosmos from 10^{-32} seconds after the Big Bang to today, 13.8 billion years later; they explain all of chemistry and form the basis for all of the technology that has allowed us to master the natural world – to a point of threatening it with utter catastrophe.

Yet the invisible is not so easily tamed.

Despite its stunning successes, quantum mechanics arguably remains utterly incomprehensible. Albert Einstein thought to the end of his life that quantum mechanics must be incomplete, his doubts already expressed in 1926 in a letter to Max Born: 'Quantum theory yields much, but it hardly brings us close to the Old One's secrets. I, in any case, am convinced He does not play dice with the universe' (Einstein [1926] 1969).[1] Richard Feynman admitted that 'we always have had a great deal of difficulty understanding the world view that quantum mechanics represents' (Feynman 1982, 471).

In over a hundred years since its inception, little progress has been made towards a fundamental understanding of the reality (or otherwise) of the mathematical entities of the quantum world, despite dozens of interpretations having been proposed. Today, most physicists still adhere to the Copenhagen interpretation of quantum mechanics, first put forward by Bohr in 1920. In essence, Bohr saw quantum mechanics as a generalisation of classical physics, but one that violates some of the principles that we are accustomed to from our everyday experience of macroscopic physical reality. To build a consistent theory of the invisible quantum world, Bohr had to jettison long-held ideas about the fundamental nature of objects: for example, that an object cannot be a particle and a wave at the same time (violated by the principle of duality in quantum mechanics); that an object must be localised in space and time (forbidden by Heisenberg's uncertainty principle); that the outcome of an observation is not affected by the observing system (the measurement process in quantum mechanics is instead context-dependent). Quantum physics remains shrouded in mystery.

The study of the immensely large has made similarly impressive strides forward in the last hundred years – pushing back the invisible only to be forced to confront it at last.

From data to meaning

Better eyes on the universe

Almost immediately after it was invented by the Dutch lens-maker Hans Lippershey in 1608, the telescope was aimed at the sky by Galileo, who used it to discover sunspots, to describe the craters of the Moon, to find the four largest moons of Jupiter and draw the rings of Saturn. Details and objects previously invisible leaped out of the eyepiece and stunned astronomers with their beauty and strangeness. Such mighty new powers of observation sometimes proved delusional, as with the non-existent Martian canals that Schiapparelli, Lowell and others believed to have detected in the late nineteenth century, leading to wild speculations on the existence of life on Mars (Lowell 1906).

As technology improved, lenses and mirrors became bigger and better, and the powers to repel the invisible became stronger. For thousands of years, the naked human eye was the only instrument with which to explore the night sky, capable of distinguishing about three thousand stars at any given point on the surface of the Earth. The Hubble Space Telescope can observe a patch of the sky the size of the eye of a needle held at arm's length, and detect over 10,000 galaxies, each containing about 300 billion stars like the sun (figure 5.1).

Not only are we capable of seeing fainter, more distant objects: our capabilities of observation now stretch right across the electromagnetic spectrum, far exceeding the boundaries imposed by 'optical light' – the colours the human eye evolved to perceive. After all, what we call 'visible light' (electromagnetic waves with a wavelength between 400 and 700 nm) is an accident brought about by a combination of astrophysics (how the energy emitted by the sun is distributed), atomic physics (the filtering properties of water vapour and other atmospheric gases, which strongly absorb wavelengths outside the visible part of the spectrum, figure 5.2), and evolutionary biology (the human eye having evolved to perceive certain colours and not others, unlike other animals) (Barrow [1995] 2011, 206–18).

That we can today 'see' dust clouds in distant galaxies emitting in the infrared, the leftover radiation from the Big Bang in microwaves or the implosion of stars with bursts of gamma rays appears conceptually straightforward: telescopes, radio antennas and other detectors are mere technologically enhanced versions of the unaided human eye. From here, the leap to other messengers is a small step. Why limit ourselves to electromagnetic radiation (light) when we can also 'see' ghostly neutrinos

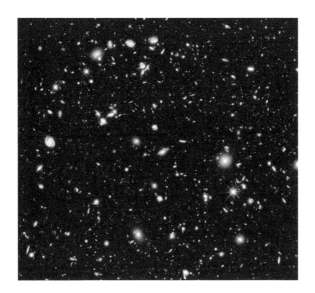

Figure 5.1 The Hubble Ultra-Deep Field reveals over 10,000 galaxies in an area of the sky that would fit inside the eye of a needle held at arm's length.

Credit: NASA/ESA/Wikimedia. Public domain.

emitted by nuclear processes inside the sun; pick up ultra-high-energy cosmic rays, atomic nuclei of uncertain origin that pack as much energy as a baseball travelling at 100 km/h; or listen in to the quivering of spacetime after a black hole merger with gravitational waves? Thus vastly enhanced, our sensory capabilities have lifted a veil on what was

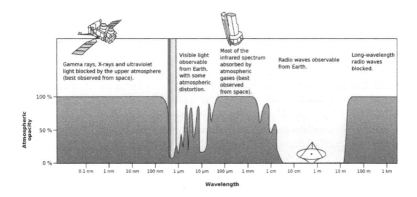

Figure 5.2 The visible part of the electromagnetic spectrum.

Credit: NASA/Wikimedia. Public domain.

previously invisible, and brought into the domain of scientific enquiry questions that were previously the precinct of philosophical speculation: the origin of the universe, its fundamental properties and its ultimate destiny.

But this simplistic view glosses over the conceptual, analytical and practical processes involved in surfacing the invisible in cosmology. Just as the study of the microscopic world requires physicists to walk the tightrope of mathematical consistency to cross the abyss of quantum strangeness, so the investigation of the cosmos is predicated on a series of precarious steps linking data (our observations) to knowledge (our physical conclusions): data representation, statistical inference and model building.

Data representation

Data in cosmology can take many different forms, all of them now digital. The path from the physical signal (such as a photon hitting a digital camera in the focus of a large telescope) to the pictorial, human-readable representation of the object (such as an image of the galaxy) is a daisy chain of decisions and judgement calls. The signal might not be due to a photon at all but rather to a glitch in the detector: if it is a real signal, it could be coming from a passing satellite, in which case it will be removed; distortions in the arrival direction of the photons due to the atmosphere will be corrected; the energy (i.e. the colour) of the photon measured, and if necessary adjusted for changes induced by dust in our own galaxy; the photon might not have been emitted by the galaxy of interest but rather by some other source, which will be subtracted; the path of the photon through the cosmos will have been distorted by gravity, its energy changed by hot gases met on route – these being sometimes precisely the effects the astronomers are looking for, but just as often merely confounding influences that need to be cleansed before the data can be processed.

Astronomers make all of these decisions based on their scientific experience, the underlying aim of the analysis, which requires focusing attention to a specific aspect (a signal in one context may be noise in a different context) as well as their aesthetic sense (Kessler 2012). The resulting image of a galaxy is, contrary to the naive assumption, not as much an objective depiction of reality but rather a heavily mediated representation of the data, produced with its objective and consumers in mind. An image intended for a press release and public consumption might have oversaturated colours and a pleasing palette, while an image that will be fed to a neural network for further processing will wear a

much more unassuming grayscale. Missing pixels and other defects will be masked and clearly marked in an image destined for scientists, while they might be cosmetically filled in and retouched to create an impression of perfection for the general public. The image emerging from this complex and tortuous process will have been filtered through multiple and invisible (to the end user) layers of cleaning, corrections, enhancements – tendrils of the invisible from which the image was born hanging from its edges.

Fibs, lies and statistics

Data and image processing are often only the very first step toward the final objective of extracting scientific meaning. This next phase involves higher-level data manipulation in the form of statistical analysis, which can be exceptionally subtle from a conceptual point of view. Statistics still reels from a somewhat poor reputation: the English Liberal and Radical politician Sir Charles Dilke, back in 1891, was reported as saying that 'false statements might be arranged according to their degree under three heads: fibs, lies, and statistics' (Dilke 1891). In fact, statistics can be fascinating, perhaps nowhere more so than in cosmology where we cannot carry out repeated experiments. All we have is observations of the one universe we inhabit.

Statistics comes in two forms. Imagine a bowl full of green and red apples: if the relative proportion of green to red apples is known, it is possible to predict the probability of picking a green apple at random, which on average is given by the number of green apples divided by the total number of apples in the bowl. This is called 'forward probability', and it predicts the outcome of a random experiment from knowledge of the system (the proportion of green to red apples). A far more interesting situation is that of a black, opaque bag containing a certain number of apples, where the fraction of green to red apples is unknown. We draw an apple at random from the bag and observe it to be red. We now wish to make a statement about the probability of green apples left inside the bag, given that we have made one observation (the red apple we picked). This is called 'inverse probability', since the aim is to go from the data we have gathered (the observation of a red apple having been drawn at random) to inference about the underlying physical reality inside the bag (how many green apples are left inside?). This is the problem of inference in cosmology, where we want to make use of data (the number, colour and direction of photons coming from a certain point in the sky) to draw conclusions about the physical phenomenon that generated them

(is there a planet orbiting around that distant star? Is there dark matter in that far-away galaxy? Is dark energy powering the expansion of the universe today?). The problem of invisibility can thus be restated in terms of the problem of inference: what does the data (the red apple) say about the invisible (and potentially non-existing) green apple inside the bag?

This takes the level of abstraction further as we need to express mathematically the relationship between data and knowledge. Fortunately, there is a simple yet extremely powerful mathematical relationship connecting forward probability (the probability of obtaining data given knowledge of the system) to inverse probability (the probability of the system having certain properties given the observed data), named after an obscure eighteenth-century Presbyterian minister, the Reverend Thomas Bayes. Bayes' theorem is the sole correct mathematical pre-scription for reasoning consistently in the presence of uncertainty (Jaynes 2003, 117). It can be considered the equation of knowledge in that it updates our prior degree of belief in a proposition (which can be quite vague and non-informative) to a posterior degree of belief in the light of the data (which will usually make our state of knowledge much better informed). Bayes' theorem enables cosmologists to translate the observed data, harnessed with our technologically enhanced sensorial capabilities, into probabilistic statements about the truth of underlying invisible phenomena. In the process, the ontological status of the invisible is upgraded from a simplistic binary dichotomy of true versus false to an infinite gradation of plausibility ranging between 0 (false) and 1 (true).

Our statements about the invisible nature of reality, both in the microscopically small and in the unfathomably large, are therefore mediated by the much-maligned statistics. In the quantum world, the outcome of any given measurement cannot be predicted exactly but only in a probabilistic manner (like the probability of drawing a green apple at random from the glass bowl). In the cosmological setting, observations do not deliver a proof of the existence of invisible entities but only varying degrees of belief in their reality. The world of immediate objects we can touch and smell, like apples, gives way to a much more insubstantial web of mathematical, statistical and physical relationships between entities, which exist below the threshold of perception.

Model building

The final step in the chain linking data to physical conclusions is the need for a theoretical framework in which to understand the observations – what physicists call 'a model'. A physics model is often a complex

structure, whose unshakeable foundations are principles deemed to be universally valid (e.g. the conservation of energy), resting on the granite of mathematical theorems. The sturdy basement floor is full of laws of Nature, arranged on shelves, with the bottom shelves displaying laws of more general validity (e.g. Einstein's General Relativity in the bottom-most shelf has, mid-way up, Newton's Universal Law of Gravitation as an approximation, which itself explains Kepler's Law of planetary motion, in the uppermost shelf). The upper floors take many different shapes and sizes, being built out of the mathematical and logical consequences derived from the lower floors. General Relativity leads to the prediction of the existence of black holes (Schwarzschild 1916), and when combined with quantum mechanics, to the conjecture that they must evaporate over time (Hawking 1975). Towards the top of the structure, pinnacles and spires jut out at improbable angles, terraces precariously hang half-finished and stairs intersect irrationally, like in an Escher painting. This is the realm of the speculative, where physicists blindly feel their way forward at the frontier of their discipline. Explanations are postulated, a couple of floors tentatively built on thin Corinthian columns, time-consuming friezes chiselled in only for the whole lot to be unceremoniously demolished by the unforgiving wrecking ball of incompatible observations.

Sometimes – often – somebody decides to build a new tower, from the basement up, by irreverently tearing down a couple of shelves of laws and replacing them with brand new ones: what if Einstein's theory of General Relativity is wrong? Can we fit in an even lower shelf, between Einstein and the floor of the basement, with a law that is even more encompassing than Einstein's? Then a new edifice goes up, with adjustments made as it grows, in order to make sure that it does not conflict with any of the many physics observations we have about the world, from precision measurements of how a solid sphere rotates in orbit to the colours of light emitted by hydrogen atoms when heated up: it all must fit in. A single observation that cannot be explained by the model is sufficient to tear the whole thing down, no matter how beautiful its profile or elegant its spires.

Sometimes – rarely – somebody succeeds in adding an entire new wing: Max Planck's explanation of blackbody radiation; Erwin Schrödinger's uncertainty principle; Pauli and the neutrino; Enrico Fermi and his description of degenerate matter; Richard Feynman's diagrams to compute difficult integrals or Einstein's spacetime. Sitting on the shoulders of giants, contemporary physicists contemplate the landscape around them from a nook somewhere halfway up the edifice and plot

their next move, speculating whether the foundations are secure or the whole model built on quicksand.

Over and over again in the history of physics, what appeared granite turned out to be as ethereal as smoke. The small imperfections in the model of epicycles used to explain the apparent motion of planets in the sky led to the seismic shift to the Copernican heliocentric model. The incapability of classical physics to explain the blackbody radiation or the stability of the atom, opened the door to the quantum revolution. The small precession of the orbit of Mercury became a cornerstone of General Relativity.

When confronted with two major invisible entities in the universe, cosmologists of the twenty-first century baulk at their own uncertainty: will a couple of well-designed steeples top the model to everyone's satisfaction, or will it have to be all torn down and painstakingly rebuilt from the foundations up?

It is time to face the invisible that is all around us: dark matter and dark energy.

The dark universe

While theoretical physicists were investing in the creation of beautiful models, astronomers and observational cosmologists sharpened their demolition tools. Perhaps the single most important instrument of observational destruction of the theorists' models is the digital camera. Since digital cameras replaced photographic plates in telescopes, our data-gathering capabilities have increased by orders of magnitude (figure 5.3). The universe that astronomers uncovered was, and still is, almost impossible to imagine.

Cosmological invisibles

That a large chunk of the cosmos is missing from the astronomers' readouts is an old story. In 1933, the Swiss-American astronomer Fritz Zwicky had mapped out the location and speed of hundreds of galaxies bound together by gravity in a structure known as 'the Coma Cluster', located some 320 million light years away from Earth. By looking at the speed at which galaxies were moving with respect to each other, he concluded that the gravitational attraction that was required to keep them bound in a cluster far exceeded the gravity generated by the visible mass of the galaxies alone. Adding an entire new empty floor to our model of the universe, he postulated the existence of 'dark matter' – a new form of matter that generates gravity but does not interact with light (Zwicky 1937).

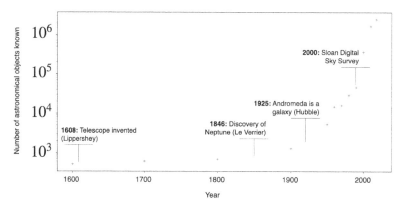

Figure 5.3 Number of astronomical objects known as a function of time, from the invention of the telescope to today. Since the ubiquitous adoption of digital technology in the late 1990s, the amount of data has increased by orders of magnitude.

Credit: Jonathan Davis and Roberto Trotta.

Since Zwicky's seminal discovery, the evidence for the existence of dark matter in the universe has mounted: from the formation and growth of galaxies to the relic light left over from the Big Bang; from collisions of galaxy clusters to the amount of hydrogen and helium produced in the Big Bang furnace. A large number of observations, when interpreted through the double lenses of statistics and theoretical modelling, indicate that dark matter is, on average, five times more abundant than normal matter in the universe (Bertone and Tait 2018).

Despite this enormous progress, it is still not known for certain what dark matter is made of, nor after decades of efforts has it been possible to detect it in the lab, thus providing conclusive proof of its nature – or existence. Zwicky's vast new floor (perhaps best imagined as a hangar!) remains stubbornly empty, populated only by hundreds of delicate and intricate friezes, each a different potential theoretical explanation for the missing mass of the universe.

A second, even more perilous development in the late 1990s opened up a potentially disastrous chasm under the very foundations of the cosmological model. Two teams of astronomers, one led by Adam Riess at Johns Hopkins University and Brian Schmidt at Australian National University (Riess et al. 1998) and the other by Saul Perlmutter at the University of California, Berkeley (Perlmutter et al. 1999), independently and almost simultaneously found evidence that the universe's expansion is not decelerating, as one would expect under the influence of gravity, but, rather, it is picking up speed.

This phenomenon cannot be understood if the universe contains only matter and energy of the usual kind, for these would make the expansion slow down. In order to explain the observed acceleration, cosmologists invoke Einstein's 'greatest blunder', resurrecting the idea of a cosmological constant that Einstein introduced in 1917. At that time, Einstein believed that the cosmos was unchanging with time, neither expanding nor contracting – the expansion of the universe would be discovered by Edwin Hubble only 12 years later. Einstein, however, knew that his own equation of General Relativity predicted a dynamic universe. In order to massage the equations to agree with his beliefs, he added an additional term, which he called 'the cosmological constant', whose effect was to balance gravity in order to get a static universe. The cosmological constant itself is a new constant of nature (like the gravitational constant G, or the charge of the electron), which cannot be predicted from theory but has to be measured observationally. Einstein picked the number that would make the universe static, but he realised later that it would also make it unstable: the smallest perturbation would make Einstein's perfectly tuned universe either expand or contract. In 1931, he recanted and eradicated the cosmological constant from his model of the universe (Einstein 1931; Straumann 2002, 6), later reportedly calling its introduction his 'biggest blunder' (O'Raifeartaigh and Mitton 2018).

The cosmological constant that Einstein so abhorred was resurrected to explain the accelerated expansion discovered in 1998: its effect is repulsive, and its value can be inferred from the astronomical observations, leading to the conclusion that about 70 per cent of the universe's contents are in the form of a cosmological constant, today dubbed 'dark energy'.

The standard cosmological model in 2022 reduces all the intricacies of galaxies, gas, stars and planets in the universe to a mere 5 per cent of everything there is – baroque bell towers that are the mere tip of the cosmological iceberg. Under the line of visibility, Zwicky's large dark matter hangar contains 25 per cent of the mass of the cosmos. Further in the depths of the unknown, Einstein's cosmological constant fills 70 per cent of the universe.

Filling the void

That 95 per cent of the contents of the universe should be invisible and unknown strikes some as preposterous. Yet the evidence for dark matter – coming as it does from multiple, independent and concordant observations of astronomical objects and phenomena throughout the

cosmos – appears to be so strong as to be incontrovertible when seen in the context of General Relativity, one of the main laws of nature currently on display in the basement of our model. Modern attempts to change the laws of gravity to avoid the dark matter hypothesis have had only partial successes: modified gravity theories can explain a small subset of the observations but are wholly incompatible with others. The dark matter floor survives unscathed.

When examining the friezes on the walls of the dark matter floor, one is struck by the variety of what is represented there. Some ideas have been etched long ago, and now appear faded and almost forgotten. Others have grown into intricate and finely carved arabesques. Others still vie for attention with their vivid, garish colours, clearly a freshly painted work-in-progress. Some are hastily scratched graffiti, knee-jerk responses to the latest observational anomaly, theoretical fads that live and die like a fast meteor shower, and are swiftly eclipsed by newer, flashier ones.

One of the most accomplished parts of the frieze has the simple, striking beauty of a painting by the surrealist Joan Miró, whose canvases attempt to capture the idea of the infinite. The leading explanation for dark matter is an idea that goes under the name of Weakly Interacting Massive Particles, or WIMPs. It has been known for a long time that, for all its successes, the standard model of particle physics, which explains the origin and nature of particle and forces, is incomplete. It does not explain why neutrinos have mass (an observational fact), nor why the Higgs boson mass has the observed value; nor is it able to provide a unified description of weak, strong and electromagnetic interactions (including the fourth interaction, gravity, which requires a rethinking of both general relativity and quantum mechanics). In the 1970s, particle physicists realised that many of these puzzles could be resolved if every known particle had a counterpart: a supersymmetric twin. Such supersymmetric particles should have much higher mass than known particles, and thus would have been copiously produced in the aftermath of the Big Bang, created out of the large energy available in the hot environment. As the universe expanded, it cooled off and this meant that higher mass supersymmetric particles decayed without being replaced. Supersymmetric particles would thus eventually disappear, except for one: under certain conditions, the lightest supersymmetric particle is neutral, massive and stable – all the characteristics for a successful dark matter candidate. A simple calculation predicts the number of such WIMPs left over in the modern universe and – lo and behold – this figure matches the 25 per cent observed in the cosmos. This striking result goes under the name of 'the WIMP miracle': a theory invented to prop up a

completely different part of the model is able to fill Zwicky's dark matter hangar with particles in just the right measure.

For decades now, physicists have been looking for WIMPs in particle accelerators, underground detectors, space-born observatories and neutrino telescopes buried in the Antarctic icecap. So far, in vain. Numerous claims added their red dot of discovery under the WIMP frieze over the years, only for it to be retracted as the signals did not live up to scrutiny. A sense of fatigue is developing in the community: if the Large Hadron Collider, the most powerful particle accelerator in the world, fails to discover supersymmetry in the next few years, that part of the frieze might well be abandoned as impossible to test. The caravan moves on to new targets, of which there is no lack: axions, sterile neutrinos, WIMPzillas, primordial black holes, extra dimensions, D-matter, hexa-quarks, gravitinos. The hangar remains empty.

The question of the existence of the cosmological constant is more controversial. A re-analysis of the astronomical data that led to its discovery claims that the statistical evidence is not as strong as previously stated (Nielsen et al. 2016) – this casts doubts on a result that was deemed Nobel Prize worthy in 2011. In contrast to dark matter, the evidence for a cosmological constant comes from a handful of observations, without the robustness redundancy that dark matter data enjoys. Some physicists question whether we are interpreting the data correctly: what if one of the major supporting pillars of the model is hopelessly wrong?

The leading explanation for the numerical value of the cosmological constant appears to some to add to the ugly, distasteful darkness of the model. It is presently impossible to compute the observed value of the cosmological constant from first principles like quantum mechanics. Attempts to do so fail miserably, missing the target by 120 orders of magnitude – quite possibly the most spectacularly wrong prediction in the history of science. Theoretical physicists have resorted to the ultima ratio of extending further the dark chasm under the model. If the observable universe is only part of a much larger collection of universes, each with its own physical laws, particles and constants of Nature, the fact that sentient life appeared in our universe constrains the possible values that such constants of Nature might take. If the Multiverse is like the Grand Canyon, with uncountable numbers of ravines, and the laws of physics are different in each gully, complex life will only emerge in those ravines where the local by-laws permit the development of complex biological systems. If we are to exist, the cosmological constant cannot be too large (as would be predicted by quantum mechanics), or its repulsive effect would prevent the formation of galaxies and stars, and hence sterilise the

universe. We must live in the rare crevice with a sufficiently small cosmological constant to be compatible with life (Weinberg 1987).

Cosmologists' solution to the largest missing piece of the universe is to multiply the invisible entities manifold, and push all of these other invisibles beyond the boundary of the observable universe – not only in practice, but also in principle. It is difficult to see at present whether there exists any path to ever observationally test this speculative conjecture. The other gullies of the canyon are unreachable, and this makes the multiverse hypothesis untestable – and thus, for the time being, unscientific.

Conclusions: from data to meaning

Twentieth-century physics pushed back the boundary of the invisible. Twenty-first-century physics might find itself confronted with the ultimate invisibles, seeping through the ontological cracks of the quantum world, weighing down from the sky as untestable dark materials.

As physicists grapple with these questions, they look for helpers and allies to tame the torrential flow of data expected from the next generation of astronomical observatories and particle physics experiments: telescopes observing all of the visible sky every three nights; space-born gravitational waves detectors scouring the cosmos for black holes mergers; planetary-sized arrays of radio telescopes plucking out the most distant, earliest stars in the cosmos; particle accelerators smashing protons to ever increasing energies, getting ever closer to the conditions at the Big Bang; dark matter detectors in deep underground caves, intently watching hundreds of tons of purified xenon for WIMP traces. All of these instruments will produce data that no human eye will ever inspect: we need machines to do it for us. Even as the invisible universe is drawn into the light of scientific scrutiny, the means of doing so recede ever more into the impenetrable. Machine learning and artificial intelligence (AI) will be the indispensable tools in the physicists' quest for the ultimate reality of the cosmos.

AI is rapidly becoming a powerful and often invisible shaper of our everyday life, through automated decision-making systems, facial recognition, social networks, autonomous driving vehicles and many more. These invisible agents are moulding human society at an alarming rate, leaving us vulnerable to manipulations that are all the more subtle for being difficult to recognise (Kissinger 2018). Against this backdrop, we must not shy away from examining the role of information and data manipulation in the production of scientific knowledge (Mézard 2018).

In which sense, exactly, will we 'understand' the universe if conclusions on its physical nature will depend on the output of an inscrutable and unintelligible algorithm, such as deep neural networks? How can we trust such methods to conform to our physical intuition? Can we teach machines to appreciate 'beauty' in scientific theories? Will a super-intelligent AI surpass the combined genius of Einstein, Hawking and Gödel, and if so, will it bother to explain its insight on the nature of the universe to us (Trotta 2021)?

The invisible is all around us.

It is in the unseen forces that make galaxies grow as they push the universe apart.

It is in the empty space between nuclei and electrons, existing only as diffuse probability clouds in a quantum mechanical space.

It is in the unthinking, unfeeling artificial neurons that silently make decisions on our behalf: keep this galaxy, discard that one; save this life, lose that one.

The more data we have, the harder it becomes to extract knowledge from noise.

The invisible has a bright future ahead.

Note

1 The original German is a little different than the translation given above: 'Die Quantenmechanik ist sehr achtung-gebietend. Aber eine innere Stimme sagt mir, daß das noch nicht der wahre Jakob ist. Die Theorie liefert viel, aber dem Geheimnis des Alten bringt sie uns kaum näher. Jedenfalls bin ich überzeugt, daß der nicht würfelt'.

References

Barrow, John. [1995] 2011. *The Artful Universe Expanded*. Oxford: Oxford University Press.

Bertone, Gianfranco and Tim M. P. Tait. 2018. 'A new era in the search for dark matter', *Nature* 562: 51–6.

Bohr, Niels. 1913. 'On the constitution of atoms and molecules', *Philosophical Magazine* 26(151): 1–24.

Dilke, Charles, 1891. *The Bristol Mercury*, 19 October 1891, p. 5 (unattributed column).

Einstein, Albert. [1926] 1969. 'Letter to Max Born'. 4 December 1926. In: *Briefwechsel 1916–1955*, edited by Albert Einstein and Max Born, 129–30. München: Nymphenburger Verlagshandlung.

Einstein, Albert. 1931. 'Zum kosmologischen Problem der allgemeinen Relativitätstheorie', *Sitzungsber. Preuss. Akad. Wiss.* 235.

Feynman, Richard P. 1982. 'Simulating physics with computers', *International Journal of Theoretical Physics* 21: 467–88.

Hawking, Stephen W. 1975. 'Particle creation by black holes', *Communications in Mathematical Physics* 43: 199–220.

Jaynes, Edwin T. 2003. *Probability Theory: The logic of science*. Cambridge: Cambridge University Press.

Kessler, Elizabeth A. 2012. *Picturing the cosmos. Hubble space telescope images and the astronomical sublime*. Minneapolis: University of Minnesota Press.

Kissinger, Henry. 2018. 'How the Enlightenment ends', *The Atlantic*, June 2018. https://www.theatlantic.com/magazine/archive/2018/06/henry-kissinger-ai-could-mean-the-end-of-human-history/559124/.

Lowell, Percival. 1906. *Mars and Its Canals*. MacMillan: New York.

Mézard, Marc. 2018. 'Opinion: Artificial intelligence and scientific intelligence', *Europhysics News* 49(2): 32.

Nielsen, Jeppe, Alberto Guffanti and Subir Sarkar. 2016. 'Marginal evidence for cosmic acceleration from Type Ia supernovae', *Science Reports* 6, https://doi.org/10.1038/srep35596.

O'Raifeartaigh, Cormac and Simon Mitton. 2018. 'Interrogating the legend of Einstein's "biggest blunder"', *Physics in Perspective* 20: 318–41.

Pauli, Wolfgang. 1930. 'Open letter addressed via Lise Meitner to the group of radioactive people at the Gauverein meeting in Tübingen'. 4 December 1930. Pauli Letter Collection, translated by Kurt Riesselmann. Geneva: CERN.

Perlmutter, S. (ed.), G. Aldering, G. Goldhaber, R.A. Knop, P. Nugent, P.G. Castro, S. Deustua, S. Fabbro, A. Goobar, D. E. Groom, I. M. Hook, A. G. Kim, M. Y. Kim, J. C. Lee, N. J. Nunes, R. Pain, C. R. Pennypacker, R. Quimby, C. Lidman, R.S. Ellis, M. Irwin, R.G. McMahon, P. Ruiz-Lapuente, N. Walton, B. Schaefer, B. J. Boyle, A. V. Filippenko, T. Matheson, A. S. Fruchter, N. Panagia, H. J. M. Newberg, W. J. Couch and The Supernova Cosmology Project. 1999. 'Measurements of omega and lambda from 42 high-redshift supernovae', *The Astrophysical Journal* 517(2): 565–86.

Riess, Adam G., Alexei V. Filippenko, Peter Challis, Alejandro Clocchiattia, Alan Diercks, Peter M. Garnavich, Ron L. Gilliland, Craig J. Hogan, Saurabh Jha, Robert P. Kirshner, B. Leibundgut, M. M. Phillips, David Reiss, Brian P. Schmidt, Robert A. Schommer, R. Chris Smith, J. Spyromilio, Christopher Stubbs, Nicholas B. Suntzeff and John Tonry. 1998. 'Observational evidence from supernovae for an accelerating universe and a cosmological constant', *The Astronomical Journal* 116(3): 1009–38.

Rutherford, Ernest. 1911. 'The scattering of alpha and beta particles by matter and the structure of the atom', *Philosophical Magazine* 21: 669–88.

Schwarzschild, Karl. 1916. 'Über das Gravitationsfeld eines Massenpunktes nach der Einsteinschen Theorie', *Sitzungsber. K. Preuss. Akad. Wiss.* 7: 189–96.

Straumann, N. 2002. Invited talk at the XVIII IAP Colloquium: Observational and theoretical results on the accelerating universe, 1–5 July 2002, Paris (France), available from: https://arxiv.org/abs/gr-qc/0208027.

Trotta, Roberto. 2021. 'Masters and Servants: The need for humanities in an AI-dominated future'. In: Campbell, Aifric. 2021. *The Love Makers*. London: Goldsmiths Press, pp. 259–68.

Weinberg, Steven. 1987. 'Anthropic bound on the cosmological constant', *Physical Review Letters* 59(22): https://doi.org/10.1103/PhysRevLett.59.2607.

Wigner, Eugene. 1960. 'The unreasonable effectiveness of mathematics in the natural sciences', *Communications in Pure and Applied Mathematics* 13(I): https://doi.org/10.1002/cpa.3160130102.

Zwicky, Fritz. 1937. 'On the masses of nebulae and of clusters of nebulae', *Astrophysical Journal* 86: 217.

Interpretation

6
Picturing the mind

Irene Tracey

Introduction

Is it possible to 'see pain'? Will we ever really unravel the mystery of your mind and all its workings? Modern brain imaging tools are giving unprecedented insight into how the human brain thinks, makes decisions and constructs perceptions. This chapter provides examples drawn from current research on pain alongside other studies in the neuroimaging neuroscience domain, to illustrate just how it is possible to harness these tools to 'picture the invisible' at an individual through to population level. The importance of incorporating interpretations of what we are able to see is demonstrated as a critical step to finding new discoveries and meaning from what we can now 'see'.[1]

History

Thousands of years before we confidently knew that the brain was the organ responsible for perception, cognition, emotion, creativity and so on, Hippocrates understood it was likely the place from which our deeply subjective states arose. The Hippocratic School of physicians (400 BCE) first challenged the ancient supernatural concepts of illness:

> Men ought to know that from nothing else but the brain come joys, delights, laughter and sports, and sorrows, griefs, despondency, and lamentations. And by this, in an especial manner, we acquire wisdom and knowledge, and see and hear, and know what are foul and what are fair, what are bad and what are good, what are sweet, and what unsavoury.
>
> (Hippocrates 400 BCE)

This insight is really quite remarkable, the more so because it took us so long and via many a dead end before we came to realise he was, of course, correct. To cut a long story short, we had theories that placed emphasis on the brain's ventricles (fluid filled spaces) as the business end of function with the grey and white matter being the 'padding' to protect the all-important ventricles. The theory went that in the first ventricle, *sensus communis*, images were created and passed onto the middle ventricle – the seat of reason (ratio), thought (cognatio) or judgement (aestimatio), and then in the last ventricle the final step occurred, memory (memoria). This schema persisted well into the sixteenth century – Leonardo da Vinci himself making a beautiful wax cast of these ventricles (putting 'sensus commune' though on the middle ventricle) (Clayton et al. 2012). However, questions were being asked and controversy waged throughout the Middle Ages as to whether the soul and thought/perception was in the brain or heart – the latter being a strong contender due to its position and ability to communicate via liquid blood to all parts of the body. You can witness this debate in Shakespeare's writings: 'Tell me where is fancy bred, or in the heart, or in the head' (The Merchant of Venice, 3.2.64–65, 1600/1980). But then along came René Descartes (1596–1650) and everything changed. Amongst his many contributions is what he did for neuroscience, and that was to make a radical distinction between the 'mind' and the 'body'. With this distinction, the concept of *dualism* was born – and this freed men, even devout ones, to speculate about the working substance of the brain. A neat move. However, the consequences of this dualistic thinking are still felt today. The idea that the 'mind' is a thing not based in anatomy or physiology but is somehow separate, ethereal, often allows for people to make false assertions that some brain-based phenomenon or mechanism is 'in the mind' and, therefore, less real and not to be bothered about. One of the many advantages of modern brain imaging tools is our ability to overturn such prejudices.

Following Descartes, Thomas Willis (1660–75) produced, with Sir Christopher Wren as the main artist, the wonderful anatomical drawings of the human brain, *Cerebri Anatome*, as well as identifying a major and clever feature of secured blood delivery to the brain (Circle of Willis) (Willis 1664). Despite some interludes in the search to understand the human brain – such as the German neuroanatomist and physiologist, Franz Joseph Gall's (1758–1828) founding of the pseudoscience of phrenology (Gall 1838) – otherwise known as the localisation of mental functions in the brain via lumps and bumps on the human skull – our understanding of how the human brain works developed through the

examination of brain lesions and their consequences on behaviour and personality (e.g. Phineas P. Gage – 1823–60 (Bigelow 1850)) and by the open surgery studies performed by the Canadian surgeon, Wilder Penfield (1891–1976) (e.g. Penfield and Boldrey 1937). The acceleration in our understanding of brain structure and function through a widening body of researchers, *neuroscientists*, interested in specialising in this particular field of brain science using an array of new techniques to examine the nervous system, *in vitro* and *in vivo*, from a neurochemical, structural (anatomical), physiological (functional) perspective, means that today we have an ever more complete understanding of how the human brain works. We can finally *see* into the black box. As a consequence, we can perhaps provide colour, in scientific terms, to what Hippocrates proposed two thousand years ago: *seeing pain arise in the brain*.

Pain: backgrounds and definitions

Pain is one of our body's oldest sensory and emotional experiences. In evolutionary terms, the experience of pain, the 'ouch' that something hurts, is shared across the animal kingdom. Pain is our body's alarm system, warning us of harm, injury or a threat in the environment. Noxious or nociceptive (harmful) stimuli in the environment that are capable of causing tissue injury and pain fall into three broad categories: mechanical, chemical and thermal stimuli. The 'hurt' and unpleasant experience that might arise as a consequence of injury from one of these, and is synonymous with the word 'pain', often produces a behavioural response – verbal expletive or sudden movement! This decision to react facilitates protection – attending to and withdrawing from the thing causing pain and learning to avoid it in future. This is good or 'acute' pain. Many of us have experienced such pain in our everyday lives, but for some people with a genetic condition called congenital insensitivity to pain, the hurt of pain cannot be felt because the signals from the site of injury do not make it to the brain – where pain emerges as a perception. Historically, these individuals rarely made it to adulthood. An injury causing internal bleeding or infection did not ring the alarm bell warning system and, as a consequence, the injury was left untreated and worsened, resulting in death. A stark warning as to the importance of feeling pain. Chronic pain is something entirely different from 'good' and acute pain. The pain here is not protective but pathological.

Such pathological pain includes conditions in which the pain is not signalling the presence of an ongoing noxious stimulus and conditions

whereby the pain is not enabling healing (i.e. not acute inflammatory pain). As such, chronic pain is the dark side of pain. It is defined as pain that persists beyond normal tissue healing time – normally three to four months – and it includes conditions like rheumatoid arthritis (inflammatory pain), painful diabetic neuropathy or multiple sclerosis (neuropathic pain) and fibromyalgia or irritable bowel syndrome (functional pain).[2] One in five of the adult population are defined as suffering from persistent, pathological chronic pain (Goldberg and McGee 2011). It is more prevalent in women and the elderly for reasons we do not fully understand. Such pathological or clinical pain has a complex biology and pathophysiology with multiple diverse pathways affected. These include abnormal peripheral drivers such as ectopic activity in injured axons, alterations in transmission, and processing in the spinal cord and higher brain centres due to sensitisation, amplification and disinhibition, through to modifications in perception (Tracey 2012; Tracey 2020; McMahon et al. 2013). Exactly what is responsible for the transition of acute to chronic pain and why some individuals are more susceptible than others are areas of active research, mitigating the development of persistent pathological pain by targeting the responsible mechanisms being the goal (Denk et al. 2014).

Patients suffer on average for seven years with their condition and 20 per cent suffer for close to 20 years with pain. It is hard to imagine the impact it has on one's life and identity. Co-morbid anxiety, depression and sleep loss occur and there is negative impact not only on the life of the sufferer but also their families and loved ones. And if this was not bad enough, we have very few effective therapies to treat chronic pain. Most of our drugs do not work in the majority of patients and for those where there is some relief, it is some but not complete relief. This bleak picture, born from the complexity of chronic pain at a mechanistic level, is why, in part, we have an opioid epidemic in the USA (and some other countries too) and is why chronic pain elicits such a high socioeconomic burden on society ($600 billion per annum in the USA and 200 billion euros per annum in Europe) (Breivik et al. 2006; Institute of Medicine (US) Committee on Advancing Pain Research, Care, and Education 2011).

Why image pain?

Pain is defined by the International Association for the Study of Pain (IASP) as: 'An unpleasant sensory and emotional experience associated with, or resembling that associated with, actual or potential tissue

damage' (Raja et al. 2020, 1977). They go on to emphasise the following key points:

- Pain is always a personal experience that is influenced to varying degrees by biological, psychological and social factors.
- Pain and nociception are different phenomena. Pain cannot be inferred solely from activity in sensory neurons.
- Through their life experiences, individuals learn the concept of pain.
- A person's report of an experience as pain should be respected.
- Although pain usually serves an adaptive role, it may have adverse effects on function and social and psychological well-being.
- Verbal description is only one of several behaviours to express pain; inability to communicate does not negate the possibility that a human or a nonhuman animal experiences pain.

These definitions are important and helpful. They emphasise the key fact that pain is a private and subjective experience. You can never really *know* or *experience* someone's subjective state or perceptual experience. Is my seeing the colour red the same as yours? Such questions philosophers have struggled with and argued over for many years without conclusion. What you can do though is better understand and explain why someone's perceptual pain experience is the way it is – you can use modern 'objective' tools to go under the bonnet, so to speak, to see the mechanics or mechanisms at work and by doing that help explain why the pain experienced might be profoundly different to what you might expect based on the visible injury or your particular judgement of what pain is appropriate to 'display' in that particular context. Why is this important? Well, that same Descartes also had things to say about pain. His famous drawing (see figure 6.1), that depicts a boy with his foot in a fire suggests that a straight connection exists from the injured foot to the brain. Almost as if a bell-cord was being rung to say: 'I'm hurt'. This 'linear' or one-to-one mapping of injury to brain response is too simplistic. We know now, largely through brain imaging, that the relationship between injury and pain perception is a highly non-linear one and not a simplistic one-to-one mapping. Your mood, your attentional state, the context in which you are experiencing the injury and, of course, your genetics all powerfully influence how those injurious (nociceptive) signals are processed on their journey from the injury to the brain, so what finally results as the 'ouch, this hurts' can be very different to what you might expect based on the degree of tissue injury. This is why understanding pain is so challenging

Figure 6.1 Descartes' original drawing and an updated version including activity related to pain in the spinal cord and brain.

Credit: R. Descartes, C. Clerselier, L. La Forge and F. Schuyl, L'homme et un Traitté de la ormation du Foetus du Mesme Autheur. Paris: Charles Angot, 1664.

and why we need more objective measures to help us understand pain, whether it's for veterinary care, in comatose patients or the demented elderly or in babies (generally in people who cannot communicate their pain), in courts of law and of course in the clinic and drug development. As pain arises in the brain then, having tools that provide a window into the brain processes from which pain as a perception emerges is essential. Brain imaging or neuroimaging is such a tool and it provides us with a key to unlock one of life's oldest and most important sensory and emotional experiences.

Can you ever really 'see' pain?

The short answer is: sort of. We have an array of tools available to us today that allow us to measure brain activity in response to external stimulation eliciting our basic perceptions (such as seeing, hearing, smelling, tasting, touching, feeling pain …), as well as brain activity from internal processes (such as making decisions, imagining). We also have tools that allow us to measure brain network activity to internal disease-related processes, such as those arising from spontaneous or ongoing pain in a chronic pain patient. We can measure the strength of these networks and the 'wiring' between different brain regions – tools

that give us structural information about grey matter volume and white matter ('wiring') integrity, as well as tools that provide insight into the neurochemistry, quantity and location of receptors to key neuromodulators like dopamine and endogenous opioids, as well as tools that measure electrical activity of the brain. In brief, the main tools that allow the capture of these attributes are: magnetic resonance methods (structural imaging for grey matter volume); diffusion tensor imaging for white matter 'wiring' measures; functional imaging (for brain activity network measures); spectroscopy (for neurochemistry); positron emission tomography (receptor quantity and location as well as neuromodulator/ neurochemical assessment); electroencephalography (EEG) and magnetoencephalography (MEG), both for electrical measures. It is a great time to be a neuroscientist, as we have this rich array of tools that we can combine in a *multimodal* manner in order to increasingly understand the human brain from a broad perspective of anatomy and physiology (structure and function) (Jezzard et al. 2001; Toga and Mazziotta 2002).

Basic pain networks

In the context of pain, early work highlighted that a healthy individual in response to a nociceptive stimulus (e.g. burning, pricking, electrical shocks) activates a large array of brain regions (Tracey and Mantyh 2007). Inferring what we know of the function of these regions from other neuroimaging studies, we can conclude that they are likely encoding various aspects of the multidimensional experience that is pain, such as sensory-discriminatory and affective-attentional-motivational. What does this mean? Well, think for a moment about a simple cut from, say, a knife while chopping vegetables. How do you react and feel? You will most likely first locate where the injury has happened (attentional circuits and body location networks in action), you then recognise it as a cut and not a burn and gauge its strength or intensity (discrimination networks), you have an emotional reaction to the fact it hurts (affective networks), you remember to be more careful next time (memory and learning networks) and you withdraw your hand from the knife – you act (motor networks). That is an awful lot of brain activity for even the simplest of injuries – and that is largely what we see as active in our brain imaging experiments. It is clear that many of these brain networks and the regions within them are not specific to pain experiences, for example attending to the pain – it is vital to attend to pain but there is no need for the brain to

have one attentional system for pain and a different one for watching a gripping movie. The brain is efficient in that regard. Pain is a multifactorial experience that encompasses all those features I have just detailed – but there is still unequivocally an element of the experience that is uniquely the *hurt* of pain. It remains a mystery to this day, despite several decades of pain brain imaging, as to how the hurt of pain arises through brain activity.

A new approach to *decode* pain is to use novel analysis tools based on classification algorithms and perform multivariate pattern analyses (MVPA). There are pros and cons to this method, but it does allow a degree of objectivity as the imaging expert is removed from interpreting brain activity. Algorithms are trained on data sets as to what patterns relate to – that is, this pattern = pain, that pattern = no pain or perhaps this pattern = physically induced (nociceptive) pain and that pattern = emotional pain through grief, social exclusion or empathic pain. Once trained up with sufficient data, a novel data set is introduced and the algorithm provides a probability that the pattern relates to pain or no pain, or nociceptive pain rather than emotional pain, depending on the relevant question and data sets used. In effect, this approach allows for *brain-reading*, and it is probably obvious what reach this application has in the context of pain in society and courts of law, as well as many other areas of neuroscience. There are several drawbacks when using this analysis technique that often produces a harsh and binary outcome. However, as the field develops and more data sets of varying types are included, it is impressive how quickly this area is giving us an ever more detailed understanding and improved granularity regarding brain activity patterns. This allows us to better disambiguate and 'see', through the network of brain activity measured, what is the likely nature of someone's pain. But we must remember that characterising someone's individual and personal pain experience based on how their brain activity relates to the brain activity of others in pain can never be completely accurate. The classification is done using crude descriptive measures to categorise the pain and this blurs boundaries and individual subjective elements of the experience.

Seeing pain mechanisms through brain imaging

Another approach to 'seeing' pain is to delineate how it is that a change in mood, attentional state or context influences the pattern of activity to the same nociceptive input such that the pain experience is altered. From a

range of experimental pain studies, we now have a clearer idea of how anxiety and depression alter the substrate of the brain into which nociceptive signals are arriving (Berna et al. 2010; Wiech and Tracey 2009; Wiech et al. 2008). As a consequence, we know that these mood influences act as 'neural amplifiers' to make pain worse. So, in addition to the patient describing their pain experience as worsened, we now have this additional and objective evidence that there is literally more brain activity; and it is this that explains a heightened pain report. Before we had such data, it was hard to understand whether the increased pain because the person was more anxious or depressed was 'report bias' – the fact that they might describe many/all things in a more negative way – or due to increased brain activity. By 'seeing' the brain activity to the same injury change as a direct consequence of mood changes was extremely important. It provided evidence to support the clear need to target these psychological elements of pain just as much as the more physiological and injurious elements. *Seeing* the explanation for this increase in pain really mattered to patients, researchers and the medical profession.

Similarly, seeing the brain mechanisms that subserve why it is that when we are distracted from pain it hurts less has been key to unravelling how the 'free-analgesia' occurs that is witnessed during the fight-or-flight response or during the high arousal situation of the sports field or battleground. We now know that an evolutionary old system centred in old brain – the brainstem – is pivotal in controlling what pain you experience (Tracey 2017). Combined with other brain regions like the amygdala, hypothalamus, insula, anterior cingulate and other prefrontal cortical areas, this exquisite set of brainstem nuclei (e.g. periaqueductal grey and rostral ventromedial medulla) has the capacity to communicate to the spinal cord (where nociceptive signals are transmitted to from the injured area prior to them being sent up to the brain) in an inhibitory or facilitatory way. In short, this descending pain modulatory system acts as a gatekeeper to pain perception, controlling whether nociceptive signals are inhibited or amplified before being sent to the brain for further processing (Tracey and Mantyh 2007). Literally turning the volume down or up via inhibitory or facilitatory mechanisms, respectively. As a consequence, its activity is key to understanding how in various situations (injury during high arousal rugby match or distracting your child during a vaccination jab) the pain can be lessened despite injury. Basically, during distraction analgesia (e.g. sports field) the inhibitory arm is activated and endogenous opioids are released that block the nociceptive signals – so, if less nociceptive signals enter the brain there is less pain (Tracey et al. 2019). Simple as that. Seeing this system in action has been

made possible through various types of brain imaging. It has also given us a mechanistic insight into the therapies used to treat chronic pain patients that might rely on distraction-based methods. Equally important, it has given us insight into the ancient and well-known phenomenon of placebo analgesia.

Placebo analgesia is the pain relief that someone experiences in response to a treatment with something that is inert, like a sugar pill or saline injection. It has confounded physicians and researchers for years as to the basis – was it simply a delusional trick or something more physiological? For hundreds and hundreds of years, it was assumed that the benefits a patient might experience in response to reassuring words and expectation management by their physicians was real – in the traditional medical sense of doing something physiological. We just didn't know how. And then right at the time it was proven, statistically, that placebo analgesia was a real phenomenon, we stopped believing in it and 'placebo tests' were brought into medical practice to catch patients out, the randomised control trial was introduced and so forth. It is almost comical what reaction we had after discovering it actually worked! Fortunately, neuroimaging has helped to explain and prove that placebo analgesia is real (Tracey 2010; Eippert et al. 2009). It works, in very large part, by hijacking the inhibitory arm of the descending pain modulatory system with concomitant release of endogenous opioids. It's one of the networks and mechanisms we understand probably best by 'seeing' pain and pain relief in action through neuroimaging. And there is nothing special about placebo analgesia – we just need to work out a way to exploit its powerful positive effects in clinical practice. This is now being pursued through the use of either 'open-placebo' studies or better management of expectation, which is a powerful cognitive mechanism at play even when patients are on actual treatments. The effectiveness of a real treatment (drug, surgery, etc.) is powerfully influenced by expectations and these play out through the descending inhibitory system during positive expectation or through those anxiety amplifiers, discussed earlier, during negative expectation (or nocebo) (Bingel et al. 2011). You really do get the pain you expect! A different way to think about expectation relates to current ideas about how the human brain actually works. The best way to describe this is to think about picking up a glass of water. Ahead of picking it up with your hand, you have an expectation about what it will feel like – based on a lifetime of picking up glasses of water. These expectations conjure up brain networks that might powerfully alter the probability of what you will perceive – this probability distribution or bias is a way to express one's beliefs about this experience before evidence (i.e. touching the glass) is taken into account.

We call these probability distributions, *priors*. In extremis, the priors will dictate what the experience is irrespective of what is coming into the brain (in terms of the actual touch of the glass or, in the case of pain, the incoming nociceptive signals). It's another way of thinking about how powerfully our expectations shape our experience and the brain is the seat of it all. We can now 'see' this Bayesian brain in action through neuro-imaging and it is helping us to understand all sorts of complex conditions where perceptions might be unrelated to inputs.

Moving to chronic pain and the mechanisms relevant here then the story is more complex. Dysfunctional descending inhibition and engagement of the facilitatory (or pain amplifying) arm of the descending pain modulatory system is a key hallmark of many chronic pain states (Soni et al. 2019; Segerdahl et al. 2018). It's something we can 'see' through brain imaging and, as such, its involvement has been highlighted in exacerbating and maintaining a persistent pain state. The amplification due to mood disturbances of brain networks encoding constant ongoing pain as well as aberrant learning and reward mechanisms all conspire to hold that 20 per cent in chronic pain (Denk et al. 2014). Further, we are able to identify changes in structural wiring, resting brain networks, neurochemistry, receptor expression and density, and even grey matter volume changes. Fortunately, most of these changes are reversible with successful treatment – again, something we have been able to prove by 'seeing' the changes pre- and post a pain-relieving intervention using brain imaging (Denk et al. 2014). The brain is amazingly plastic, in that it can change and is malleable. One classic pain condition that is often explained by such brain plasticity is phantom limb pain – feeling pain and weird sensations in a limb that is missing. The science behind this is still being determined but brain imaging has provided some really exciting and new clues as to what might be going on. This is a nice example whereby 'seeing' the pain in the human brain has given us new mechanisms to target in this devastating pain condition. The final frontier is to 'see' whether there are vulnerabilities in the brains of patients who are the one in five that go on to develop persistent chronic pain. Again, using brain imaging we are able to 'see' the brain develop functionally and structurally from a baby through adolescence to adulthood. Our life's journey with its bumps and scrapes as well as our genetics shape our brain networks and neurochemistry in ways we are only now really discovering. The current thinking is that such life events, sculpting and shaping our brains, confer a resilience or vulnerability to injury – whether that is pain or another chronic condition affecting the central nervous system. One way we will 'see' this better is using very large data sets of brain images

from thousands of people and then following them up to see who develops a chronic pain condition. UK Biobank is one such data set that is being gathered at the time of writing. Out of the 500,000 people whose genetic and lifestyle features are being collected, 100,000 of them are having their brains and hearts imaged from a functional and structural perspective.[3] This is giving us unprecedented windows into the human brain as we can now relate what we 'see' in the brain with peoples' lifestyle choices, their genetics and perhaps their eventual disease likelihood or vulnerability. These are exciting times.

Conclusion

We do not really 'see' the mind, or pain or even consciousness for that matter. But what we do 'see' is a link between brain activity and a person's perception or the degradation of perception by changes in conscious awareness – revealed (if they can) via verbal means. This description itself is limited to the language and cultural norms of that individual. When there is no ability to communicate, we have to infer what the brain activity means by relation to other behaviours and other brain imaging data sets. But it will always remain the case that a person's pain is their private and subjective experience and, as such, the ground-truth that might never be captured with words or neuroimaging. However, what we 'see' does help us to understand a person's pain even if it might never tell us how it is felt.

Notes

1 Suggested further reading: Pain Exhibit: Online art galleries. http://painexhibit.org/en/. (Accessed 30 June 2021); Scarry, E. 1985. *The Body in Pain: The Making and Unmaking of the World*. New York: Oxford University Press; Sontag, S. 2003. *Regarding the Pain of Others*. London: Hamish Hamilton; Tracey, Irene. 'Finding the hurt in pain', *Cerebrum*. December 2016. https://www.dana.org/article/finding-the-hurt-in-pain/. (Accessed 30 June 2021); Irene Tracey. 'From agony to analgesia', BBC Radio 4. August 2017. https://www.bbc.co.uk/programmes/b0925604. (Accessed 30 June 2021); Nicola Twilly. 'The neuroscience of pain', *The New Yorker*. 2 July 2018. https://www.newyorker.com/magazine/2018/07/02/the-neuroscience-of-pain. (Accessed 30 June 2021); Patrick Wall. 2000. *Pain: The science of suffering*. New York: Columbia University Press; Davis, K., Flor, H., Greely, H. et al. 2017. 'Brain imaging tests for chronic pain: Medical, legal and ethical issues and recommendations', *Nature Reviews Neurology* 10: 624–38. https://doi.org/10.1038/nrneurol.2017.122. Epub. 8 September 2017. PMID: 28884750.
2 For further information, see The International Association for the Study of Pain. https://www.iasp-pain.org.
3 For details about UK Biobank, see https://www.ukbiobank.ac.uk.

References

Berna, Chantal, Siri Leknes, Emily A. Holmes, Robert R. Edwards, Guy M. Goodwin and Irene Tracey. 2010. 'Induction of depressed mood disrupts emotion regulation neurocircuitry and enhances pain unpleasantness', *Biological Psychiatry* 67(11): 1083–90.

Bigelow, Henry Jacob. 1850. 'Dr Harlow's case of recovery from the passage of an iron bar through the head', *American Journal of the Medical Sciences* 3: 13–22.

Bingel, Ulrike, Vishvarani Wanigasekera, Katja Wiech, Roisin Ni Mhuircheartaigh, Michael C. Lee, Markus Ploner and Irene Tracey. 2011. 'The effect of treatment expectation on drug efficacy: Imaging the analgesic benefit of the opioid remifentanil', *Science Translational Medicine* 3(70): art. no. 70ra14.

Breivik, Harald, Beverly Collett, Vittorio Ventafridda, Rob Cohen and Derek Gallacher. 2006. 'Survey of chronic pain in Europe: Prevalence, impact on daily life, and treatment', *European Journal of Pain* 10(4): 287–333. doi:10.1016/j.ejpain.2005.06.009. Epub. 10 August 2005. PMID: 16095934.

Clayton, Martin and Ron Philo. 2012. *Leonardo da Vinci: Anatomist*. London: Royal Collection Publications. Accessed 30 June 2021. https://www.rct.uk/sites/default/files/file-downloads/Leonardo%20da%20Vinci%20Anatomist.pdf.

Denk, Franziska, Stacey McMahon and Irene Tracey. 2014. 'Pain vulnerability: A neurobiological perspective', *Nature Neuroscience* 17(2): 192–200.

Eippert, Falk, Ulrike Bingel, Eszter D. Schoell, Juliana Yacubian, Regine Klinger, Jürgen Lorenz and Christian Büchel. 2009. 'Activation of the opioidergic descending pain control system underlies placebo analgesia', *Neuron* 63(4): 533–43.

Gall, Franz Joseph. 1838. *On the Functions of the Cerebellum*. Trans. George Combe. Edinburgh: Machlachlan and Stewart.

Goldberg, Daniel S. and Summer J. McGee. 2011. 'Pain as a global public health priority', *BMC Public Health* 11(770): https://doi.org/10.1186/1471-2458-11-770.

Hippocrates. 400 BCE. *On the Sacred Disease*. Translated by Francis Adams. Accessed 19 July 2021. http://classics.mit.edu/Hippocrates/sacred.html.

Institute of Medicine (US) Committee on Advancing Pain Research, Care, and Education. 2011. *Relieving Pain in America: A blueprint for transforming prevention, care, education, and research*. Washington, DC: National Academies Press. https://doi.org/10.17226/13172.

Jezzard, Peter, Paul M. Matthews and Stephen M. Smith, eds. 2001. *Functional Magnetic Resonance Imaging: An introduction to methods*. Oxford: Oxford University Press.

McMahon, Stephen, Martin Koltzenburg, Irene Tracey and Dennis C. Turk, eds. 2013. *Wall and Melzack's Textbook of Pain*. 6th Edition. Philadelphia: Elsevier.

Penfield, Wilder and Edwin Boldrey. 1937. 'Somatic motor and sensory representation in the cerebral cortex of man as studied by electrical stimulation', *Brain* 60(1937): 389–443.

Raja, Srinivasa N., Daniel B. Carr, Milton Cohen, Nanna B. Finnerup, Herta Flor, Stephen Gibson, Francis J. Keefe, Jeffrey S. Mogil, Matthias Ringkamp, Kathleen A. Sluka, Xue-Jun Song, Bonnie Stevens, Mark D. Sullivan, Perri R. Tutelman, Takahiro Ushida and Kyle Vader. 2020. 'The revised International Association for the Study of Pain definition of pain: Concepts, challenges, and compromises', *PAIN* 161(9): 1976–82. https://doi.org/10.1097/j.pain.0000000000001939.

Segerdahl, Andrew R., Andreas C. Themistocleous, Dean Fido, David L. Bennett and Irene Tracey. 2018. 'A brain-based pain facilitation mechanism contributes to painful diabetic polyneuropathy', *Brain* 141(2): 357–64.

Shakespeare, William. (1600) 1980. *The Merchant of Venice*. In: *Shakespeare: Complete works*. London: Oxford University Press.

Soni, Anushka, Vishvarani Wanigasekera, Melvin Mezue, Cyrus Cooper, Muhammad K. Javaid, Andrew J. Price and Irene Tracey. 2019. 'Central sensitization in knee osteoarthritis: Relating presurgical brainstem neuroimaging and PainDETECT-based patient stratification to arthroplasty outcome', *Arthritis Rheumatology* 71(4): 550–60.

Toga, Arhur and John Mazziotta, eds. 2002. *Brain Mapping: The methods*. 2nd Edition. San Diego: Elsevier.

Tracey, Irene. 2010. 'Getting the pain you expect: mechanisms of placebo, nocebo and reappraisal effects in humans', *Nature Medicine* 16(11): 1277–83.

Tracey, Irene, ed. 2012. *Pain 2012 Refresher Courses: 14th World Congress on Pain*. Washington: IASP Press.

Tracey, Irene. 2017. 'Neuroimaging mechanisms in pain: from discovery to translation'. *Pain* 158 Suppl. 1 (April 2017): S115–S122.

Tracey, Irene. 2020. *Pain: A Ladybird expert book*. London: Penguin Random House.

Tracey, Irene and Patrick W. Mantyh. 2007. 'The cerebral signature for pain perception and its modulation', *Neuron* 55(3): 377–91.

Tracey, Irene, Clifford J. Woolf and Nick A. Andrews. 2019. 'Composite pain biomarker signatures for objective assessment and effective treatment', *Neuron* 101(5): 783–800.

Wiech, Katja, Markus Ploner and Irene Tracey. 2008. 'Neurocognitive aspects of pain perception', *Trends in Cognitive Science* 12(8): 306–13.

Wiech, Katja and Irene Tracey. 2009. 'The influence of negative emotions on pain: Behavioral effects and neural mechanisms', *Neuroimage* 47(3): 987–94.

Willis, Thomas. 1664. *Cerebri anatome, cui accessit nervorum descriptio et usus.* London: James Flesher, Joseph Martyn and James Allestry.

7

The formidable challenge of (MRI) invisible prostate cancer

Joseph Norris and Mark Emberton

Introduction

Widespread adoption of magnetic resonance imaging (MRI) has now elevated us from the dark ages of prostate cancer diagnosis. The introduction of transrectal ultrasound enabled us to visualise the prostate itself, but for decades, we were blind to the presence and location of cancer within the prostate. This created a dual insult of under-diagnosis (of important cancer) and over-diagnosis (of unimportant cancer). MRI has now corrected for this, by revealing what was previously invisible: the architecture, shape and size of the prostate gland, and importantly, the existence of significant tumours within. However, particular prostate cancers appear to remain invisible to MRI – and this is a real challenge. Invisible cancer poses a series of difficult questions, each warranting a collaborative, interdisciplinary response. First, mechanisms of cancer invisibility on MRI are complex and understanding these requires detailed research at the level of the scan, the radiologist, the prostate and the tumour. Second, the true clinical importance of invisible cancer remains a paramount concern: does it really matter if we cannot see it? To solve this, we must take a broader view, assessing behaviour of invisible disease over time, while exploring the factors that matter most to the patients themselves. Third, by consolidating insights achieved to date, we can address what may be the most difficult challenge of all: how do we picture the invisible?

Historical context

Throughout history, we have strived to reveal the invisible – our desire driven primarily out of curiosity or fear. We seek to find what we know

exists but cannot see, and we pursue what we believe may exist but cannot currently perceive. Often, technological innovation has been central to this search and there are many key examples, including, of course, the use of MRI to detect prostate cancer.

In 1610, the Italian astronomer Galileo Galilei looked into the night sky and dreamt of seeing the hidden details in the stars and planets that were faintly visible above (Zanatta et al. 2017). To picture previously invisible features, Galileo created a simple prototypic refractor telescope (figure 7.1). His telescope consisted of a basic arrangement of lenses that began as nothing more than optician glasses fixed to either end of a hollow cylinder. By a process of trial and error, he determined the correct lens shape, size and position needed to picture the invisible. Prior to his invention, the moon was thought to be featureless like a smooth gemstone, but with Galileo's telescope, he revealed it be 'uneven, rough, full of cavities and prominences' (Hallyn 2013, 90). The details that he and his invention revealed about space and the solar system have revolutionised the field of astronomy, and our appreciation and understanding of our position in the universe.

In 1895, Professor of Physics in Worzburg Wilhelm Roentgen made the remarkable discovery that electromagnetic radiation could be used to see inside the human body – the first time this could be done without the need for surgery or autopsy (Sternbach and Varon 1993). In a dark room, Roentgen explored the path of electrical rays from an induction coil, through a partially evacuated glass tube covered in black paper. He noticed that across the room, a screen coated in fluorescent material was being illuminated by the rays, despite the tube being covered. He extrapolated from this finding and discovered that these rays could penetrate other objects before they reached the screen and, eventually, he showed that the rays could penetrate his own wife's hand, revealing the contrast between her bones and soft tissues. When he replaced the screen with a photographic plate, he realised that this contrasting image could be captured and in doing so created the first ever X-ray. This extraordinary discovery enabled him to picture the invisible and sparked the creation of medical imaging as we know it today.

In both world wars of the twentieth century, incoming aircraft posed a significant threat and, as such, considerable effort was placed into developing early methods of detection. Despite being large and loud, enemy planes often remained invisible until it was too late; for instance, when a bombing aircraft was visible by eye, it was likely too late to institute sufficient counter-measures or evacuations (interestingly, there is a close analogy here with cancer in the human body). Some of the

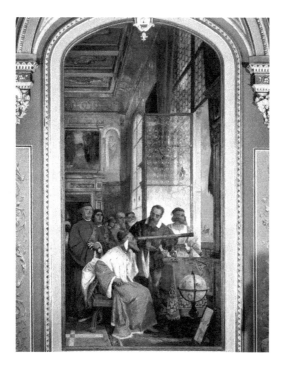

Figure 7.1 The historic use of technology to picture the invisible. Galileo constructed a simple telescope to reveal the stars and planets.

Credit: CC BY licence from ESO.org.

earliest methods of detection were known as acoustic mirrors. Passive acoustic detection was done with horns or cones that would 'catch' the vibrations as they were transmitted from the engines of distant planes. The location and distance of the incoming enemy threat was then estimated by the intensity and laterality of the incoming sound, but this was a crude test and many of the inbound aircraft remained invisible for too long. All of this changed with the advent of a new piece of detection technology – radar.

Technological pursuit of invisible threat – radar and ROC curves

During the Second World War, rapid innovations in engineering, science and technology were made in an attempt to gain advantage over enemy forces. This 'war effort' saw developments in a myriad of fields and in many ways could be credited with the creation of the science of detection

(Carter et al. 2016). As discussed, early identification of incoming (invisible) enemy vehicles was tremendously important, as the sooner these invisible threats could be identified, the better the outcome. Existing technology, whether binoculars or acoustic mirrors, were inadequate and hence a new technological solution was created in the form of radar (RAdio Detection And Ranging). In 1864, the British physicist James Clerk Maxwell described equations regarding electromagnetic wave behaviour that incorporated laws of radio wave reflection (Reid et al. 2008). Taking this theory further, the German engineer Christian Hülsmeyer later proposed that radio echoes could be used to avoid ship collisions (Blanchard 2019, 38). In 1935, Sir Robert Watson-Watt built upon these concepts and created the first working radar machine, which could emit radio waves and detect them as they returned, having 'bounced' off solid objects in the distance (Galati 2015, 88). The intention of this device was to monitor reflected waves to identify the presence, location and size of seemingly invisible incoming aggressors. As a result of Watson-Watt's pioneering work, a series (or chain) of radar stations were established all along the south and east coast of England in 1939 (figure 7.2). Among several other pertinent factors, the development of radar is considered a crucial factor in turning the tide of the Second World War.

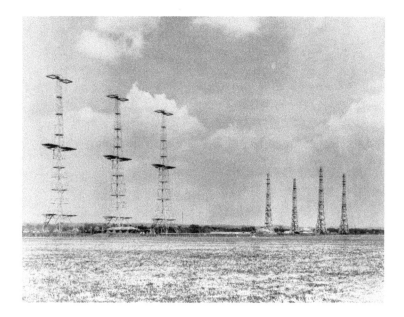

Figure 7.2 Chain Home radar stations.

Credit: IWM Non-Commercial Licence from IWM.org.uk.

In parallel with the development of radar, the science of detection and methods of assessing detection accuracy were also developed during the Second World War. The concept of the 'ROC curve' (receiver operator characteristic curve) was developed as a method of assessing the ability of radio operators to detect true incoming threats (e.g. aircraft) and distinguish these from false ones (e.g. flocks of geese). The ROC curve is plotted in a binary way, where all the 'hits' are plotted individually and a curve formed by connecting these. The higher the proportion of 'true hits' that the operator or test can identify, then the closer the curve will be to the vertical axis. In other words, the greater the amount of true positive results, then the more sensitive the test (figure 7.3). This approach to assessing the ability of a test to distinguish true signal from noise is directly applicable to diagnostic medical imaging, including MRI scans and the detection of prostate cancer, which incidentally performs excellently in this regard (Ahmed et al. 2017, 815).

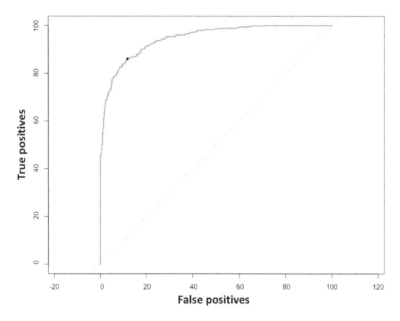

Figure 7.3 Example of a receiver operator characteristic (ROC) curve in which detection of perceived 'hits' are plotted against true 'hits' to demonstrate how accurate a method or device is at detecting the presence of real entities. This method of assessing and conveying diagnostic accuracy is used widely in medical imaging, including prostate MRI.

Credit: Mr Vasilis Stavrinides, UCL.

Visualising prostate cancer

Situated deep in the male pelvis, the prostate has been a notoriously difficult organ to image with any degree of accuracy. The goal of picturing early cancer within the prostate has proved to be an even greater challenge, which has taken several decades to overcome.

For centuries, the only real way of viewing the prostate was either to reveal it with major surgery (e.g. during radical prostatectomy) or with cadaveric dissection in the deceased. In 1957, John Wild and John Reid first posited the concept of transrectal ultrasound imaging, however, at this time, the technology was only at a basic developmental stage with only the rectal wall contours being visualised (Watanabe 2017, S207). In 1967, the first clinically applicable ultrasound device was released for imaging the oesophagus (Watanabe 2017, S207). This device was then adapted to finally reveal what had been invisible until that point, the human prostate. Ultrasonic images of the prostate delivered useful information such as gland volume and approximate anatomy (figure 7.4). However, disappointingly, ultrasound images did not adequately identify cancer within the prostate. Even with advanced ultrasound techniques (e.g. microultrasound, contrast ultrasound, elastography or histo-scanning), the utility of this approach in locating prostate cancer appears to be limited (Simmons 2019, 261).

The use of MRI for cancer diagnosis began in 1971, using rodents as test subjects (Damadian 1971, 1151), but it was not until 1982 that John Steyn and Francis Smith performed the first MRI study of the human prostate (Steyn and Smith 1982, 726). The image quality at this stage was poor with the prostate barely discernible from the surrounding organs. Since then, further developments have occurred that have transformed this technology (figure 7.5). The introduction of higher strength MRI magnets, phased-array coils, newer 'sequences' (including dynamic contrast sequences, diffusion sequences and spectroscopic imaging) has now positioned MRI as the most accurate diagnostic imaging modality for this disease.

To test the accuracy of MRI for the diagnosis of prostate cancer, we have conducted several high-impact clinical trials and the results of these trials have been transformative for modern urology. PROMIS (Prostate MRI Imaging Study) (Ahmed et al. 2017, 815) was a pivotal clinical trial in which MRI and traditional transrectal biopsy were both compared against a reference standard (a 'mapping biopsy' in which prostates were sampled at every 5 mm to reveal whether cancer was present or not, without removing the whole prostate) to establish diagnostic accuracy for

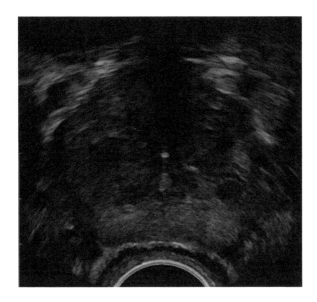

Figure 7.4 Transrectal ultrasound image of the prostate (axial view). The prostate is the large dark-grey round structure that fills most of the image. While the prostate itself is visible, we cannot identify tumours within gland. The ultrasound probe is the smooth, curved object at the bottom of the frame.

Credit: Mr Clement Orczyk, UCL.

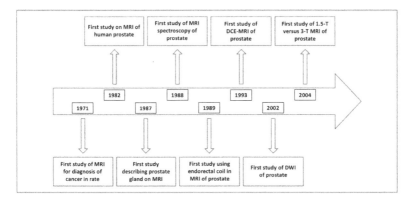

Figure 7.5 Timeline of the key stages in the development of prostate MRI. Giganti et al. 2019.

Credit: © American Roentgen Ray Society, 2019.

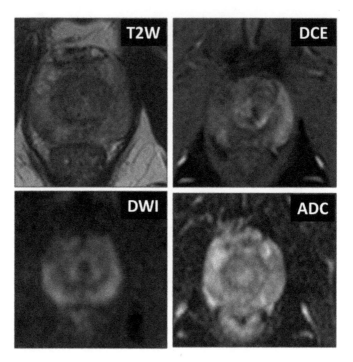

Figure 7.6 Multiparametric MRI images of the prostate with a significant right peripheral zone tumour (on these images, cancer is located in the bottom left corner of the prostate). T2-weighted sequence demonstrating the general anatomy of the gland and tumour (top left panel). Contrast-enhanced sequence demonstrating the increased tumour vasculature (top right panel). Diffusion sequences (bottom two panels) demonstrating the increased tumour tissue density.

Credit: Mr Joseph Norris, UCL.

both modalities. The results were staggering when considering 'significant' prostate cancer (that being disease that is likely to affect the quality or quantity of life). MRI was able to detect over 90 per cent of this disease, whereas transrectal ultrasound biopsy was only able to detect 50 per cent (Ahmed et al. 2017, 815). The findings of the PROMIS study were then tested in the PRECISION trial (Kasivisvanathan et al. 2018, 1767), a randomised controlled trial in which men with suspected prostate cancer either underwent traditional 'systematic' transrectal biopsy or an MRI-targeted biopsy, in which biopsies were only taken from tumours that were seen on their pre-biopsy MRI. PRECISION demonstrated the power of MRI as a diagnostic tool for prostate cancer. First, fewer men actually needed a biopsy (only men who had suspicious

findings on MRI were biopsied), and then second, men who underwent MRI-targeted biopsy only had higher rates of detection of significant cancer and lower rates of detection of insignificant disease.

The success of prostate MRI can partly be attributed to the 'multi-parametric' approach that is used. With a multiparametric approach, the prostate is visualised in multiple ways (figure 7.6) before a radiologist conducts an assessment of each sequence in tandem to generate an overall impression for the suspicion level for the presence of prostate cancer. Each sequence theoretically examines the prostate tumour in a different, complimentary way, and if a lesion appears to be suspicious in the same location on multiple sequences, then this raises the possibility of malignancy.

Despite the huge developmental steps that have been made in the field of prostate MRI, there are still barriers to overcome. These include, but are not limited to, the dissemination of technology, standardisation of acquisition and reporting, quality control, radiological training, reduction of false positive MRI, and importantly, tackling undetectable (invisible) disease (Norris et al. 2020a).

Invisible prostate cancer

Defining the problem

All diagnostic tests for cancer will 'miss' a spectrum of disease. The amount of disease undetected, of course, depends on the disease, the test and the tolerance (or threshold) that is set for the definition of a hit or a miss. MRI scans for prostate cancer have a fine sensitivity with the proportion of true positive results being very high. In the PROMIS trial, the sensitivity of MRI for detection of 'significant' prostate cancer was very impressive: 93 per cent. In the PICTURE trial, in which the men with previous transrectal biopsy were scanned with MRI and re-biopsied, the sensitivity of MRI was even higher at 97.1 per cent (Simmons 2017, 1159). In the real clinical setting, around 80–90 per cent of the important prostate cancers are detected by MRI, with the implication that around 10–20 per cent of cancers remain invisible (Norris et al. 2019a, 340).

But what is currently known about these inconspicuous tumours? By looking at the results of research trials from recent years, it is possible to begin to define and understand the issue of invisible cancer. In the PROMIS trial, cancers that were not detected by MRI tended to be significantly smaller than those that were detected (figure 7.7, bottom).

Figure 7.7 In the PROMIS trial, prostate cancer that was invisible to MRI (red bars) was significantly less aggressive (top) and smaller (bottom) than prostate cancer that was detected (blue bars).

Credit: Mrs Lina Carmona Echeverria.

The limits of spatial resolution of MRI likely account for this, as small tumours will, at a certain volume, fall below the detectable limits of an MRI scanner. Second, the tumours that were undetected by MRI were significantly less aggressive (Norris et al. 2020b, e1243) than those that were detected (figure 7.7, top). This intriguing finding may be due to innate aspects of MRI physics. Aggressive prostate cancer tumours tend to be vascular structures, composed of densely clustered cells, which may render them visible on MRI. But there is much more to the story of invisible prostate cancer than just size and aggressivity.

Characterising the disease

To gain a holistic understanding of MRI-invisible prostate cancer, it is necessary to examine it at every possible level from the molecular to the microscopic, and from the individual patient to the population as a whole.

Figure 7.8 List of genes associated with conspicuity of prostate cancer on MRI.

Credit: Image used courtesy of Benjamin Simpson, UCL.

When visible and invisible cancers are compared, it is possible to find that the two entities differ in many ways, and this extends all the way to the smallest biological units of the genes (i.e., the 'coding' for living things, including cancer). We have already discussed how prostate cancer that is invisible on MRI tends to be smaller and lower grade and this trend of invisible cancer being 'lower risk' seems to also be reflected at the genetic level as well, with visible tumours being enriched with genes that are associated with aggressive prostate cancer (Norris et al. 2019a, 340). Through a unique bioinformatic approach (Norris et al. 2020c, 3), we have analysed large publicly available gene databases to create a specific list of genes that are associated with tumour visibility/invisibility (figure 7.8). This list is impressive as it now gives us an opportunity to link genes to biological processes (e.g. cell growth) and then link these to conspicuity on MRI. Furthermore, these genes could represent potential 'targets' to be focused on in order, potentially, to develop tests to help elucidate invisible disease.

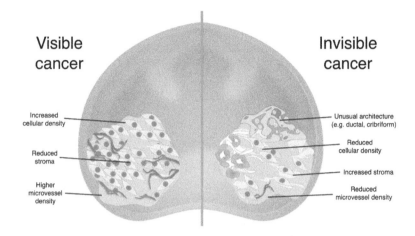

Figure 7.9 Key features of MRI-invisible versus MRI-visible prostate cancer at the histopathological level.

Credit: Benjamin Simpson, UCL.

Beyond the genetic code of invisibility, it seems that invisible disease is also differentiated from visible disease at a cellular level (figure 7.9). Prostate cancer that is inconspicuous on MRI tends to have lower density of cells and blood vessels (figure 7.10). Theoretically, it is possible to link the reduced density of invisible tumours to potential methods through which they avoid detection (Norris et al. 2020d, 2). Part of the prostate MRI process depends on the measurement of the diffusion of water, with the assumption that tumours tend to be denser and, as such, usually have

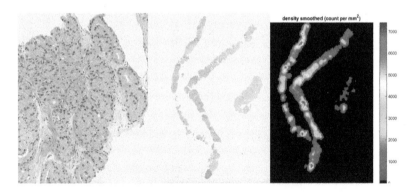

Figure 7.10 Prostate biopsy slides from MRI-invisible cancer (left). Heat-mapped cell density of the same biopsy (right).

Credit: Mr Joseph Norris, UCL.

Figure 7.11 Position in the clinical pathway in which men's views are surveyed on the accuracy of MRI.

Credit: Mr Joseph Norris, UCL.

restricted amounts of water diffusion. Tumours with lower cellular density may be more likely to be invisible as the diffusion of water in these tumours will be less restricted and more like the state of normal prostate tissue. In a similar way, another aspect of the prostate MRI process relies upon a type of dye (gadolinium, a contrast-agent) that is injected into the bloodstream and is taken up more strongly by cancer cells due to a higher number of vessels (and leaky vessels) in tumours. As such, cancers with lower vessel density may be harder to identify, with lower contrast uptake compared to densely vascularised tumours.

Until now, the views of our patients have been neglected, particularly with regards to MRI-invisible prostate cancer. The introduction and use of MRI in the prostate cancer diagnostic pathway represents a significant change to the traditional approach to diagnosis, and the men who experience this novel approach have not yet been consulted on this change. To address this, current studies are engaging men who have been referred with suspected prostate cancer to give their views on this topic after they have attended the prostate cancer assessment clinic (figure 7.11) (Norris et al. 2020e, 3).

Despite the 'new' challenge that MRI creates (without MRI there would be no such thing as MRI-invisible prostate cancer), it appears that men with suspected cancer are highly supportive of this novel technology. The vast majority of men perceive the accuracy of prostate MRI as 'very good', and none found it to be 'poor' or 'very poor' (Norris et al. 2019b, 2203). Men expressed little or no concern that MRI might miss a proportion of prostate cancer (figure 7.12).

Finally, in order to examine the extent to which men with suspected prostate cancer would be willing to tolerate the possibility of invisible prostate cancer, they were asked whether they would want to have a

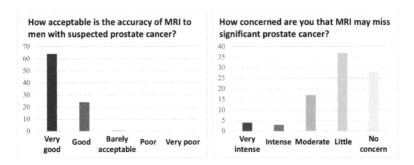

Figure 7.12 Acceptability of diagnostic accuracy of MRI (left). Levels of concern regarding MRI-invisible cancer (right).

Credit: Mr Joseph Norris, UCL.

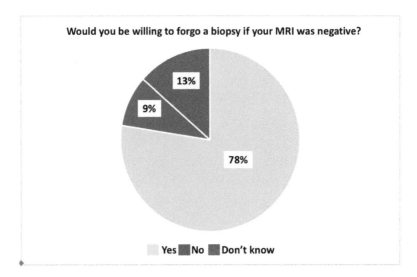

Figure 7.13 Acceptance from men to forgo biopsy in the case of 'normal' prostate MRI.

Credit: Mr Joseph Norris, UCL.

biopsy if their MRI scan appeared to be normal, that is, with no visible cancer. The results were striking – almost 80 per cent of men responded by saying that they would be happy to forgo a biopsy if the MRI scan appeared to be normal (figure 7.13), which conveys the faith that patients have in both the accuracy of this new technology, and potentially their trust in the limited lethality of invisible cancer.

Once it is acknowledged that invisible disease exists, an obvious question arises – how can we find the invisible?

Revealing the invisible may come through technological advancement of our imaging hardware and software. One such example is 'hyperpolarised MRI' scanning (figure 7.14, left). Hyperpolarised MRI works by monitoring the metabolism of molecules within the body. Research conducted in mice has shown that hyperpolarised lactate appears to generate a stronger MRI 'signal' in cancer tissue, compared to normal tissue, which also appears to reduce after cancer treatment (Chen et al. 2007, 1099). Similarly, in humans, early work has suggested that areas of biopsy-proven prostate cancer demonstrate elevated levels of hyperpolarised pyruvate (a molecule that enables us to monitor how the body breaks down sugars), thus generating increased MRI signal compared to benign tissue (Nelson et al. 2013, 2). Using this technology, it may be possible to exploit the metabolism of invisible tumours and potentially render them visible with hyperpolarisation. Another novel MRI approach is 'luminal water imaging' (LWI; figure 7.14, right). LWI uses an existing MRI sequence and generates additional information about the different types of tissue present in the prostate including the 'lumen' (i.e. the gaps or holes in the tissue). LWI suffers less artefact (i.e., 'noise' on the scan that might distract the radiologist from making the correct diagnosis) than other MRI techniques and is highly accurate at differentiating malignant and non-malignant tissue (Devine et al. 2019, 910). Again, by utilising an advanced imaging technique such as

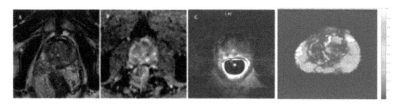

Figure 7.14 New MRI techniques may help us to see what we currently cannot. Hyperpolarised MRI scans (left three panels) reveal previously invisible details about the 'metabolism' within the prostate and may help us to find invisible cancer. Similarly, luminal water MRI scans (right panel) help illustrate hidden aspects of tissue architecture of the prostate, which could help us to identify tumours.

Credit: Professor Shonit Punwani, UCL.

LWI, we may find that tumours that are invisible to traditional MRI, may in fact become visible as our technology improves.

While LWI and hyperpolarised imaging may offer hope for the future, there are still many steps to go before they can be brought into the regular clinic. It is reassuring then, that there are some simple techniques that can be used to help us find these cancers, without the need for extensive further research. One such example is 'PSA density' (PSAD). PSAD is calculated by taking the PSA level of an individual (a common blood test used to screen for prostate cancer) and dividing this value by the size of his prostate (which can be calculated using an MRI scan). We found that if a 'PSAD threshold' of 0.15 ng/mL/cc was applied to men with invisible prostate cancer in the PROMIS study, it was possible to reduce the proportion of missed significant cancer to just 5 per cent

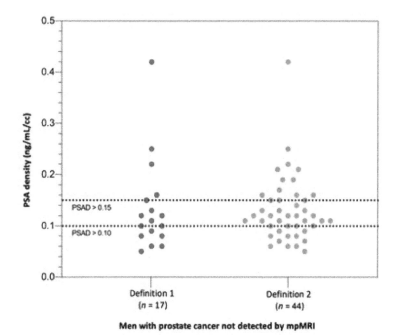

Figure 7.15 Applying a 'radiological biomarker' such as PSA density (in other words, the amount of PSA for the given prostate size) may help to reduce the proportion of invisible disease. This example is taken from patients in the PROMIS study. Each point represents a man with invisible prostate cancer – if we apply a PSA density threshold (above which a biopsy should be performed) then all men above the dotted line would, in theory, have their cancer detected by a biopsy.

Credit: Mr Joseph Norris, UCL.

(figure 7.15). This is exciting, as it means we can make MRI an even more effective test for prostate cancer, in a very simple way.

However, it is possible that a proportion of MRI-invisible cancers will never truly be visible to the human eye or scanner, but we may still find them through other means. Bodily fluids (e.g. blood, urine or semen) are easily obtained from men with suspected prostate cancer and there is currently a concerted scientific effort to identify proteins and genes in these fluids that are associated with the presence of cancer (Pepe 2020, 393). One day, we may be able to develop a test with these bodily fluids to help us reveal the hidden prostate cancer in men with seemingly 'normal' MRI scans.

Finally, and perhaps most controversially, it is important to raise the question of whether we always need to reveal the invisible? The combined results of the PROMIS study (Ahmed et al. 2017, 815) and the SPCG-4 trial (Bill-Axelson et al. 2018, 2319) offer interesting insights. In the recent long-term update of the Swedish SPCG-4 randomised controlled trial of watchful waiting compared to radical prostatectomy for prostate cancer, Bill-Axelson and colleagues found that after 29 years, 'intermediate risk' prostate cancer (i.e. Gleason score 3+4) was not associated with prostate-cancer-related death. In contrast, 'high risk' prostate cancer (i.e. Gleason score 4+3 or worse) was associated with prostate-cancer-related death. Given the results of the PROMIS trial, in which no men with overall Gleason 4+3 prostate cancer had MRI-invisible disease, it suggests that MRI may visualise all truly significant cancer (if SPCG-4 is used to guide the threshold). This is exciting and raises the possibility that disease invisibility may, in fact, be useful, to help avoid unnecessary diagnoses and treatment.

Conclusion

The advent of multiparametric prostate MRI has transformed the manner in which it is possible to diagnose and treat prostate cancer, through accurate visualisation of the most aggressive disease even before a biopsy is performed. However, introduction of this novel technology has created several unexpected challenges, the most prominent of which is understanding the entities that we do not see. Multilevel characterisation of MRI-invisible prostate cancer will enable us to fully appreciate the nature of inconspicuous disease and potentially allow us to develop strategies to eventually picture the invisible. Furthermore, longitudinal analyses of clinical and MRI data may, in fact, reveal that it is actually useful to have a spectrum of disease that we cannot see, indeed, there may be utility in invisibility.

Acknowledgements

Thank you very much to Mr Vasilis Stavrinides for providing figure 7.3, Mr Clement Orczyk for providing figure 7.4, Dr Francesco Giganti for providing figure 7.5, Mrs Lina Carmona Echeverria for assistance with figure 7.7, Benjamin Simpson for assistance with figures 7.8 and 7.9, and Professor Shonit Punwani for the MRI sequences in figure 7.14. Thank you for additional supervision from Dr Hayley Whitaker, Dr Alex Freeman, Mr Veeru Kasivisvanathan and Professor Daniel Kelly.

References

Ahmed, Hashim U., Ahmed El-Shater Bosaily, Louise C. Brown, Rhian Gabe, Richard Kaplan, Mahesh K. Parmar, Yolanda Collaco-Moraes, Katie Ward, Richard G. Hindley, Alex Freeman, Alex P. Kirkham, Robert Oldroyd, Chris Parker and Mark Emberton. 2017. 'Diagnostic accuracy of multi-parametric MRI and TRUS biopsy in prostate cancer (PROMIS): A paired validating confirmatory study', *Lancet* 389(10071): 815–22.

Bill-Axelson, Anna, Lars Holmberg, Hans Garmo, Kimmo Taari, Christer Busch, Stig Nordling, Michael Häggman, Swen-Olof Andersson, Ove Andrén, Gunnar Steineck, Hans-Olov Adami and Jan-Erik Johansson. 2018. 'Radical prostatectomy or watchful waiting in prostate cancer – 29-year follow-up', *New England Journal of Medicine* 379(24): 2319–29.

Blanchard, Yves. 2019. 'Une histoire du radar en lien avec les mutations du système technique', *Revue de l Electricité et de l Electronique* 2: 35–46.

Carter, Jane V., Jianmin Pan, Shesh N. Rai and Susan Galandiuk. 2016. 'ROC-ing along: Evaluation and interpretation of receiver operating characteristic curves', *Surgery* 159(6): 1638–45.

Chen, Albert P., Mark J. Albers, Charles H. Cunningham, Susan J. Kohler, Yi-Fen Yen, Ralph E. Hurd, James Tropp, Robert Bok, John M. Pauly, Sarah J. Nelson, John Kurhanewicz and Daniel B. Vigneron. 2007. 'Hyperpolarized C-13 spectroscopic imaging of the TRAMP mouse at 3T-initial experience', *Magnetic Resonance in Medicine* 58(6): 1099–106.

Damadian, Raymond. 1971. 'Tumor detection by nuclear magnetic resonance', *Science* 171: 1151–3.

Devine, William, Francesco Giganti, Edward W. Johnston, Harbir S. Sidhu, Eleftheria Panagiotaki, Shonit Punwani, Daniel C. Alexander, and David Atkinson. 2019. 'Simplified luminal water imaging for the detection of prostate cancer from multiecho T2 MR images', *Journal of Magnetic Resonance Imaging* 50(3): 910–7.

Galati, Gaspare. 2015. '100 years of radar', Cham, Switzerland: Springer, p. 88.

Giganti, Francesco, Andrew B. Rosenkrantz, Geert Villeirs, Valeria Panebianco, Armando Stabile, Mark Emberton and Caroline M. Moore. 2019. Adapted from 'The evolution of MRI of the prostate: The past, the present, and the future', *The American Journal of Roentgenology* 213(2).

Hallyn, Fernand. 2013. 'Metaphor and analogy in the sciences. Volume 1 of origins: Studies in the sources of scientific creativity', Dordrecht, Netherlands: *Springer Science & Business Media*, p. 90.

Kasivisvanathan, Veeru, Antti S. Rannikko, Marcelo Borghi, Valeria Panebianco, Lance A. Mynderse, Markku H. Vaarala, Alberto Briganti, Lars Budäus, Giles Hellawell, Richard G. Hindley, Monique J. Roobol, Scott Eggener, Maneesh Ghei, Arnauld Villers, Franck Bladou, Geert M. Villeirs, Jaspal Virdi, Silvan Boxler, Grégoire Robert, Paras B. Singh, Wulphert Venderink, Boris A. Hadaschik, Alain Ruffion, Jim C. Hu, Daniel Margolis, Sébastien Crouzet, Laurence Klotz, Samir S. Taneja, Peter Pinto, Inderbir Gill, Clare Allen, Francesco Giganti, Alex Freeman, Stephen Morris, Shonit Punwani, Norman R. Williams, Chris Brew-Graves, Jonathan Deeks, Yemisi Takwoingi, Mark Emberton and Caroline M. Moore. 2018. 'MRI-targeted or standard biopsy for prostate-cancer diagnosis', *New England Journal of Medicine* 378(19): 1767–77.

Nelson, Sarah J., John Kurhanewicz, Daniel B. Vigneron, Peder E. Z. Larson, Andrea L. Harzstark, Marcus Ferrone, Mark van Criekinge, Jose W. Chang, Robert Bok, Ilwoo Park, Galen Reed, Lucas Carvajal, Eric J. Small, Pamela Munster, Vivian K. Weinberg, Jan Henrik Ardenkjaer-Larson, Albert P. Chen, Ralph E. Hurd, Liv-Ingrid Odegardstuen, Fraser J. Robb, James Tropp

and Jonathan A. Murray. 2013. 'Metabolic imaging of patients with prostate cancer using hyperpolarized [1-^{13}C]pyruvate', *Science Translational Medicine* 5(198): https://doi.org/10.1126/scitranslmed.3006070.

Norris, Joseph M., Benjamin S. Simpson, Marina A. Parry, Veeru Kasivisvanathan, Clare Allen, Rhys Ball, Alex Freeman, Daniel Kelly, Alex Kirkham, Hayley C. Whitaker and Mark Emberton. 2019a. 'Genetic correlates of prostate cancer visibility (and invisibility) on multiparametric MRI: It's time to take stock', *British Journal of Urology International* 125(3): 340–42.

Norris, Joseph M., Veeru Kasivisvanathan, Hayley Whitaker, Maneesh Ghei, Daniel Kelly and Mark Emberton. 2019b. 'Investigating men's perceptions on the use of multiparametric MRI for the diagnosis of prostate cancer', *European Journal of Surgical Oncology* 45(11): 2203.

Norris, Joseph M., Adam Kinnaird, Daniel J. Margolis, Anwar R. Padhani, Jochen Walz and Veeru Kasivisvanathan. 2020a. 'Developments in MRI-targeted prostate biopsy', *Current Opinion in Urology* 30(1): 1–8.

Norris, Joseph, Lina Carmona Echeverria, Simon Bott, Louise Brown, Nicholas Burns-Cox, Timothy Dudderidge, Ahmed El-Shater Bosaily, Elena Frangou, Alex Freeman, Maneesh Ghei, Alastair Henderson, Richard Hindley, Richard Kaplan, Alex Kirkham, Robert Oldroyd, Christopher Parker, Raj Persad, Shonit Punwani, London, United Kingdom; Derek Rosario, Iqbal Shergill, Vasilis Stavrinides, Mathias Winkler, Hayley Whitaker, Hashim Ahmed and Mark Emberton. 2020b. 'Which prostate cancers are overlooked by mpMRI? An analysis from PROMIS', *Journal of Urology* 203: e1243–4.

Norris, Joseph M., Benjamin S. Simpson, Marina A. Parry, Clare Allen, Rhys Ball, Alex Freeman, Daniel Kelly, Alex Kirkham, Veeru Kasivisvanathan, Hayley C. Whitaker and Mark Emberton. 2020c. 'The genetic landscape of prostate cancer conspicuity on multiparametric MRI: A protocol for a systematic review and bioinformatic analysis', *BMJ Open* 10(1): e034611.

Norris, Joseph M., Lina M. Carmona Echeverria, Benjamin S. Simpson, Clare Allen, Rhys Ball, Alex Freeman, Daniel Kelly, Alex Kirkham, Veeru Kasivisvanathan, Hayley Whitaker and Mark Emberton. 2020d. 'Prostate cancer visibility on multiparametric magnetic resonance imaging: High Gleason grade and increased tumour volume are not the only important histopathological features', *British Journal of Urology International*. https://doi:10.1111/bju.15085.

Norris, Joseph M., Veeru Kasivisvanathan, Clare Allen, Rhys Ball, Alex Freeman, Maneesh Ghei, Alex Kirkham, Hayley Whitaker, Daniel Kelly and Mark Emberton. 2020e. 'Exploring patient views and acceptance of multiparametric magnetic resonance imaging for the investigation of suspected prostate cancer (the PACT study): A mixed-methods study protocol', *Methods and Protocols* 3(2): 1–11.

Pepe, Pietro, Giuseppe Dibenedetto, Ludovica Pepe and Michele Pennisi. 2020. 'Multiparametric MRI versus SelectMDx accuracy in the diagnosis of clinically significant PCa in men enrolled in active surveillance', *In Vivo* 34(1): 393–6.

Reid, John S., Charles H. T. Wang and J. Michael T. Thompson. 2008. 'James Clerk Maxwell 150 years on', *Philosophical Transactions of the Royal Society A*: 366(1871): 1651–9.

Simmons, Lucy A. M., Abi Kanthabalan, Manit Arya, Tim Briggs, Dean Barratt, Susan C. Charman, Alex Freeman, James Gelister, David Hawkes, Yipeng Hu, Charles Jameson, Neil McCartan, Caroline M. Moore, Shonit Punwani, Navin Ramachandran, Jan van der Meulen, Mark Emberton and Hashim U. Ahmed. 2017. 'The PICTURE study: Diagnostic accuracy of multiparametric MRI in men requiring a repeat prostate biopsy', *British Journal of Cancer* 116(9): 1159–65.

Simmons, Lucy A. M., Abi Kanthabalan, Manit Arya, Tim Briggs, Susan C. Charman, Alex Freeman, James Gelister, Charles Jameson, Neil McCartan, Caroline M. Moore, Jan van der Meulen, Mark Emberton and Hashim U. Ahmed. 2019. 'Prostate Imaging Compared to Transperineal Ultrasound-guided biopsy for significant prostate cancer Risk Evaluation (PICTURE): A prospective cohort validating study assessing Prostate HistoScanning', *Prostate Cancer and Prostatic Diseases* 22(2): 261–7.

Sternbach, George and Joseph Varon. 1993. 'Wilhelm Konrad Roentgen: A new kind of rays', *The Journal of Emergency Medicine* 11(6): 743–5.

Steyn, John. H., and Francis W. Smith. 1982. 'Nuclear magnetic resonance imaging of the prostate', *British Journal of Urology* 54: 726–72.

Watanabe, Hiroki. 2017. 'History of transrectal ultrasound (TRUS)', *Ultrasound in Medicine and Biology* 43(supplement 1): https://doi.org/10.1016/j.ultrasmedbio.2017.08.1708.

Zanatta, Alberto, Fabio Zampieri, Cristina Basso and Gaetano Thiene. 2017. 'Galileo Galilei: Science vs. faith', *Global Cardiology Science and Practice* 2: 10.

Absence and voids

8

The fragmentary exhibition

Tactics towards making architecture visible

Owen Hopkins

Contrasting the experience of a work of art with a work of architecture, Walter Benjamin, in 1935, observed that 'Architecture has always represented the prototype of a work of art, the reception of which is consummated by a collectivity in a state of distraction' (1999, 232). Over 80 years later, this statement is truer than ever. Architecture is *seen* but rarely *discerned*, perceived as backdrop rather than as something more active, 'there' but also invisible. When architecture does become visible, it frequently does so as image or spectacle, whether in the form of the iconic building, or as heritage cum visitor attraction. When architecture enters public discourse, it typically does so in highly polarised terms: 'good' or 'bad', 'beautiful' or 'ugly', or simply 'old' and 'new'. The result of this limited engagement is the exclusion of the public from the systems, networks and economies that ultimately determine what gets built, where and, to an increasingly large extent, what form a building takes.[1]

Architecture and the aura

This chapter addresses the realm of exhibitions and other curatorial practices as an area of cultural production where architecture has come decisively into view. Recent years have seen a proliferation of architecture exhibitions, installations, events and biennials of all types.[2] It is clearly reductive to ascribe a common set of motivations or even posit a general trend to explain a phenomenon so global in its extent. Yet, it is hard not to see the prevalence of this type of activity as a reaction to the architectural profession's diminished status, at least since the post-war

era when architects were central to the societal transformations of that moment, notably the creation of the welfare state. Connected to this has been the decades long homogenisation of architectural production, partly through globalisation, with the genuinely radical or innovative ever more marginalised from actual building production. The latter aspect of the present situation has arguably directly led to one of the most notable characteristics of the increase of architectural exhibitions and other cultural initiatives, that is, projects where the exhibition itself is conceived as a work of architecture.

This chapter begins with a brief critical analysis of these types of projects, focusing in particular on the disjuncture between their aims and implications. This provides the starting point for posing a new theorisation for exhibitions of architecture, which re-conceives them in terms of intervention – both spatial and temporal – as opposed to more traditional notions of the set-piece. From this theorisation, this chapter poses several curatorial tactics that work towards heightening awareness of architecture both in the context of the exhibition and wider world – with the aim of making the invisible visible.

While the prevalence of the 'exhibition as architecture' is certainly related to present concerns, curatorial or otherwise, these types of projects also attempt the negation of one of the recurrent, even clichéd, criticisms of architecture exhibitions: that they are always compromised because they can never show the finished work of architecture. The 'real thing' (i.e. a building), this view contends, is always absent, leaving the exhibition visitor forced to try to comprehend it through representations. Underlying this position is the enduring importance of the notion of the aura, and of the 'original' object, whose power depends, to cite Benjamin again, upon 'its presence in time and space, its unique existence at the place where it happens to be' (1999, 214).

So, when it comes to the display of architecture, if one conceives the auratic original to be a building, then it is inescapably absent from an exhibition. If, moreover, that display contains the typical repertoire of objects – drawings, models, photographs, films, furniture, material samples, prototypes – that tend to populate architecture exhibitions, then the characteristics that create the aura are not just absent but inverted.

Setting aside issues of content, on a structural level, when an auratic work of art is put on display, one of the chief assumptions that governs how it is presented is that the connections of the work of art to the wider world – both the one that created it and the one in which it exists in now – are usually secondary to our experience of the object itself. When

inspecting an architectural drawing or model, in contrast, our focus always extends beyond the object to its referent, which is ultimately the building or project to which it relates. The object in a sense signifies the absence of the building.

Of course, architectural objects can be auratic in their own right, but the point is that their representational qualities outweigh that status. When we look at objects in an architecture exhibition, our experience and understanding of them are shaped by what the object points to as a signifier, representation, or kind of conduit, to the wider networks of ideas, processes and contexts that determine how we might understand a work of architecture.

Every exhibition is a synthesis of some kind and it is far too simplistic to try to draw a clear line between architecture exhibitions that deal mostly in representations and those that aim in some way to be architecture itself. However, it is not unreasonable to suggest that pavilions, installations and structures that have been commissioned for the purposes of exhibition or display represent a concerted attempt to break down the practical and conceptual barriers between architecture and its display, to take the representation out of the equation, and present unmediated architecture itself. Thus, what is on display is very often intended to qualify as a work of architecture in its own right: the exhibition itself becomes architecture. Architecture becomes visible.

Cultural implications

In the narrow terms of negating absence, these types of projects are undeniably successful, with the added benefit of often appealing to a wider audience than would otherwise be interested in more conventional architecture exhibitions. However, the implications of this approach are far from universally positive and arguably even counterproductive in achieving the underlying aim of engaging a public audience with architecture more broadly.

First, the concept of the aura was articulated by Benjamin in relation to art, rather than architecture. One of the by-products of an exhibition of architecture conceived in those terms, even if implicitly (that is, an exhibition *of* rather than *about* architecture), is that architecture becomes just another form of sculpture. Here, architecture is recast in a conservative and potentially even reactionary manner as the on-off or bespoke building as object, rather than as part of everyday experience, which is where its impact for good or ill is felt strongest.

Second, the notion that pavilions, installations and structures actually constitute real works of architecture is at best partial and at worst entirely misleading. All projects of this nature are time-limited and highly constrained by budget, so very often what we experience is not architecture at all but its simulacrum, held together by all manner of trickery, fakery or some element of the stage set. This also extends to the types of practices invited to realise such projects. Without a proper fee, these opportunities are only available to practices able to support themselves through other means rather than being open to everyone.

Third, one of the chief upsides of the auratic architecture exhibition is, as already noted, their accessibility to a wide audience. No specialist training or knowledge is required to move through and experience a set of spaces, in contrast to trying to understand them on a plan or elevation. Yet, the reliance on the spectacular object or experience risks draining out the intellectual content of an exhibition, resulting in something ultimately shallow and superficial. Spectacle might help drive an audience to an exhibition, but may end up exacerbating the lack of engagement with architecture and the built environment.

Given the examples explored above, it may be reasonably questioned to what degree absence is inherent to all architecture exhibitions and whether the traditional model, where the building is unavoidably elsewhere and we are left dealing with representations, or if the architecture is claimed to be present, what we experience actually exists as something other than architecture: stage-set or spectacle.

The following part of this chapter poses a counter-narrative to this suggestion, putting forward a new theorisation of curating architecture that takes a hybrid approach with the aim of making architecture present rather than absent, visible rather than invisible, both in the context of the exhibition and our experience of the wide world.

This approach conceives architectural exhibitions not as singular and tightly delineated spatial and temporal entities but as interventions into the settings in which they are staged and situated. Critical to this is the way the exhibition is not limited to the intervention itself; instead it exists as a hybrid of the intervention and setting, re-casting the latter from a passive container or platform into a fundamental part of the experience. Everything the visitor experiences – from an architectural model, to the fire extinguisher in the corner of the room – is lifted out of invisibility, becomes 'on display' and is subject to the heightened sensibility that we bring to exhibitions. Much of the inspiration for this theorisation comes from my own, largely intuitive experience of situating exhibitions in historic settings, a mode of practice that is rather more familiar in the field of contemporary art.

Artistic contexts

Working in the context of historic settings or institutions has been a familiar strand of contemporary art practice since the 1970s. Emerging in part from minimalist and conceptual art strategies of shifting the viewer's focus towards, and thereby activating, the 'contained' space that both the work and viewer inhabit, this practice has frequently been directed towards museums and collections. As Martha Buskirk has noted, 'The strategy of inviting artists who have made collection and display practices the subject of their work into the museum, not just to create a site-specific installation in the space but to work with the collection itself, is one that became increasingly common in the 1980s and 1990s' (2005, 178).

Among the most notable and influential projects of this type is Fred Wilson's *Mining the Museum* at the Maryland Historical Society, Baltimore, in 1992. The project saw Wilson present objects from the collection in ways that brought to the fore narratives – principally concerning African American histories and race relations – that were overlooked or intentionally excluded from existing displays and interpretation. As Buskirk has described in consideration of the relationship of projects such as Wilson's to conceptual art practices,

> If it was conventions associated with museum and gallery display that initially allowed artists to point to everyday objects and identify them as art, an expanded definition of the work has now been taken up and used by artists to point outward in ways that heighten perception of the world at large.
>
> (2005, 208)

The notion of the referent being the broader 'world at large' is now a well-developed aspect of the scholarship around these practices in museums, institutional settings and, increasingly, historic houses. A notable feature of the latter is a focus towards groups and narratives that have been marginalised and/or excluded from standard discourses around historic houses such as issues of class, race and LGBTQ identities.[3] While these types of projects are becoming more frequent, culturally focused approaches also remain prevalent, where the houses operate essentially as non-conventional venues for already existing work rather than as drivers for new projects, with the programmes at Blenheim Place and Chatsworth among the best known in the UK.[4]

In consideration of this type of practice from the perspective of architecture, while the discourse around curating architecture is well developed,[5] there has been little academic research on architects and

architectural interventions in historic settings, whether domestic or institutional. This is despite the growing prominence of these types of practice, for example, in the contemporary programme at Peter Salter's houses at Walmer Yard in West London,[6] the biennial pavilion programme at the Dulwich Picture Gallery, or in exhibition projects such as *PHANTOM. Mies as rendered society* by Andrés Jacque, which was staged over 2012–13 in the re-created Barcelona Pavilion at the Fundació Mies van der Rohe.[7]

Exhibition as fragment

In the absence of a rigorous theorisation of this mode of curatorial practice within the field of architecture, I have looked to the work of Paul Ricoeur and, in particular, his subtle yet profound distinction between 'history' and 'the past'. History, we might say, is not simply the study of the past, but its assimilation, principally through documents, records and other evidence, into discourse. The past itself is ultimately unrecoverable, yet is 'represented' through these historical artefacts that enter into discourse. Central here is Ricoeur's notion of the 'trace', the concept he applied to these artefacts. As he wrote, 'Inasmuch as it is *left* by the *past*, it [the trace] *stands for* the past, it "represents" the past […] the trace takes [the] place of the past, absent from historical discourse' (1984, 2, italics in original).

The survival of the past in the present is an inherent characteristic of architecture, especially in urban settings, and in this regard, architecture is the most visible and profound example of the 'trace'. All buildings are at once the product of a particular historical moment, and inescapably part of the present, existing, and typically experienced, in a form of perpetual simultaneity with other buildings deriving from other historical moments. When 'historic' buildings are studied, that existence in the present is largely ignored and they are typically seen solely in terms of the 'historical'. The notion of the 'trace' offers a way of connecting these two seemingly incompatible positions, and situating a building's existence in the present and as a product of the past.

For Ricoeur, 'the ontological question implicitly contained in the notion of the trace is immediately covered over by the epistemological question of the document' (1984, 3). Following this, my work has been concerned primarily with this ontological question. And although it is frequently focused towards the past, this distinction fundamentally differentiates my curatorial practice from the epistemological concerns of the historian.

From this theoretical position, I have evolved several curatorial tactics, all of which are strongly informed by the notion of the fragment, especially as articulated by Dalibor Vesely in his book *Architecture in the Age of Divided Representation* (2004). Vesely argues that 'fragmentation is a distinctly modern phenomenon', which has had a 'detrimental', even deleterious effect on architectural culture (2004, 322). Conversely, he points out, there have been moments when 'fragmentation has played the opposite role, contributing to the formation of meaning and a sense of wholeness' (2004, 318). Vesely sees the emergence of what he calls the 'positive fragment' in surrealism, which 'represents the most admirable effort to date to bring the latent world of our common existence into our awareness, not only in the domain of art but also in everyday life' (2004, 343).

Collage is central to surrealism's endeavours in this area. Vesely observes how 'The fragment of a building, the torso of a sculpture, an object taken out of its context, and an artificial ruin often initiate symbolic meaning and reference more powerfully than does the piece intact in its original setting' (2004, 322). Although these examples involve literal fragments, the tactic is a structural one, allowing for 'overlapping figures and elements, as a simultaneous perception of elements in various spatial locations, and as a dialectic of visual facts and their implications' (2004, 344). My curatorial practice draws from this notion of collage – whether spatial or discursive – to conceive an exhibition as a series of fragmentary, discrete, autonomous yet related, interventions in frequently historic settings. Situating an intervention into an existing setting in this way looks beyond conventional notions of history to reconstitute the past into a kind of object, which becomes both discontinuous and tangible, and foregrounds its existence in terms of what Ricoeur characterised as the 'trace'.

Curatorial tactics

Across my projects as a curator at Sir John Soane's Museum, one of the world's great house museums, and before that at the Royal Academy of Arts, I have evolved a series of specific, though far from mutually exclusive, 'tactics' emerging from this notion of curating as a spatial and discursive collage of fragments. With more and more architecture exhibitions focusing on the experiential as an end in itself, these tactics are critical to the way the experiential might become meaningful and architecture might become more visible.

Disruption occurs through creative contrast and juxtaposition, inserting an unfamiliar, incongruous or foreign object, idea or narrative into a particular setting. All (contemporary) interventions (in historic settings) are disruptive in some way. Often this is immediate, for example, in the case of the bold forms and bright colours of the four architectural 'characters' created by Studio MUTT for *Out of Character* (2018). The challenge for the curator is to avoid these types of experiences becoming 'one-liners', with the disruption taking place in just one dimension, and to negotiate a richer and more meaningful relationship so that disruption leads to the activation of both the surrounding space – changing how it is perceived – and the object itself. This was central to the idea behind *The Roman Singularity* (2017) by Adam Nathaniel Furman, where the immediate de-familiarisation of situating a colourful Roman city in 3D-printed ceramics in the Sir John Soane's Museum's old kitchens allowed the appropriation of that domestic space into the orbit of the broader museum. (See figures 8.1, 8.2, 8.3, 8.4 and 8.5.)

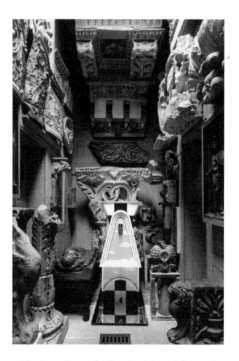

Figure 8.1 Installation shot of 'The Architect' from *Out of Character: A Project by Studio MUTT* (12 September – 18 November 2018), Sir John Soane's Museum, London.

Credit: Courtesy of Sir John Soane's Museum. Photograph: French + Tye.

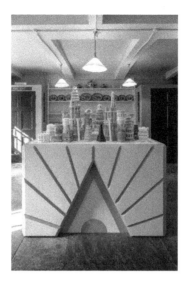

Figure 8.2 Installation shot of *Adam Nathaniel Furman: The Roman Singularity* (16 September – 10 December 2017), Sir John Soane's Museum, London.

Credit: Courtesy of Sir John Soane's Museum. Photograph: Gareth Gardner.

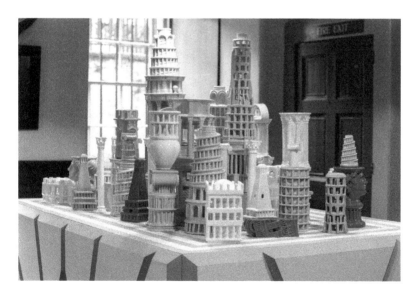

Figure 8.3 Installation shot of *Adam Nathaniel Furman: The Roman Singularity* (16 September – 10 December 2017), Sir John Soane's Museum, London.

Credit: Courtesy of Sir John Soane's Museum. Photograph: Gareth Gardner.

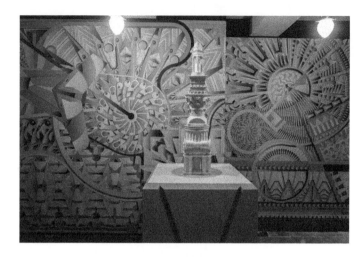

Figure 8.4 Installation shot of 'Pasteeshio' and 'Capreeshio' from *Adam Nathaniel Furman: The Roman Singularity* (16 September – 10 December 2017), Sir John Soane's Museum, London.

Credit: Courtesy of Sir John Soane's Museum. Photograph: Gareth Gardner.

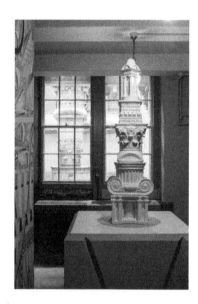

Figure 8.5 Installation shot of 'Pasteeshio' with Soane's 'Pasticcio' in the background from *Adam Nathaniel Furman: The Roman Singularity* (16 September – 10 December 2017), Sir John Soane's Museum, London.

Credit: Courtesy of Sir John Soane's Museum. Photograph: Gareth Gardner.

In contrast to these projects' reliance on abrupt formal disruption to lead to a more nuanced conceptual or narratival disruption, more subtle approaches such as those employed by Fred Wilson in *Mining the Museum,* which self-consciously utilise the museum's own curatorial approaches, also constitute forms of disruption, focused explicitly on the narratives, histories and ideologies the institution implicitly or explicitly perpetuates.

This was the tactic pursued by Paul Coldwell in his project *Picturing the Invisible* at the Sir John Soane's Museum in 2019, which saw a body of work created in dialogue with, and subsequently installed in, the old kitchens. (See figures 8.6. and 8.7.) The work emerged from over a year of research, during which time Coldwell became particularly interested in the idea of 'the house seen from below': the ways the servants would have seen, understood and perhaps even attempted to replicate aspects of what the architect and collector Sir John Soane created upstairs. Unlike the master they served, the views and perspectives of the servants are

Figure 8.6 Installation shot from *Paul Coldwell: Picturing the Invisible* (17 July – 19 September 2019), Sir John Soane's Museum, London.

Credit: Courtesy of Sir John Soane's Museum. Photograph: Gareth Gardner.

Figure 8.7 Installation shot from *Paul Coldwell: Picturing the Invisible* (17 July – 19 September 2019), Sir John Soane's Museum, London.

Credit: Courtesy of Sir John Soane's Museum. Photograph: Gareth Gardner.

largely unrecorded and ultimately unknowable and inaccessible. Coldwell's project was therefore part speculation, part creative imagination and part ventriloquisation, giving voice to those largely absent from, and almost entirely silent within, the historical record, yet whose presence was vital to the house's functioning.

Synthesis takes place alongside disruption, either before disruption has occurred and the intervention, whether physical or conceptual, has made itself clear, or afterwards, when the intervention enters into its setting. Here, an intervention operates as a kind of synthetic trace, with an object appearing at first glance like it 'could have been there'. This approach of combining both decoys and disruptions was central to *The Return of the Past: Postmodernism in British Architecture* (2018) in which exhibition objects – drawings, models, photographs, ephemera such as brochures and newspaper clippings, and large 1:1 objects such as furniture and actual fragments of buildings – were situated in historic interiors in a way that deliberately blurred the distinction between intervention and setting, drawing inspiration from Peter Greenaway's classic postmodern film *The Draughtsman's Contract* (1982). (See figures 8.8, 8.9, 8.10 and 8.11.)

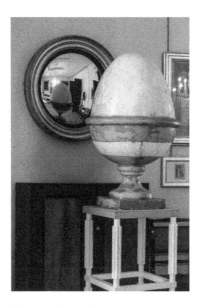

Figure 8.8 Installation shot of Terry Farrell's TV-am eggcup from *The Return of the Past: Postmodernism in British Architecture* (16 May – 26 August 2018), Sir John Soane's Museum, London.

Credit: Courtesy of Sir John Soane's Museum. Photograph: Gareth Gardner.

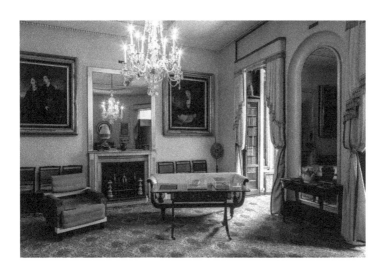

Figure 8.9 Installation shot of the South Drawing Room with Terry Farrell's TV-am chair from *The Return of the Past: Postmodernism in British Architecture* (16 May – 26 August 2018), Sir John Soane's Museum, London.

Credit: Courtesy of Sir John Soane's Museum. Photograph: Gareth Gardner.

Figure 8.10 Installation shot of Charles Jencks' 'Window Seat Window' from *The Return of the Past: Postmodernism in British Architecture* (16 May – 26 August 2018), Sir John Soane's Museum, London.

Credit: Courtesy of Sir John Soane's Museum. Photograph: Gareth Gardner.

Figure 8.11 Installation shot of *The Return of the Past: Postmodernism in British Architecture* (16 May – 26 August 2018), Sir John Soane's Museum, London.

Credit: Courtesy of Sir John Soane's Museum. Photograph: Gareth Gardner.

This approach was also central to *Origins – A Project by Ordinary Architecture* at the Royal Academy of Arts (2016–17). For this project, a range of interventions were situated in spaces usually occupied by works of art that fashion narratives about the origins of architecture and the pre-eminence of British culture and of the Royal Academy of Arts' place within in it – an idea that the project both drew from and subverted through its overtly stylised graphic approach. (See figures 8.12, 8.13 and 8.14.)

Re-contextualisation issues from both disruption and synthesis, describing how situating the contemporary within the historic has the effect of altering the frameworks in which the intervention and setting are viewed and also understood. This effect was particularly important in the *Code Builder* (2018) project for which a prototype cable construction robot was situated in the heart of the Sir John Soane's Museum. The intention was for the visitor to encounter the robot quite suddenly and unexpectedly, almost as a jolt to their experience of the historic spaces. A corresponding exhibition/installation in the gallery spaces elsewhere in the museum, explicitly explored the ideas of the Polibot's creators, Mamou-Mani Architects, about the future of construction and its effect on architectural design and experience in the context of Soane's own example, in effect positing both disruptions and continuities between the two. (See figures 8.15 and 8.16.)

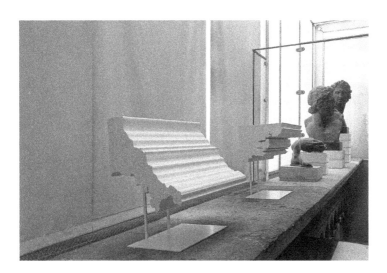

Figure 8.12 Installation shot of '… of Decoration' from *Origins – A Project by Ordinary Architecture* (15 October 2016 – 15 January 2017), Royal Academy of Arts, London.

Credit: Courtesy of Royal Academy of Arts. Photograph: Francis Ware.

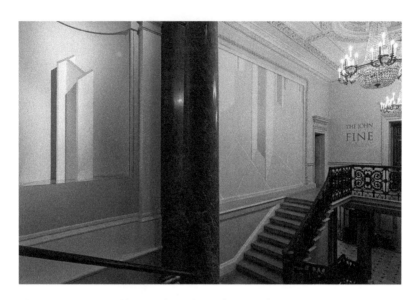

Figure 8.13 Installation shot of '… of Space' from *Origins – A Project by Ordinary Architecture* (15 October 2016 – 15 January 2017), Royal Academy of Arts, London.

Credit: Courtesy of Royal Academy of Arts. Photograph: Francis Ware.

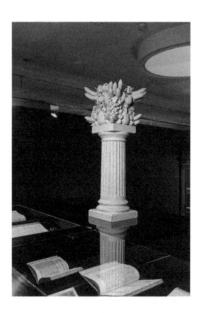

Figure 8.14 Installation shot of 'The Greengrocer's Order' from *Origins – A Project by Ordinary Architecture* (15 October 2016 – 15 January 2017), Royal Academy of Arts, London.

Credit: Courtesy of Royal Academy of Arts. Photograph: Francis Ware.

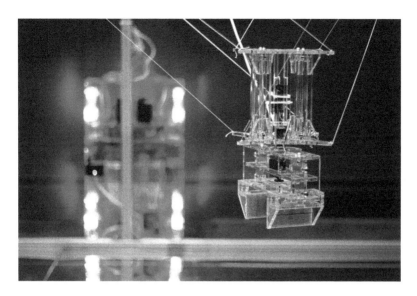

Figure 8.15 Installation shot of 'The Polibot' from *Code Builder: A Robotic Choreography by Mamou-Mani* (5 December 2018 – 3 February 2019), Sir John Soane's Museum, London.

Credit: Courtesy of Sir John Soane's Museum. Photograph: Gareth Gardner.

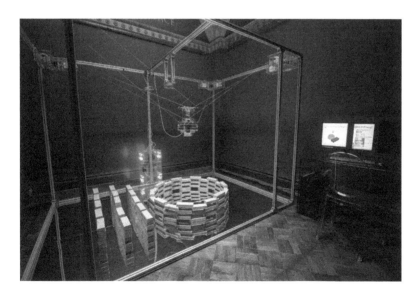

Figure 8.16 Installation shot of 'The Polibot' from *Code Builder: A Robotic Choreography by Mamou-Mani* (5 December 2018 – 3 February 2019), Sir John Soane's Museum, London.

Credit: Courtesy of Sir John Soane's Museum. Photograph: Gareth Gardner.

Re-contextualisation was also vital to the situating of *proposal B*, a conversation seat designed by Peter Salter and Fenella Collingridge for the 2018 Venice Architecture Biennale, for a short-run project in June 2019. Responding to the biennale's theme, *proposal B* was designed as a kind of 'freespace', a work of part-architecture and part-furniture that people could occupy and alter to create a space for conversation. Situating such a structure in the Sir John Soane's Museum, therefore, posed an intriguing challenge to conventional notions of appropriate museum behaviour; in place of 'do not touch' and 'do not sit', it encouraged active participation. (See figures 8.17 and 8.18.)

Anticipation emerges through the staging of interventions across different spaces. This is one of the aspects that distinguish the situating of contemporary projects within historic settings from their more conventional display in 'white cube' gallery spaces. Rather than the visitor stepping into a particular set of spaces in which a project is automatically contained, a project situated in multiple spaces is almost always explored in an episodic manner, with each encounter building anticipation for the next. In the exhibition *Out of Character*, meeting one character naturally created the anticipation of meeting the next. (See figures 8.19 and 8.20.)

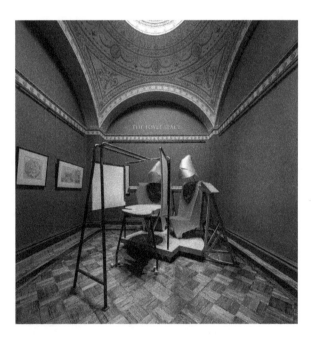

Figure 8.17 Installation shot of *proposal B* by *SALTER + COLLINGRIDGE* (30 May – 16 June 2019), Sir John Soane's Museum, London.

Credit: Courtesy of Sir John Soane's Museum. Photograph: Gareth Gardner.

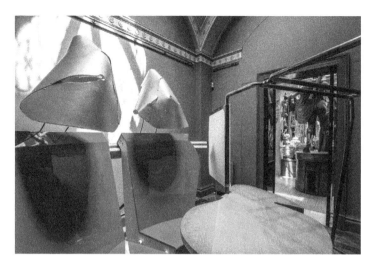

Figure 8.18 Installation shot of *proposal B by SALTER + COLLINGRIDGE* (30 May – 16 June 2019), Sir John Soane's Museum, London.

Credit: Courtesy of Sir John Soane's Museum. Photograph: Gareth Gardner.

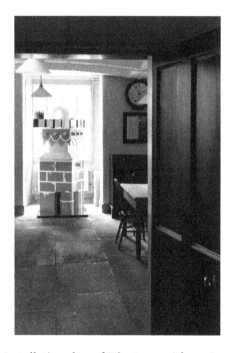

Figure 8.19 Installation shot of 'The Lawyer' from *Out of Character: A Project by Studio MUTT* (12 September – 18 November 2018), Sir John Soane's Museum, London.

Credit: Courtesy of Sir John Soane's Museum. Photograph: French + Tye.

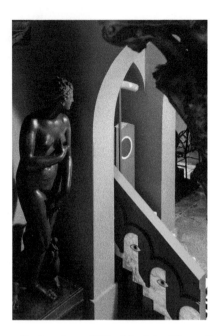

Figure 8.20 Installation shot of 'The Magician' from *Out of Character: A Project by Studio MUTT* (12 September – 18 November 2018), Sir John Soane's Museum, London.

Credit: Courtesy of Sir John Soane's Museum. Photograph: French + Tye.

This tactic was also vital to the exhibition *Eric Parry: Drawing* (2019), for which over 40 of the architect's sketchbooks were situated in five specially designed vitrines at strategic locations across the Sir John Soane's Museum. (See figures 8.21 and 8.22.) Encountering one vitrine led visitors to search for the next and so on, reflecting the spatial and temporal fragmentation of the selection of sketchbooks, which ranged over four decades and were made across the world. In this way, a largely continuous experience of a particular setting is transformed into a fragmented one in which perception is heightened.

Asynchrony stands in contrast to the way we typically experience the city as a kind of simultaneity in which buildings of all periods exist alongside each other in a perpetual present. Fragmentary interventions serve to rupture this simultaneity, creating new temporal proximities that allow for the posing of alternate or counter narratives that relate to both the past and present. This is one of the starting points for a project by the architectural practice CAN and artist Harry Lawson. Entitled *All That Could Have Been* (2020), the project meditates on the interactions of architecture, objects and time through a series of site-specific

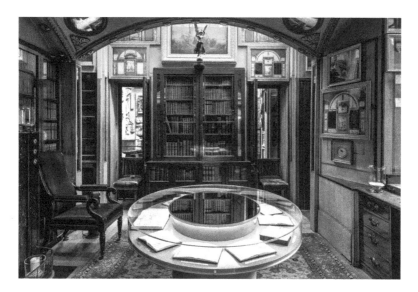

Figure 8.21 Installation shot of 'Movement' vitrine in the 13 Breakfast Room from *Eric Parry: Drawing* (20 February – 27 May 2019), Sir John Soane's Museum, London.

Credit: Courtesy of Sir John Soane's Museum. Photograph: French + Tye.

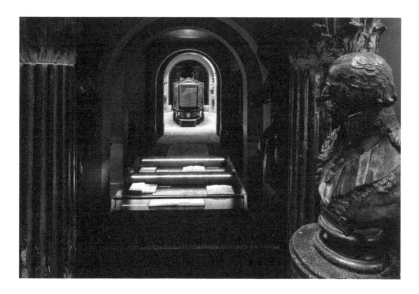

Figure 8.22 Installation shot of 'Effect' vitrine in the Crypt from *Eric Parry: Drawing* (20 February – 27 May 2019), Sir John Soane's Museum, London.

Credit: Courtesy of Sir John Soane's Museum. Photograph: French + Tye.

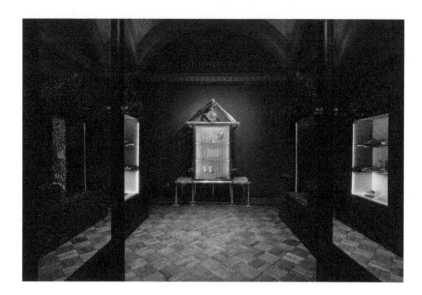

Figure 8.23 Installation shot of *All That Could Have Been: A Project by CAN + Harry Lawson* (16 January – 16 February 2020), Sir John Soane's Museum, London.

Credit: Courtesy of Sir John Soane's Museum. Photograph: Jim Stephenson.

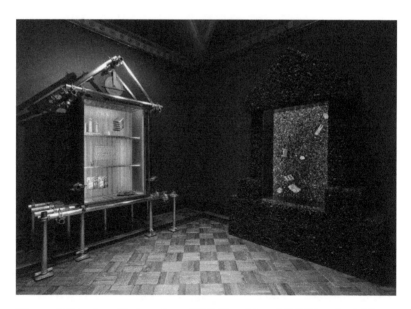

Figure 8.24 Installation shot of 'All That Is' and 'All That Could Have Been' from *All That Could Have Been: A Project by CAN + Harry Lawson* (16 January – 16 February 2020), Sir John Soane's Museum, London.

Credit: Courtesy of Sir John Soane's Museum. Photograph: Jim Stephenson.

constructions. As well as architectural structures in their own right, they also act as containers of small collections of disparate objects that together explore how the ways we see and experience the world around us is affected by time, and how this, in turn, articulates the way we think about the past, present and future.

The situating of this project within such a culturally and temporally loaded and resonant space as Sir John Soane's Museum was critical to its conception, self-consciously placing it within a framework of simultaneity and continuity, and conceiving the present discussion as a link between past and future. In this way, intervening in historic settings is not simply about adding another layer of 'history', but can function as a vital means of critical interpretation and reconstitution in which the past becomes a tool for examining the present and future.[8] (See figures 8.23, 8.24 and 8.25.)

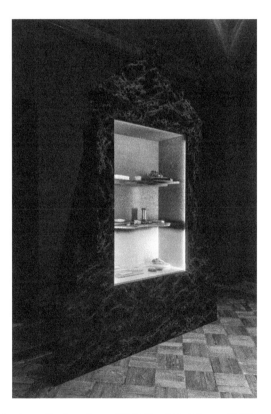

Figure 8.25 Installation shot of 'All That Was' from *All That Could Have Been: A Project by CAN + Harry Lawson* (16 January – 16 February 2020), Sir John Soane's Museum, London.

Credit: Courtesy of Sir John Soane's Museum. Photograph: Jim Stephenson.

Conclusion

One way of understanding the 'state of distraction' that Benjamin saw as characterising our experience of architecture is in relation to the view of the city as a simultaneity and the smoothness of experience that results from all buildings being seen as 'present'. As this chapter has illustrated, in the context of an exhibition, the 'positive fragment', in contrast, introduces temporal texture and depth, and brings to the fore the status of the architectural setting in which the fragment intervenes as a collection of 'traces'. Distraction is replaced by attention and the previously invisible becomes visible.

While the examples cited here are small scale and all drawn from my own curatorial practice, in offering this theorisation it is hoped that this can begin the process of establishing a discourse around this mode of practice that might engage a wide range of curators of architecture working across a number of different spheres. The ultimate goal of this project is, in Vesely's words, to 'bring the latent world of our common existence into our awareness' (2004, 343), and extend that state of attention into the ways we experience the city. Architecture might then become visible, legible and meaningful in ways that ultimately lead to its positive transformation.

Notes

1 This notion provided one of the starting points for my edited special volume of *Architecture Design*: Owen Hopkins, 'Architecture and freedom: Searching for agency in a changing world', *Architecture Design* 88, Issue 3 (May/June 2018).

2 For example, 2019 saw biennials or triennials in Lisbon, Oslo, Milan, Chicago, Seoul and Tallinn among others.

3 For example, see Richard Sandell, *Prejudice and Pride: LGBTQ heritage and its contemporary implications* (Leicester: University of Leicester RCMG, 2018).

4 The project by Jeff Koons at Versailles in 2008–9 was also another notable example. See Ronit Milano, '(Re)Staging art history. Jeff Koons in Versailles', *Museum and Curatorial Studies Review* 2, no. 1 (2014): 39–66.

5 A survey of influential architecture exhibitions can be found in Eeva-Liisa Pelkonen, *Exhibit A: Exhibitions that transformed architecture, 1948–2000* (London: Phaidon, 2018), with more critical discussions in Sarah Chaplin and Alexandra Stara, eds., *Curating Architecture and the City* (Abingdon: Routledge, [2009] 2018) and Kristin Feireiss, ed., *The Art of Architecture Exhibitions* (Rotterdam: NAi Publishers, 2001), among other works.

6 Walmer Yard is not a historic house in the strict sense, but in terms of how it is positioned as a house to visit and in its curatorial programme it has much in common with the category.

7 See https://walmeryard.co.uk/whats-on/, https://www.dulwichpicturegallery.org.uk/whats-on/exhibitions/2019/may/dulwich-pavilion-2019-the-colour-palace/ and https://officeforpoliticalinnovation.com/work/phantom-mies-as-rendered-society/.

8 This tactic is a frequent characteristic of my broader curatorial work, for example, in curating events and other types of cultural programming as well as in my writing.

References

Benjamin, Walter. 1999. 'The work of art in the age of mechanical reproduction'. In: *Illuminations*, edited by Hannah Arendt, 211–44. London: Pimlico.

Buskirk, Martha. 2005. *The Contingent Object of Contemporary Art*. Cambridge, MA: MIT Press.

Ricoeur, Paul. 1984. *The Reality of the Historical Past*. Milwaukee: Marquette University Press.

Vesely, Dalibor. 2004. *Architecture in the Age of Divided Representation*. Cambridge, MA: MIT Press.

9

Seeing things
Anna Mary Howitt in art history
Susan Tallman

It does not matter whether the world is conceived to be real or only imagined; the manner of making sense of it is the same.

Hayden White, *Tropics of Discourse*, 1978

Introduction

One of the peculiarities of human perception and cognition is that concentrated looking is accomplished by screening out distraction, with the result that things said to be 'invisible' often prove to have been sitting in plain view, unseen because they were not what was being sought. The famous 'invisible gorilla' experiment of Christopher Chabris and Daniel Simons demonstrated this phenomenon to YouTube viewers around the globe.[1] Equally apt, if less entertaining, illustrations of this principle exist in every work of history.

Of necessity, historians sweep away most of the information they encounter in order to lay bare certain narratives. Ideally, scholars would take the full measure of every piece of evidence that comes their way, but human brains do not have the bandwidth to do this. As a species we are always engaged in attention triage – which is more urgent: the barking dog or the babbling brook? For historians, as for everyone else, seeing one story means ignoring another.

In the case of art history, the question of visibility shifts from the metaphorical ('seeing' as a stand-in for 'understanding') to the literal. It is a discipline predicated on the visible. Art historians are trained to look: to analyse colour and form, to observe materials, to identify an artist's habits of hand or a culture's deployment of symbols. To call something

'art' is to make an assumption of human intent, to infer that *meaning* is somehow packed into something. To uncover that meaning, art historians connect the visible object to other ideas from other disciplines. For example: literature and religion convey what people believed and how they understood their world; economics, political science and anthropology shed light on the limits and opportunities that shape what gets made and how it is used; sciences provide crucial information about dating, materials and processes of production.

*In*visibility enters art history at many points. For a start, much, perhaps most, art exists to give physical form to metaphysical content. One of the tasks assumed by art history is unravelling the connection between the visible object and the invisible structures it represents. In addition, artworks may harbour physical information invisible to the naked eye but nonetheless meaningful, as when infrared photographs of Jan van Eyck's much studied Arnolfini double portrait revealed a different arrangement of the hands, and suggested new theories of the picture's purpose (Koster 2003). Furthermore, many art objects are incomplete: museums are full of armless statues, broken vases and dismantled altarpieces. Before the twentieth century, it was common for restorers to fabricate new substitutions for the missing parts, giving viewers a sense of the intended whole. Today's audiences prefer to know what is missing.[2]

Finally, like all human endeavours, art history is afflicted by blindness, the unwillingness or inability to see certain things as subjects. A carving or drawing made on a particular continent or by a particular class of people might be treated as an ethnographic artefact rather than a work of art, or simply discarded altogether. Blindness differs from invisibility because it lies in the eye of the beholder rather than in the object, but blindness can produce invisibility when objects ignored by institutions are cast aside and lost.

In terms of what art history chooses to see, a critical watershed was breached with Linda Nochlin's 1971 essay 'Why Have There Been No Great Women Artists?'[3] The realisation that women had been making art for millennia but had been selectively written out of the historical record was troubling (a miscarriage of justice), and also inspirational, launching rafts of scholars on exploratory voyages into the overwritten past. Scouring primary sources such as exhibition catalogues, periodicals, letters, diaries and inventories, they identified female names and rediscovered female careers. They also investigated the social conditions that enable or disable artistic achievement, whether explicitly, such as bans on entry to training, or implicitly, through the drumbeat of 'truths' about what women could or should be.

One intriguing figure resurrected in this process was the British nineteenth-century artist and writer Anna Mary Howitt (1824–84). The shifting message of her biography, as researched and reported by art historians, offers a salutary lesson in visibility, invisibility and selective attention.

Anna Mary Howitt

In the 1850s, Howitt was a successful author and artist immersed in the cultural milieu of Pre-Raphaelite London as well as in early efforts to improve the legal rights of women.[4] Her closest friends – Barbara Leigh Smith (later Bodichon) and Bessie Parkes (later Belloc) – became important figures in the fight for women's rights and education. Her parents, William and Mary Howitt, were prominent progressive writers, and Anna Mary grew up in a household organised around good deeds (the responsibility to make the world a better place), financial pragmatism (the need to earn a living), metaphysical certainties (Christ is love) and social reform (the expansion of justice). William and Mary were friendly with Wordsworth, Dickens and Tennyson, but Anna Mary was 'generally acknowledged to be of a higher order of intellect than either of her parents', according to a family acquaintance (Crosland 1893, 195–6). A swift ink sketch by Dante Gabriel Rossetti captures her in animated conversation – brio in a basque bodice (figure 9.1).[5]

Denied access to the Royal Academy because of her gender, Howitt spent two years in Germany studying under the painter Wilhelm von Kaulbach – a course of action considered so remarkable her dispatches were published in Dickens' *Household Words* and other periodicals. Collected into two volumes under the title *An Art-Student in Munich* (1853), her account was praised by the *New York Times* as 'one of those sunny works which leave a luminous trail behind them in the reader's memory [. . . Of all the books published this season – aye, and for many seasons past – none will be found better worth reading and preserving' (1854, 2). She also wrote fiction, including a serialised novella, *The Sisters in Art* (1852), about an idealised inter-class feminine support group.

Concurrent with this literary success, Howitt was making a name for herself as a painter. Of her breakout painting, *Margaret Returning from the Fountain*, William Rossetti wrote in the *Spectator*, 'it would be difficult to recall a first picture of more assured promise' (1854, 302). The *Art-Journal* concurred, 'it is safe to augur her future eminence in art and professional distinction' (1854, 105), and the *Atheneum* called it 'the

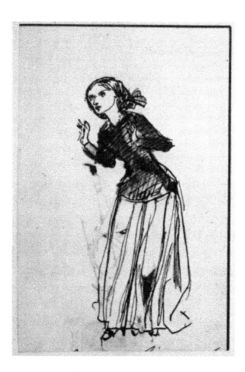

Figure 9.1 Dante Gabriel Rossetti, *Miss Howitt*, circa 1853. Pen and ink on paper, 15.7 × 10.3 cm.

finest picture so far of the year, and one of the best pictures – both as to the conceiving imagination and the executing hand – ever painted by a woman' (1854, 380).

All in all, Howitt was well-situated for success: she was persistent, socially connected and well supported by both family and friends. Yet her blaze of glory was brief. By 1858, her career as an exhibiting artist was over. And therein hangs the tale that art historians have been chasing for five decades.

There is nothing necessarily noteworthy about a fizzled career *per se*. Financial circumstance, illness or simple shifts in public taste can push once celebrated artists to the sidelines. Women in particular may be derailed by family obligations (or death in childbirth) at exactly that cusp-of-30 moment when serious career-building is usually done.

What *is* unusual is that Howitt's mother laid the blame for her daughter's collapse squarely at the feet of one person, writing in her autobiography:

Our daughter had, both by her pen and pencil, taken her place amongst the successful artists and writers of the day, when, in the spring of 1856, a severe private censure of one of her oil-paintings by a king among critics so crushed her sensitive nature as to make her yield to her bias for the supernatural, and withdraw from the ordinary arena of the fine arts.

(1889c, 117)

The identity of the critic was not a secret. Family accounts and common sense confirm it as John Ruskin, the great champion of Pre-Raphaelitism, whose book *Modern Painters* had provided the epigraph for *An Art-Student in Munich*.[6] The painting in question was Howitt's ambitious portrayal of the insurrectionist Celtic queen Boadicea, using Barbara Leigh Smith as the model. Howitt's 'bias for the supernatural' referred to the new movement of spiritualism.[7]

The first serious scholarship to focus on Anna Mary, rather than her parents, was Lenore Ann Beaky's 1974 PhD dissertation (in literature, interestingly) at Columbia University. Curious as to why Ruskin's letter had been so destructive, Beaky examined Anna Mary's books and letters, her relationship with other Pre-Raphaelites, and the social norms for educated women in Victorian England. Details were drawn from her mother's autobiography and from a 1955 biography of both her parents, written by Mary Howitt's great-niece Amice Lee. Taking a psychological approach, Beaky reformulated 'sensitive nature' as anxiety and depression, and posited a traumatic cognitive dissonance between Anna Mary's aspirations to a career in art and her acceptance of socially sanctioned feminine virtues. This conflict, Beaky argues, could only be expressed subconsciously: 'What Anna Mary could not tell her contemporaries about the condition of women, what she could not admit to herself about her own position, escapes into her art', first through her paintings of victimised women and then by abandoning art altogether (1974, 77).

'Impelled by the shock of Ruskin's letter', Beaky explains, Anna Mary turned to spirit-drawing, letting her hand be guided by outside forces (1974, 99). Beaky describes these drawings as 'abstract geometric designs done without drafting tools' but seems to have mistaken her father's attempts for Anna Mary's (1974, 99–100). In 1859 Howitt married a childhood friend and fellow spiritualist, Alfred Alaric Watts, and remained committed to spiritualist beliefs until her death. It was a development that flummoxed some in her circle. George Eliot wrote to a friend, 'Have you heard that Anna Mary Howitt, alas! has become a spirit medium?' (1954, 267) and William Rossetti reflected, 'If only the spirits

had let her alone, she would have drawn and painted very much better than she ever did under their inspiration' (1906, 171).

Concluding that Anna Mary had been shattered by a combination of inherent psychological weakness, Ruskin's callousness and crushing social strictures, Beaky effectively merged the nineteenth-century maternal view with the insights of twentieth-century feminism (1974).[8]

Much the same conclusion was reached by art historians Jan Marsh and Pamela Gerrish Nunn in publications that first presented Howitt to modern readers as 'the nearest thing to a female Pre-Raphaelite, *tout court*' (1989, 31). For feminist scholars, *An Art-Student in Munich* and *The Sisters in Art* became important documents, revealing how a key group of ambitious nineteenth-century women experienced and hypothesised art and their place within it. The subject matter of many of Howitt's paintings also lent itself to parsing in terms of gender politics: her 1855 painting *The Castaway* depicted prostitution, her 1854 *Margaret* portrayed the young woman 'ruined' by Faust, and her 1856 *Boadicea* went still further, portraying a wronged woman plotting revenge, through the recognisable features of a living female activist. All can be seen as picturing the effects of male power and sexual predation.

Given Ruskin's undeniably peculiar relations with women, his role in the drama was viewed by contemporary scholars as perfidious. The only known account of his letter's contents comes from Amice Lee, in vivid prose:

> Annie snatched and tore open the letter. Then came a cry of grief and anger as from a wounded creature [...] she almost screamed the words, 'What do *you* know about Boadicea? Leave such subjects alone and paint me a pheasant's wing'.
>
> (1955, 217)

To historians such as Deborah Cherry, these words suggested an attack, not just on the execution of the painting, but on its intellectual validity and – through the italicised 'you' – the right of Anna Mary specifically to weigh in on topics of historic or moral import (2000, 126–7). As literary historian Linda Peterson put it: 'Art historians tend to blame Ruskin – or more generally, patriarchy – for the loss of a potentially great woman artist' (2009, 128). In the freshly written saga of Victorian women artists, Howitt was cast as the system's 'tragic victim'.[9]

This story is seductive. It pits a likeable, relatable heroine against a misogynistic villain, and dovetails neatly with current understandings of gender politics. It is, however, full of holes.

Voids

The most yawning lacuna concerns the art itself: none of Anna Mary Howitt's paintings are currently locatable. The only visual documentation we have consists of black-and-white photographs of one early commissioned portrait and an 1855 diptych, *The Lady* (also known as *The Sensitive Plant*) (figure 9.2.).[10] The paintings at the heart of the story – *Margaret, Castaway* and *Boadicea* – are known only from verbal descriptions.

This invisibility should give us pause. If we are not able to *see* the *Boadicea*, how can we know that Ruskin was wrong about it? Even if Ruskin's letter was quoted correctly (a big 'if', given that the story was first committed to print a century after the event), and even if it was mean-spirited (also questionable, since painting pheasant wings was the kind of thing Ruskin liked to do himself), he might have had motives other than psycho-sexual torsion. It is *possible* that Howitt's foray into the high-moral-dudgeon mode of history painting resulted in a picture that, however ambitious and (from a contemporary viewpoint) politically admirable, was not very rewarding to look at. It is also possible that the painting *was* great. The point is, we cannot know. And that not-knowing should be kept in view.

Figure 9.2 Anna Mary Howitt, *The Lady (The Sensitive Plant)*, 1855. Oil on canvas, diptych, 30 × 25 cm.

Credit: Public domain.

Ruskin is also held to blame for this dearth of evidence. Lee reported that in the aftermath of the letter, 'palette and brushes were put away, most of her paintings destroyed' (1955, 217). Yet documents show that the *Margaret* had been bought from its exhibition, probably by the painter John Rogers Herbert; the *Castaway* was purchased by the Manchester collector Sir Thomas Fairbairn and re-exhibited in the 1857 'Art Treasures' exhibition; at least two works were owned by the philanthropist Angela Bourdett-Coutts; and letters make reference to further commissions. None of these paintings were in Anna Mary's hands to destroy had she wanted to. If we cannot trace them now, it is because they have suffered the fate of most art, gradually becoming separated from their backstories and attributions until one day they are put out in the rubbish or flogged at an estate sale as 'unknown Victorian'.

Just as Howitt did not destroy all her work in 1856, she also did not stop painting. A year after the *Boadicea* debacle, on 4 March 1857, Charles Dickens wrote to William Howitt that he would be paying a visit and looked forward to seeing Miss Howitt's pictures (Lohrli 1971). Two months later, Anna Mary wrote of frustrations with a commission she was working on.[11] Another year on, she exhibited a landscape at the Society of Female Artists, and was still enough of a name to be singled out by *The Athenaeum* as indicative of the exhibition's importance. In the 1860s, she was tromping the countryside, painting *en plein air* with Barbara Bodichon. She had ceased submitting oil paintings for exhibition; she had not ceased making pictures.

Silence

This brings us to the second great omission in the story: the silence concerning the 28 years of Howitt's life *after* the Ruskin letter. She was not idle. She spent that time advocating for beliefs that were no less radical than her earlier causes, though they are harder for contemporary academics to sympathise with. By the early twentieth century, spiritualism had been debunked as a fraud and a fad. For historians trying to make the case for women as serious cultural contributors, Howitt's spiritualism could pose a threat to the credibility of her earlier artistic feminism – her poor judgement about the one potentially tainting the legitimacy of the other.

But was it poor judgement? For every sceptic like Charles Dickens or George Eliot, there were distinguished nineteenth-century believers such as the chemist Sir William Crookes, the physicist Sir Oliver Lodge or the

evolutionary biologist Alfred Russel Wallace. It was in the home of the mathematician and logician Augustus de Morgan that the Howitts attended their first séance. These people were not faddists; they were responding to a fundamental restructuring of the possibilities of knowledge. In the preceding decades, understanding of the natural universe had been transformed through discoveries of invisible forces such as electromagnetism and atomic theory. If one was an educated, open-minded person who believed in God (and almost everyone believed in God), it was not unreasonable to think that some combination of human ingenuity and godly grace was in the process of revealing how *everything* worked – life, death, spirit, matter, infinity and eternity. Before quantum gave us a dice-throwing god, spiritualism offered hope for a theory of everything, physical and metaphysical. Before Freud gave us the subconscious, spiritualism provided a mechanism that explained perplexing impulses and behaviours. It was convincing to the educated classes because it gave material manifestations to immaterial hypotheses, an analogue to the workings of the natural sciences. These manifestations came in a wide variety of forms, from table rappings to spoken words, but for educated spiritualists, the most sophisticated and compelling of these was drawing.

Spiritualism also offered women opportunities for achievement and even leadership unavailable elsewhere. Because the stereotypically feminine virtues of sensitivity and passivity were essential to mediumship, it was possible in a spiritualist context to be both ladylike and powerful. In addition, as a new movement without an established hierarchy, spiritualism was open to the creation of new roles and the carving out of spaces in which women could be seen and heard.[12]

Social and literary historians began examining the cultural complexities of spiritualism in the 1970s, but art history remained aloof. Even the spirit-vision claims of William Blake tended to be downplayed, and art historical curiosity about Howitt did not follow her beyond the *Boadicea* debacle. In their important 1989 profile of her, Marsh and Nunn observed of her spirit drawing: 'nothing of this survives' (46).

In fact, those drawings had survived in the hundreds. One large cache had been left to the Society for Psychical Research and has been at Cambridge University Library since 1990. Others are in the archives of the College of Psychic Studies (formerly the London Spiritualist Alliance).[13] The first art historical examination of these drawings was offered by Rachel Oberter in her 2007 Yale PhD dissertation. Oberter treats spiritualism not as 'cloud cuckoo séances' (Beaky's term), but as a philosophical inquiry rooted in the Romanticism, religious yearning and scientific positivism of Victorian intellectual culture (Beaky 1974, 103).

Reading Howitt's writings before and after the events of 1856, Oberter finds not rupture but continuity. A fervent sense of immanence, for example, was part of Howitt's experience of art from the beginning, as can be seen in her 1850 description of the Munich Hofkapelle:

> Christ seemed to speak as he stretched forth his benevolent arms, till the Virgin's eyes sent peace into the depths of one's soul, till the whole quire of angels, overshadowed with their azure wings, burst into one anthem of praise and rejoicing! It is not nature, at least not familiar nature such as we see in our streets and our homes; it is an abstraction, an exaltation, an ecstasy! It is prayer, – praise.
>
> (Howitt 1853, 6)

Such passages would not catch the eye of scholars in search of sisterhood, but the equation between art-as-religion and religion-as-art runs through all her writing, and is inseparable from her gender-forward political thinking and social ideals. Her spirit drawings and spiritualist writings were, correspondingly, infused with unorthodox theological structures in which the masculine gives way to the feminine as spiritual forces evolve toward perfection.

The drawings themselves come in a few different types. There are rough pencil drawings on paper – some tangled and anarchic, others bubbling with spheres that coalesce into roly-poly Jesus figures and women with arms stretched out in a gesture that conflates welcome and crucifixion. There are intricately detailed pen and ink drawings in which human figures, weird plant forms and ornamental lettering intertwine. The most finished images use brightly coloured gouache to depict centralised figures, winged or lit with crowns of flame. The quality varies: some suggest amateurish New Age greeting cards, while others are finely wrought and sensitively drawn. In most of them, Pre-Raphaelite fussiness and neo-Medievalism are juxtaposed with a radical disregard of rational space and size relationships. We see peonies packed with baby heads, elegant ladies who morph into snail shells, bits of Christian iconography – angel wings, halos, the cross – amid paisley ornament and whirling flames. It is as if a Kashmiri shawl jumped into a blender with an illuminated manuscript and the prophetic books of William Blake. They look like nothing that came before – or for that matter after – until the psychedelic sixties.

To make them, Howitt put herself into a passive state that allowed spirit forces to move her hand without her volition. Though she offered a different explanation for its meaning, her process is similar to that

employed in Surrealist 'automatic drawing' (a term probably coined by Howitt[14]). This refusal of reasoned creation was, she believed, important. Writing later about her methods, she again chose an epigraph from Ruskin:

> Nor has ever any great work been accomplished by human creatures, in which instinct was not the principal mental agent, or in which the methods of design could be defined by rule or apprehended by reason. Therefore it is that agency by mechanism destroys the powers of Art and sentiments of Religion together.
>
> (Ruskin 1875)

'Until now', Oberter writes, 'Anna Mary Howitt-Watts' place in art history has ended [at the Ruskin letter], with scholars recounting this moment of defeat. Yet I have recovered a second career' (2007, 98). What is most remarkable, for our purposes, is that Oberter did so by reading books and periodicals long available in libraries around the world, and by locating a group of drawings in the single most obvious place to look for such things: the archives of the Society for Psychical Research.

Context

The final flaw in the standard version of Howitt's life has to do with the events of 1856. That *something* happened to alter her trajectory is certain, but the Ruskin story is not quite satisfying. To begin with, it requires a pretzel-like reconfiguration of the bright tenacious Anna Mary of the early 1850s (of whom Gabriel Rossetti wrote, 'I never knew any artist with more genuine hopefulness and enthusiasm' (1917, 69)) into a fragile neurotic, crushed by a few words.

Her *Boadicea* painting was indeed rejected by the Royal Academy and received mixed notices when hung at the Crystal Palace (*The Athenaeum* declared it the exhibition's 'most promising picture' but complained about its Pre-Raphaelite superfluity of detail). She probably did ask Ruskin for his views on it, and in the months that followed, her behaviour was disturbingly erratic. All of this is confirmed by multiple sources.

The idea that Ruskin's letter was the cause of Howitt's break, however, has just two sources: the paragraph penned by her mother in the 1880s and Lee's biography written in the 1950s. The most immediate account of her breakdown was penned by Anna Mary herself, a year after the event, but since it was published in the spiritualist press and under a

pseudonym, it was missed or ignored by art historians before Oberter.[15] It takes the form of an extended letter in the 1857 book *Light in the Valley: My Experiences of Spritualism* (Crosland 1857), and is accompanied by six spirit drawings, probably the first ever reproduced. In it, Howitt describes the unexpected emergence of spirit writing amongst her family members in 1856 and how the messages went from friendly to terrifying. She began to experience strange symptoms such as:

> warm streams of electricity in waving spirals from the crown of my head to the soles of my feet; and occasionally, generally at midnight, I was seized with twitchings and convulsive movements of my whole body, which were distressing beyond words. All these symptoms at length came to a crisis in a frightful trance.[16]

Sent to the country to recover, she found her hands writing without her control, saw images inscribed on her eyelids and when she tried to draw from nature, watched as her pencil moved against her will:

> The first drawings were very rude indeed, like the uncertain, tottering lines of a child, and also singularly resembling the designs of the very early Italian paintings, – heads of Christ, angels, and curious female figures seated within spheres and hearts; and always these drawings were accompanied with strange ornaments of spiral and shell forms with dots and scroll-like ciphers.[17]

Several of the drawings in Cambridge match these descriptions. At first, she fought against these strange images, and weeks of anguish ensued. Eventually, she turned her mind to interpreting them, at which point their hopeful message of spiritual evolution and survival was made clear to her. The drawings over which she had no conscious control became objects of conscious study. She unravelled their symbols and texts; she looked for meaning in their forms and compositions. As in her Pre-Raphaelite period, she understood pictures as allegory: however entrancing to the eye, images should also teach. Later she explained:

> The power of spirit developed drawing in me [. . .] simultaneously with the faculty to behold symbolical visions and spirit personages, and to hear an internal voice speaking; which voice explained the purport of both the spirit-drawings and of the visions beheld [. . .] This took place in the year 1856 – in the early summer.[18]
>
> (Howitt 1889a)

She does not mention Ruskin.

To a twenty-first century reader, Howitt's account is suggestive of temporal lobe epilepsy (TLE). TLE seizures may present simply as an odd feeling – déjà vu or sudden terror – or as 'spacing out'. People may appear awake but unresponsive (the artist William Bell Scott recalled her sitting and 'listening not so much to you as to the empty air' (1892, 242)). Hyperreligiosity and hypergraphia (an uncontrollable compulsion to write or draw) are associated behaviours. Patients may experience auditory and visual hallucinations, including complex 'cinematographic' hallucinations, described as 'seeing people in color but with interruptions, as if in frames in an old movie' (Nelson et al. 2016, 78–9). 'Cinema' was not available to Howitt as a simile; instead she described her visions in terms of 'dissolving views', a nineteenth-century entertainment of sequential projected images, and wrote:

> Imagine that the figure thus sketched, by the hand being moved involuntarily, represented a woman seen in profile, with one hand raised, the other holding a book by her side. By the time my hand was moved again to the head of the figure to complete the profile, my spirit-moved hand could not draw any longer the profile of the woman. The face was now turned towards the spectator [...] gradually the whole figure would be entirely altered.
>
> (Howitt 1889b, 203)

To accommodate this instability, she developed a process using tracing paper so she could capture changes without having to redraw the parts that stayed the same – a tactic not dissimilar to animation cels.

One hundred and fifty years on, it is not possible to diagnose the cause of Howitt's visions and voices, and, arguably, the aetiology of her experience is not the issue. Once we remove silliness from the table (and there is no evidence she was ever silly), we are left with the same outcome: someone working to make sense of an otherwise inexplicable situation.

It is, however, probably useful to address the intimations of madness or instability that colour most posthumous accounts of Howitt's life. The idea seems to have arisen from documented family worry about her condition in the summer of 1856, alongside the twentieth-century's disdain for spiritualism and fondness for explanatory psychopathologies. Arguing *against* the idea of mental illness is the record of Howitt's life: her ongoing achievements, social interactions, letters and publications. None of her writing, before or after 1856, shows disordered thinking. Even when the subject matter is theologically peculiar, the prose is cogent. She

maintained close relationships with her friends and family, many of whom had no truck with spirits. She was the intellectual confidant of her brother Alfred, a noted explorer, geologist and pioneering anthropologist in Australia. Their steady correspondence shows her vetting scientific texts, suggesting lines of inquiry, securing scientific instruments, and maintaining academic and publishing connections in England on his behalf. 'I am so glad you are reading Darwin', she remarked when *On the Origin of Species* appeared, 'to us the theory has great possibilities' (Walker 1971, 191). Nor did she shy from political issues. For an 1878 pamphlet on women's suffrage she wrote:

> I find it difficult to comprehend how, in an age in which exceptional legislation directed against particular classes of society is so universally deprecated, it can still be deemed right by any order of thinkers that [...] women should be debarred from that highest of all culture which is provided by the exercise of individual responsibility in relation to important questions, some, especially and materially affecting themselves.
>
> I cannot avoid adding the expression of my earnest belief that the existing state of things, and the habit of thought which it perpetuates, is as injurious to man as it is to woman, and that the happiness and welfare of both in this matter are one and indivisible.
>
> (Howitt 1879)

This is neither the phrasing of a psychotic nor the sentiment of a crushed soul.

The tragic victim account of Howitt's life is inaccurate, and also something worse. In accepting a conventional narrative of power structures – men on top, women on bottom – it completes what the patriarchy started: it robs Howitt of agency. Rather than a grown-up making conscious decisions, she has been portrayed as a weak woman felled by a powerful man. All power was ceded to Ruskin.

Authorship

On the face of it, the art historical disinclination to investigate Howitt's spirit drawings is peculiar. One would think that the idea of a Pre-Raphaelite painter taking up, some 70 years *avant la lettre*, tactics championed by the Surrealists would be of interest to a broad range of scholars. But spirit drawings present a challenge to the key conceptual

component of art as we have understood it for the past 600 years: authorship. A work of art means what it means *because of who made it.* A black square painted by a kindergarten child and a black square painted by Kazimir Malevich mean different things. But since drawing mediums ascribe the authorship of 'their' images to ineffable beings most of us do not believe in, they effectively paralyse the process of art historical meaning production.

The worship of artistic genius and a willingness to situate it beyond the artist's conscious control was part and parcel of the Romantic worldview. As Nochlin observed of the nineteenth century, 'art historians, critics, and, not least, some of the artists themselves tended to elevate the making of art into a substitute religion, the last bulwark of Higher Values in a materialistic world' (1971, 140). Though this 'substitute religion' resonates with Howitt's aims on one level, Nochlin was talking about the cultic quality of painters like van Gogh, in whom ideas of diminished control and personal authorship are tightly wed. Spirit drawing took things a step further by eliminating the persona of the artist.

The willing abdication of power inherent in mediumship may seem antithetical to the kind of intentional authorship that marked Howitt's earlier career. If, however, one is interested in *learning* something rather than *saying* something, such detachment is useful. Rhetorically, Howitt turned herself into a seismograph. Images and texts were made manifest by a hand over which she had no control. In practice, however, it was not so simple. While her raw pencil drawings might have been entirely executed in an altered state, the more finished images – those that have been reworked on tracing paper, refined, coloured in and positioned at the centre of the page – indicate a far more complicated push-pull of passive acceptance and active creation.

It is worth reiterating that Howitt's spirit drawings were preserved, with her name and history attached, in a way that her conventionally authored oil paintings were not. Among believers, the idea of 'authorship' was reconfigured such that Howitt's connection to the drawings clarified their meaning and enhanced their importance. The most widely uploaded image of her on the internet is not a photograph, but a luminous abstraction by drawing-medium Georgiana Houghton entitled *The Spiritual Crown of Annie Mary Howitt Watts, 24 April 1867.*

The art historical difficulties presented by spiritualist practices are writ large in the treatment of the contemporary art world's favourite artist-medium, Hilma af Klint (1862–1944). Like Howitt, af Klint was a well-connected, professionally trained painter who never showed her spiritualist work in a fine art context. In recent years, the paintings she

made under spiritual control in the first decades of the twentieth century have been used to position her, with enormous success, as the 'woman who beat Kandinsky to abstraction'. The 2018–19 exhibition 'Hilma af Klint: Painting for the Future' at the Guggenheim in New York was the most visited show in the museum's history (Guggenheim Museum 2019). For the most part, however, af Klint's claim that the compositions were dictated by spirits has been treated as a winning eccentricity rather than as the artist's deeply felt reality (Tallman, 2019). Like Howitt and Houghton, af Klint wrote voluminous exegeses explaining the programmatic meaning of her images, but almost no one pays attention.

Howitt's spirit drawings are not candidates for such a transformation. They are small, fragile, intricate and ladylike in an art world that still prefers the large, forceful and 'manly'. Though there is now rhetorical acknowledgement that the traditional subjects of art history have been selected as such because they serve systems of power, most art historians remain tied to the institutions, individuals and objects that have defined 'fine art'. For nineteenth-century England this means the Royal Academy, certain periodicals and oil painting. In stepping away from those arbiters, in choosing the séance table over the gallery wall, the spiritualist periodical *Light* over the chattering classes' *Athenaeum*, and paper over canvas, Howitt made herself invisible in ways that go beyond gender.

The mystery – what made Anna Mary Howitt disappear? – is, it turns out, largely an invention of the detectives. She did not disappear; she just was not to be found where art historians were in the habit of looking. The classic detective story, of course, hinges on the initial failure of looking in the usual places, followed by a breakthrough in which the importance of some category of clue, present but unheeded, is recognised – a dog that did not bark, a happy medium.

Notes

1 See https://www.youtube.com/watch?v=IGQmdoK_ZfY.
2 For further discussion, among many other sources, see Uwe Pelz and Olivia Zorn, *KulturGUTerhalten: Restaurierung archäologischer Schätze an den Staatlichen Museen zu Berlin* (Staatlichen Museen zu Berlin/Philipp von Zabern, 2009).
3 Nochlin's essay appeared in two forms: in the January 1971 issue of *ArtNews* and under the title 'Why are there no great women artists?' in *Woman in Sexist Society: Studies in power and powerlessness*, edited by Vivian Gornick and Barbara K. Moran.
4 Full disclosure: Anna Mary Howitt was my grandmother's first cousin twice removed. Growing up, I knew her name from the collapsing spine of *Pioneers of the Spiritual Reformation* (1883) on a family shelf, but it was only as a graduate student that I encountered her history as a painter.

5 Published in William E. Fredeman, 'A Rossetti gallery', *Victorian Poetry* 20(3–4) (1982) and in William E. Fredeman, ed., 'A Rossetti Cabinet: A portfolio of drawings by Dante Gabriel Rossetti', *Journal of Pre-Raphaelite and Aesthetic Studies* 2 (1989).

6 The five volumes of Ruskin's *Modern Painters* were published over 17 years beginning in 1843.

7 Both Howitt's parents took up spiritualism, but by the time of her autobiography Mary Howitt had renounced it and converted to Catholicism.

8 Beaky observed, 'If Anna Mary's belief in spiritual womanhood reveals her as a compleat [sic] Victorian, her conviction that the male nature was inferior to the female places her in agreement with certain strains of the women's movement in the 1970's. Of far greater consequence to her own well-being was her failure to acknowledge consciously the degree to which women were oppressed' (1974, 82).

9 Clarissa Campbell Orr observed, 'If Barbara Leigh Smith Bodichon is something of the triumphant heroine of this volume, Anna Mary Howitt is its tragic victim' (1995, 19).

10 In addition, there are a couple of known portrait drawings of Lizzie Siddal and William Robinson, and some illustrations done for books by her mother.

11 Anna Mary Howitt to Bessie Parkes, 11 May 1857. GCPP Parkes 7A, Girton College Library, Cambridge.

12 This openness can be overstated: some organisations banned women from membership.

13 Howitt was a founding member of the Spiritualist Alliance and involved in the SPR from its beginnings.

14 In the preface to *Glimpses of a Brighter Land* (London, Baillière, Tindall, and Cox, 1871).

15 Biographical details and a reproduced drawing from an original now the SPR archive confirm that 'Comfort' is indeed Anna Mary Howitt.

16 Anna Mary Howitt (writing as 'Comfort'), in Mrs Newton Crosland, *Light in the Valley: My experiences of spiritualism* (1857).

17 Anna Mary Howitt (writing as 'Comfort'), in Mrs Newton Crosland, *Light in the Valley: My experiences of spiritualism* (1857).

18 Text written in 1875, published posthumously as 'A contribution towards the history of spirit-art', *Light*, 13 April 1889.

References

The Art-Journal. The National Institution Exhibition 1854, 1 April 1854: 105.

The Atheneum. Fine Arts, 25 March 1854: 380.

Beaky, Lenore Ann. 1974. 'The letters of Anna Mary Howitt to Barbara Leigh Smith Bodichon', PhD dissertation, Columbia University.

Campbell Orr, Clarissa. 1995. *Women in the Victorian Art World*. Manchester: Manchester University Press.

Cherry, Deborah. 2000. *Beyond the Frame: Feminism and visual culture, Britain 1850–1900*. New York: Routledge.

Crosland, Camilla. 1893. *Landmarks of a Literary Life 1820–1892*. London: Samson Low, Marston & Company.

Crosland, Mrs Newton. 1857. *Light in the Valley: My experiences of spiritualism*. London: G. Routledge & Company.

Eliot, George. 1954. In: *The George Eliot Letters*, edited by Gordon S. Haight, 267. New Haven: Yale University Press.

Guggenheim Museum. 2019. 'Hilma af Klint; Paintings for the future. Most-visited Exhibition in Solomon R. Guggenheim Museum's History'. Press release, 18 April 2019.

H. [Anna Mary Howitt]. 1871. *Glimpses of a Brighter Land*. London: Baillière, Tindall, and Cox.

Howitt, Anna Mary. 1852. *The Sisters in Art. The Illustrated Exhibitor and Magazine of Art* 2: 214–6; 238–40; 262–3; 286–8; 317–9; 334–6; 347–8; 362–4.

Howitt, Anna Mary. 1853. *An Art-Student in Munich*. London: Longman, Brown, Green, and Longmans.

Howitt, Anna Mary. 1879. 'Statement 30'. In: *Opinions on Women's Suffrage*. London: Central Committee of the National Society for Women's Suffrage.

Howitt, Anna Mary. 1889a. 'A contribution towards the history of spirit-art', *Light*, 13 April 1889: 176.

Howitt, Anna Mary. 1889b. 'A contribution toward the history of spirit-art (part 2)', *Light*, 27 April 1889: 203.

Howitt, Mary. 1889c. *Mary Howitt: An autobiography*, edited by Margaret Howitt. London: W. Isbister.

Koster, Margaret L. 2003. 'The Arnolfini double portrait: A simple solution – critical essay.' *Apollo*, September 2003.

Lee, Amice. 1955. *Laurels and Rosemary: The life of William and Mary Howitt*. London: Oxford University Press.

Lohrli, Anne. 1971. 'Anna Mary Howitt'. *Dickens Journals Online*. Accessed 20 November 2019. http://www.djo.org.uk/indexes/authors/anna-mary-howitt.html.

Marsh, Jan and Pamela Gerrish Nunn. 1989. *Women Artists and the Pre-Raphaelite Movement*. London: Virago Press.

Nelson, Alexis E., Frank Gilliam, Jayant Acharya and Sabina Miranda. 2016. 'A unique patient with epilepsy with cinematographic visual hallucinations', *Epilepsy & Behavior Case Reports* 5: 78–9.

New York Times. 1854. 'Notices of new books: An art student in Munich', *New York Times*, 11 May 1854.

Nochlin, Linda. 1971. 'Why are there no great women artists?' In: *Woman in Sexist Society: Studies in power and powerlessness*, edited by Vivian Gornick and Barbara K. Moran, 344–66. New York: Basic Books Inc.

Oberter, Rachel. 2007. 'Spiritualism and the visual imagination in Victorian Britain'. PhD dissertation, Yale University.

Peterson, Linda H. 2009. *Becoming a Woman of Letters*. Princeton: Princeton University Press.

Rossetti, William. 1854. 'The national institution', *The Spectator*, 18 March 1854.

Rossetti, William Michael. 1906. *Some Reminiscences*. New York: Scribner & Sons.

Rossetti, Dante Gabriel. 1917. Letter from D. G. Rossetti to Woolner. In: *Thomas Woolner, R.A.: Sculptor and poet: His life in letters*, Amy Woolner, New York: Dutton.

Ruskin, John. 1875. *Fors Clavigera*. Orpington: George Allen.

Scott, William Bell. 1892. *Autobiographical Notes of the Life of William Bell Scott*. London: Osgood, McIlvaine.

Tallman, Susan. 2019. 'Painting the Beyond', *New York Review of Books*, 4 April 2019.

Walker, Mary Howitt. 1971. *Come Wind, Come Weather: A biography of Alfred Howitt*. Melbourne: Melbourne University Press.

White, Hayden. 1978. *Tropics of Discourse: Essays in cultural criticism*. Baltimore: Johns Hopkins University Press.

10

The invisible between philosophy, art and pregnancy

Tanja Staehler

Introduction

This chapter combines resources from philosophy and art to approach the invisible. The invisible has always concerned philosophy because it calls into question our motivation for being good or ethical: if we were invisible, what would we do? What would an invisible man do, as both Plato and H. G. Wells explore? The main philosophical theories of ethics fail to explain why we should act in accordance with morals if we cannot be held accountable. However, there are immediate experiences that confront us with ethics or the responsibility for the Other, on an invisible yet tangible or visceral level that runs deeper than all conceptualisation. In this chapter, pregnancy will be discussed as an experience that turns out to be paradigmatic for human relations in general. By drawing on the work of Paul Coldwell that addresses the invisible, it is possible to see that art can approach the invisible without dragging it into the light, and pregnancy as a paradigm can reveal our embodied existence and human relations.

Invisibility in Plato and H. G. Wells

The myth of Gyges in Plato's *Republic* tells a story about Gyges, a shepherd in the service of the king of Lydia ([375 BCE] 1997, 359a–360d). One day, after a thunderstorm and an earthquake had broken open the ground, Gyges discovers a corpse in a chasm opened by the earthquake.[1] The corpse is wearing nothing but a golden ring, which the shepherd procures. After some time, he realises that the ring makes him invisible if he turns it inwards and visible again if he turns it outwards. Gyges abuses the

power of the ring to seduce the king's wife, kill the king with her help, and take over the kingdom.

Glaucon tells this story to Socrates to show that humans only act justly because they want to avoid punishment. The argument goes on to outline that nobody would stay on the path of justice if they had the chance to do whatever they wanted to without being seen and thus without having to be accountable for it. This is not at all Socrates' conviction: he wants to show that we not only want to *appear* just, but in fact to *be* just. However, the myth highlights the difficult task awaiting Socrates if he wants to show that justice can be valued both for its own sake and because of its consequences.

The myth of Gyges thus comes to symbolise the greatest dilemma that Plato struggles with in the 10 books of the *Republic*. The dilemma is to show that we are not just behaving 'ethically' because we are afraid of punishment, but that good compels us to do good for its own sake, and not for some ulterior motive. Socrates insists that the just (or ethical) person will be happy because their soul will be in harmony rather than conflict.

H. G. Wells approaches the idea of an invisible man quite differently. At first, one might even be tempted to conclude that as a literary author, Wells fails to attend to the ethical dimension of the phenomenon, but careful consideration reveals that this is not the case. By approaching the fiction of invisibility neutrally and without a fixed ethical agenda in mind, Wells manages to reveal a dimension of our existence that is absolutely crucial to our being ethical, yet it is one often neglected in philosophy: our embodied or corporeal existence.

Wells' main character Griffin, who makes himself invisible with the help of science, is attracted by the 'wild and wonderful things' ([1897] 2017, 112) he will be able to do and by the power he will gain. Yet he comes to realise that even though he is invisible, he is still embodied and thus still vulnerable. Now that he is invisible, he can still get hurt – even accidentally by others – and most importantly, he can be hungry and cold. He needs food and clothes or blankets, which in turn undermine his invisibility. These problems aggravate him. When he hurts others or sets the house on fire in which he conducted his original experiments, he does so not because his invisibility makes him prone to unethical acts, but to protect himself, and because the realisation of his increased rather than diminished vulnerability has a negative impact on him.

In order to understand the link between embodiment and ethics better, the twentieth-century philosopher Emmanuel Levinas offers a vantage point from which it is possible to appreciate the existential

significance of Wells' *The Invisible Man*, and provides an interesting interpretation of Plato's myth of Gyges. Levinas describes the human body as the site of vulnerability. Vulnerability is mostly a descriptive rather than negative concept for Levinas; it refers to the deepest level of embodiment, which forms the basis of enjoyment as well as suffering. Being a body means being exposed to the world, in productive as well as detrimental ways.

Levinas describes this exposure by referring to the Ancient Greek concept of elements, which he re-interprets. In contrast to things, elements are 'non-possessable'. The examples Levinas gives are 'earth, sea, light, city' (1969, 131). Why not 'earth, water, fire, air'? Levinas wants to describe the way in which we experience the elements first and foremost. Our most important experience of being 'steeped in' the elements is our dwelling place or domicile. This dwelling place, even if often referred to as 'property', is not in the first instance a property; possession is a secondary and derivative relation to it. What makes a dwelling place is not primarily a set of walls, a house or an apartment, but rather the location – the city, as Levinas says, the area I know, the streets I walk, the stores and cafes I visit. Levinas also points out that the wine I drink and the bread I eat can be regarded as 'fuel in the economic machinery' (1969, 134), but this presupposes a certain interpretation of the world that conceals and ultimately destroys the level of enjoyment.

A radical change of circumstance such as the one experienced by the invisible man in Wells' novel brings this dependence on the elements to the fore. Levinas states, '*To be a body* is on the one hand *to stand* [*se tenir*], to be master of oneself, and, on the other hand, to stand on the earth, to be in the *other*' (1969, 164, italics in original). 'To stand on the earth, to be in the *other*' signifies my dependence on the elements; yet this dependence according to Levinas does not diminish the enjoyment. I am vulnerable even before I consider the role of other human beings in relation to me because I am always already exposed to the elements: 'nakedness and indigence, exposed to the anonymous exteriority of heat and cold' (Levinas 1969, 175).

By making himself invisible, Griffin presumes he may have gained power and mastery, but he quickly realises that all the things that hold true about being a body still hold true for him. Levinas calls the body a crossroads, a point where different movements meet – enjoyment, dwelling, but also nakedness and vulnerability. For Levinas, having a body is essentially connected to ethics. The vulnerability of another person makes me responsible for him or her. Having a body means that one can kill and be killed; it also means that one can offer support and protection.

The ethical side of embodiment becomes clearer if we return to Plato's myth of Gyges. Broadly, the function of this myth for Levinas is that it represents our condition of being separated from each other, being enclosed in ourselves, and not acknowledging the needs of others. While Socrates argues that injustice brings about a conflict in the soul, Levinas maintains that injustice is so powerful because it does not involve any apparent contradiction, which would force us out of this condition. Levinas calls this state the ego's separation, and he designates the myth of Gyges as a myth of the I.

> Separation would not be radical if the possibility of shutting oneself up at home with oneself could not be produced without internal contradiction as an event in itself, as atheism itself is produced – if it should only be an empirical, psychological fact, an illusion. Gyges's ring symbolizes separation. Gyges plays a double game, a presence to the others and an absence, speaking to 'others' and evading speech; Gyges is the very condition of man, the possibility of injustice and radical egoism, the possibility of accepting the rules of the game, but cheating.
>
> (Levinas 1969, 173)

The state of the ego that closes itself off is not a contradictory state but a self-sufficient one. There are no internal contradictions because there is no absence that the presence of the Other would fill. If egoism is interrupted, this happens not because there are logical contradictions in this position or because I might want to live my life differently, but because the Other makes me aware of my egoism. It is not possible to develop an ethics grounded in egoism; rather, ethics happens at the moment the other human being calls my selfishness into question. Egoism will then still be a moment in ethics; yet it will not be the basis of ethics. It is the possibility of – and the temptation toward – playing the game of Gyges.

The ego's separation is ambivalent; it opens the possibility of error *and* of truth. Gyges is the very condition of man because we can radically close ourselves off from others. We have the option of seeing without being seen. We can turn away, lower our heads, remain inconspicuous. And we can excel in this attitude to such an extent that we do not even notice the imbalance between seeing and not being seen.

We can be invisible, and act as an invisible person in that realm which we take to be that of the visible. Being on the threshold between visibility and invisibility, being present in absence and absent in presence

is what Levinas calls 'phenomenality'. The phenomenon is the being that 'appears, but remains absent' (Levinas 1969, 181). The absence that characterises phenomenality is an essential absence, a shadow 'which is not simply the factual absence of future light' (Merleau-Ponty 1964, 178). Some things cannot be drawn into any light; others can, but are not meant to be drawn into the light. Levinas is suspicious of vision in general. Gyges exploits the possibilities of visibility and invisibility, which speech and silence, for example, do not offer. Vision gives us the illusion of power; it means to have things on display, at our disposal. Furthermore, Levinas believes that the visual metaphors in the history of Western philosophy (among which *theoria* is the most prominent but certainly not the only one) had a major influence on the violent and totalising character that philosophy has exhibited at times.

To illustrate such dangers, it is helpful to consider briefly another version of the myth of Gyges, told not by Plato but by Herodotus ([425 BCE] 1996, 8–13). According to Herodotus, a strange episode occurred in Lydia when King Candaules had the idea of asking Gyges, his favourite spearman, to confirm how beautiful Candaules' wife was. The tale goes that Candaules was so in love with his wife that praising his wife's beauty was not enough; he suggested that Gyges hide behind the door to watch the queen undress and see with his own eyes how beautiful she was. Gyges, though reluctant at first, was willing to show that he completely trusted the king's judgement and finally agreed. But when he left the bedchamber, the queen spotted him. She was ashamed, and yet she remained silent. The following day, she summoned Gyges and gave him the choice to die himself or to kill the king and take his place. She said, 'Either he must die who formed this design, or you who have looked upon me naked' ([425 BCE] 1996, 9). So Candaules was killed and Gyges became king. This is a story about the ambiguity of love, about shame, secrecy and possessiveness – and a story about visibility and invisibility, about breaking the secret of Gyges, in this case not broken by Gyges himself, but by the queen. The king who succumbed to the power of vision in the end loses it all.

Pregnancy as paradox and paradigm

Levinas is critical of the emphasis on vision, which has determined traditional Western philosophy, declaring in his last work *Otherwise Than Being or Beyond Essence* (1981) that the Other gets under our skin. Skin is an interesting concept for various reasons. When Griffin, in Wells' novel, becomes invisible, it is not just his skin but all of his organs that become

invisible. Yet when he eats (or, as Levinas would say, nourishes himself with elements), the undigested food can be seen in his stomach thus making him visible. Furthermore, skin is the point of contact with the outer world. For Griffin, this remains true even as he is invisible. His invisible skin is where he is affected by the element of coldness, and it is also where he is most vulnerable and can bleed leaving a visible trace. It is one of the many ironies of Griffin's fate that in protecting himself with clothes, bandages or blankets he makes himself visible again.

According to Levinas, everything that is visible about us is ultimately a distraction, namely, a distraction from who we are as a 'soul' (Levinas 1981, 199). We are misled by the looks and skin colour of others. As a result, we fail to acknowledge that the other person is 'under my skin'. For Levinas, pregnancy – in which the other person is literally 'under my skin' – is a paradigm for human relations in general. Pregnancy is a paradox in several ways. It goes against our opinion or conviction of what it means to be a body, as we normally conceive of a body as both a dependence and separation from the world. Being a separate and self-enclosed body gives us the impression that pregnancy and childbirth are ultimately inconceivable.[2] It is inconceivable that one body would give birth to another body and yet both bodies remain unscathed.

It is thus paradoxical to suggest that being pregnant is the paradigm case of a kind of otherness in me that has more general significance, as it means ethical responsibility. Levinas showed the significance of a "contact' without the mediation of the skin' (Levinas 1981, 199). Pregnancy is the paradigmatic example for encountering the Other without the separation of skin. Pregnancy or maternity is one of Levinas' models for explaining the Other in me, my being obsessed by the Other, and my being there for the Other. Maternity, Levinas points out, is a 'gestation of the other in the same' (Levinas 1981, 95). Pregnancy is an extreme case in which the Other is literally under my skin, but beyond this, there are various ways in which the Other can get under my skin.

According to Levinas, pregnancy becomes the paradigm for my relation to the other human being, which is from the beginning ethical, provided we accept his idea of ethics. While it will not be possible to explain the benefits of Levinasian ethics here in any comprehensive fashion, I would like to point out that this wider idea of ethics, which was indicated in the discussion of Plato and Wells, has the advantage of going beyond the usual distinction between 'is' and 'ought' that comes to haunt traditional ethics in all of its formats. David Hume's insistence that an 'ought' cannot be derived from an 'is' undercuts possibilities to build ethics based on insights into our human existence (Hume [1739] 1975, 27). Levinas attempts to start from a much more basic level when he

suggests, 'We name this calling into question of my spontaneity by the presence of the Other ethics' (Levinas 1969, 43).

The Other calls me into question because he or she always exceeds my expectations and concepts; this holds particularly true for the unborn child whom I cannot really anticipate at all, and who will continue to surprise me even after it is born. We will be able to see the paradigmatic role of pregnancy better if we consider its bodily dimension. What pregnancy means on the bodily level can best be understood by exploring the concept of 'carrying'. Following on from Levinas, Jacques Derrida explores how carrying the Other in pregnancy transforms my world relation as a whole:

> *Tragen*, in everyday usage, also refers to the experience of carrying a child prior to its birth. Between the mother and the child, the one in the other and the one for the other, in this singular couple of solitary beings, in the shared solitude between one and two bodies, the world disappears, it is far away, it remains a quasi-excluded third. For the mother who carries the child, 'Die Welt ist fort.'
>
> (Derrida 2005a, 159)

The world is gone? Initially, this description can appear to be implausible, prejudiced and romantic: mother and child as self-sufficient, self-absorbed, uninterested in any other human beings or in the world? Yet, the impending arrival of the child returns me to the world since I know that the baby will (initially) share my world, and I will need to explain this world to them?

A closer exploration shows that the child relates to the world in three ways:

1. As an *origin of the world*, opening up a new context of meanings and possibilities. At the same time, this opens up a realm of responsibilities, which do not even cease in death, but acquire an even stronger dimension: '(If) the world disappears, I must carry you'.
2. As an *eclipse of the world*, as described by Derrida when he writes that for mother and child, the world disappears or becomes a quasi-excluded third. One reason for this disappearance of world seems to lie in the excess of vulnerability that the child exhibits before being born and in the initial period of life: 'If I must carry you, the world disappears'. Derrida proposes that this inversion of the sentence is permissible and plausible (Derrida 2005a, 158).

3. As a *new encounter with the world* because I start imagining (even before the baby is born) what it might be like to encounter the world for the first time. In this attempt at imagining such initial encounters (which can never quite succeed because I can only partially abstract from my familiarity with the world), some essential phenomenological characteristics of the world come to the fore: the world always precedes me as a meaningful context that I did not bring about, and this is one dimension of the world's uncanniness. Derrida, following Celan, refers to the 'unreadability' of the world (Derrida 2005a, 162), which becomes manifest in its complexity, preventing full comprehension. To be sure, this is one of those paradoxical moments where it holds true that we have always already read the world, and will need to read it to the child, despite the ultimate unreadability of world. This time, we need to further transform the initial sentence: 'The world is unreadable, I must carry you'. And at the same time, going beyond Celan but following the general finding that absence can also mean disclosure: 'If I must carry you, the world (re)appears'.

Considering the relations between me, you and the world or, in our case, mother, child and the world, it turns out that pregnancy is not simply about two entities, one being located *in* the other. Rather, it involves a number of complex relations between these two beings and their respective relations to world.

Being inhabited by a secret of sorts means a strange kind of carrying. It means to carry something which, when I face it, is already different from the creature inside. I must carry you: you, an origin of the world, a new world, which eclipses as well as reveals the world. The paradox of pregnancy thus serves as a paradigm as it informs us of a more interrelated existence in which we carry the Other and their world.

It also reveals how other human beings touch us from the inside – literally in pregnancy, metaphorically yet no less powerfully otherwise. The philosophical emphasis on vision creates the illusion of a world that we can survey and master. Vision gives us a 'panoramic' view of the world; everything seems to be on display, as it were (Levinas 1969, 192, 294). Vision conveys an impression that we perceive world from a detached vantage point. Touch, on the other hand, means involvement. Moreover, being a body means being exposed to the world, being touched by things conducive as well as detrimental to our existence. Being a body means being vulnerable and on the basis of that fundamental vulnerability, also able to experience pleasure.

Touch is the most bodily sense to the extent that philosophers like Jean-Luc Nancy and Derrida call it *the* sense. Nancy states, 'sense *is* touching' (Nancy 2003, 110). Derrida takes this idea further by proposing: 'This sense transcends the others; it also grounds them; it makes them possible, but to the extent that it is not quite a sense any longer' (Derrida 2005b, 146). Touch is not a sense alongside the others, not the second, third, fourth or fifth sense, and not even the first sense, because it lets the other senses originate and thus does not stand in a line with them. Being touched is the original meaning of what it is to sense things. Being touched means being affected, being touched in the wider sense, and when we are strongly affected through the other senses, they become reminiscent of touch – confronted with very bright light or a shrill sound, I shrink back because world is affecting me too much, *as if* it was pressing too hard on me.

Touch is the most basic or elemental sense because it corresponds directly to the experience of being a body – it is the most bodily sense – and being a body is the most basic fact of our existence. Because of these fundamental connections, some of the ideas presented in this section will sound self-evident, if not tautological. At the same time, these fundamental connections are to some extent alien to us, just as our bodies are alien to us, for a number of reasons. They are alien to us because they bring home some uncomfortable truths about our existence as finite and vulnerable.

'Touch is finitude', Jacques Derrida says in discussing Nancy's philosophy (Derrida 2005b, 138). He points out that a 'finite living being can live and survive without any other sense' (Derrida 2005b, 139), as is the case with a number of very basic animals. Being touched from the inside is thus indeed a paradigm for human relations. Since we have seen through considering pregnancy and how a paradox can indeed prove to be a paradigm, it will perhaps not come as a surprise if I now suggest that visual arts provide us with a special opportunity to encounter the invisible. Visual art, as we will see, manages to reveal the invisible without making it visible, or without dragging it into the light.

Relations and responsibilities: Coldwell's art

Paul Coldwell describes his methodology as follows:

> As an artist, I try to intensify experience through the making of objects and prints in the hope that through this, ideas can find a visual equivalent and become part of the collective memory. As

a humanist and in the context of conflict, I have to believe it might just be possible to effect change. But art invariably operates outside of the immediate call for action, a role more fitting to journalists and politicians. However, through reflection, art practice might support notions of empathy and contribute to an understanding of difference, common needs and values.

(2019a, 151)

This differential statement confirms what Heidegger and Merleau-Ponty observe about art. Heidegger states that art has unique possibilities when it comes to revealing the hidden as hidden, or disclosing the invisible without undermining its essential characteristics (Heidegger 2002, 43–7). Merleau-Ponty states in 'Eye and Mind' that visual art holds a special intermediate place that allows it to 'draw upon this fabric of brute meaning', which is related to his idea of flesh and, in turn, resembles Heidegger's concept of earth (Merleau-Ponty 1993, 123). Only the visual artist is allowed to 'hold the world suspended', whereas 'from the writer and the philosopher, in contrast, we want opinions and advice' (Merleau-Ponty 1993, 123). While we expect those who use the medium of language to express their opinions, at the other extreme there is music, which for Merleau-Ponty, 'is too far on the hither side of the world and the designatable to depict anything but certain schemata of Being – its ebb and flow, its growth, its upheavals, its turbulence' (Merleau-Ponty 1993, 123). Thus, only visual art falls in the middle, which allows it, paradoxically, to reveal the invisible as visible.

The context from which Coldwell's reflections on methodology are taken is that of his artwork *A Life Measured; Seven sweaters for Nermin Divović* made in response to the death of Nermin Divović who was shot by a sniper in Sarajevo in 1994. (See figure 10.1.)

Coldwell explains that, for him,

Nermin's story is made poignant for the fact that his life was so suddenly cut short at just seven years old, when, having survived the natural risks of birth and the early years, he would have expected a long life, school, playing football, a job, falling in love, a family of his own and even beyond as a grandparent.

(Coldwell 2019a, 152)

The artwork thus emerged from the desire 'to capture this loss of both a life and its potential through memorialising his life through a series of sweaters, one for each year of his life' (Coldwell 2019a). The title, Coldwell

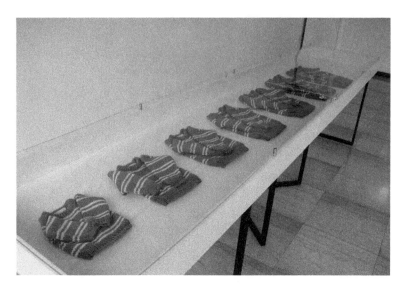

Figure 10.1 Paul Coldwell, *A Life Measured; Seven sweaters for Nermin Divović*, 2018. Wool and acrylic printed labels ranging from one to fit a child of 0–1 years old through to 6–7 years old.

Credit: © Paul Coldwell. Photograph: Esad Hadžihasanović.

explains, stems from T. S. Eliot's famous poem 'The Love Song of J. Alfred Prufrock' (1915) in which Eliot speaks of 'measuring out my life in coffee spoons'. Similarly, we see Nermin's life measured out in woollen sweaters.

What has become invisible through death, namely, Nermin and his possibilities, is thus revealed through the sweaters, which signify growth and potential. Coldwell cites from literature on knitting and also recalls his own childhood experiences of his mother knitting clothes as an act of care and nurture. The sweaters as displayed cannot be touched, but their softness and warmth are, nonetheless, disclosed. The series of sweaters thus come to signify the cultural trauma of those who nurtured their children yet were deprived of seeing their potential develop.

In the context of the thesis presented here on pregnancy, the sweaters immediately offer insights into the ways in which parents who experienced miscarriages or had stillborn children struggle to describe in language how the invisible lost infants are still tangible for them as they continue to carry their worlds. The best expression was perhaps found by this mother:

> The language we use to describe miscarriage is loaded with questions around what it means to be, how we confer humanity to

the Other and the extent to which it relates to particular experiences. I don't often speak of having lost 'children' or 'babies' because I am deeply conscious of the fact that they never really came to be. And yet, I am acutely aware of the losses. These are losses of *potential* people who were tangible to me, and to whom I had already attached myself and imagined. They might have been born, but they weren't, and that was completely out of my control.

<div align="right">(Anonymous mother, submitted to birthsite.org)[3]</div>

In interpreting Coldwell's work on Nermin, care has been confirmed as a more pervasive structure of human existence, guiding not just the relation with infants or children but human relations more generally. The more we care, that is, the more we help each other to realise our potential, the more we can grow our worlds.

Yet if pregnancy and being with infants are taken as paradigmatic in the way developed here through philosophy and art, there seems to be a clear problem because pregnancy is such an asymmetrical relation (especially in terms of visibility/invisibility), and infants are so excessively vulnerable. In the first section, Griffin as the invisible man came to reveal our general dependence on the elements and the way in which all of us, as bodily creatures, are exposed to that which is not in our control. Another of Coldwell's projects, *Picturing the Invisible – The house seen from below*, made for the Sir John Soane Museum in 2019, can serve to indicate how human relations tend to be asymmetrical in one way or the other. Yet even the most asymmetrical relationship, namely, the existence of servants, comes to reveal our human potential if we realise how our bodily engagement with the earth achieves some permanence through labour.

Coldwell states how in preparing *Picturing the Invisible – The house seen from below*, he was motivated not so much by the absence of Sir John Soane himself, who is represented by the museum, but by the more evasive absence of the 'invisible group of staff who were engaged in maintaining a house such as this' (2019b, 14). Their labour seems Sisyphus-like as it has to be repeated every day and does not seem to have any permanence. Yet with the help of Coldwell and Hegel, we will see that the matter is more complex.

Like Hegel, who for the first time in philosophy attended seriously to history, Coldwell is interested not in the past *as* past, but in how the past relates to the present and is reflected in it. The servants in Soane's house were invisible partly because their entire existence was dependent on their labour and 'their accommodation tied to their employment'

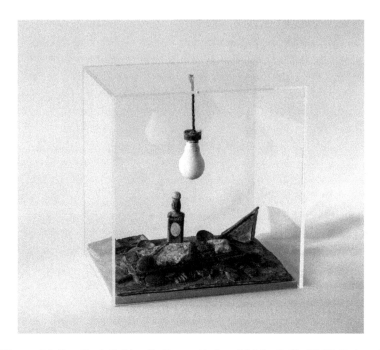

Figure 10.2. Paul Coldwell, *Room, Bed and Light Bulb*, 2019. Painted bronze and perspex, 38 × 30 × 38 cm.

Credit: © Paul Coldwell. Photograph: Peter Abrahams.

(Coldwell 2019b, 34). The most basic care and protection of their own bodies was thus precarious, and Coldwell 'began to see parallels with the condition of temporary workers and rough sleepers, now so tragically a common feature of city life' (Coldwell 2019b, 34). Lincoln's Inn Fields, where Soane's house is located, was one such place, and in designing the series of small sculptures 'Rooms', which are part of the exhibit, Coldwell takes some inspiration from the cardboard boxes rough sleepers tended to bring to the Fields (see figure 10.2).

Each 'Room' 'is overlooked by an exposed light as if to hamper sleep' (Coldwell 2019b, 34). Sleep is one of two elementary states in life, which stand in opposition: sleep and wakefulness. In my project on pregnancy and being with infants, I suggest that sleep actually qualifies as an element in the Ancient Greek sense. We have seen in the first section above, with the help of Levinas, that the concept of element can be expanded to include other states that fulfil the basic conditions of being boundless, being elementary to our existence and to life more generally, and acquiring its meaning from their opposition to a related state. Sleep is certainly elementary – basic, fundamental, needful – and thereby

connects us to earth in the sense of that which supports us. Elements are invisible like earth; even those which seem to be visible, like light and darkness, extend in their significance much more deeply than that which is visible about them.

By placing the light sources into each room, 'as if to hamper sleep' (Coldwell 2019b, 34), Coldwell implies the ways in which the servants' lives are not safe, not properly sheltered. Coldwell points out that the room, the shelter of the servants, is linked to their work and if they were to lose their employment, they would be rid of their shelter as well; a fear which might keep them awake at night. Second, the Sisyphus-like character of their labour, which we will explore in its dialectical significance below, might also be a source of discomfort and frustration: not really being able to build something, build a life. Third, there is the sense in which an excess of light undermines our privacy, and privacy is exactly something that servants were lacking, but also something which we increasingly lack, all of us, in contemporary life.

This contemporary connection is certainly intriguing and fitting. According to Derrida, we have at this stage handed over most if not all of our privacy. Derrida, in *Of Hospitality* (2000), uses the example of CCTV cameras. Nowadays, we could mention the ways in which social networks as well as interactive audio devices 'spy' on us and deliver this information to actual humans. Derrida points out that privacy, while initially perhaps pointing towards the unethical (as in Plato and, more indirectly, Wells), is actually a foundation of our ethical being. Privacy allows us to be a good host, offer proper hospitality, offer shelter, including to those who need it most.

Of course, it is not possible to reflect on servants without considering Hegel and his famous master-servant dialectics. This may at first glance seem irrelevant or even opposed to the considerations here as Coldwell's work shows exactly how the servants are stuck, deprived even of their privacy and proper sleep, where sleep also forms the basis for productive work. The servants in Soane's house are not going to start a revolution based on the realisation that, ultimately, the masters depend on the servants and not vice versa. But the potential to do so, that is, the realisation at the basis of the servants discovering their power, is very present in all of Coldwell's project on *Picturing the Invisible – The house seen from below* (see figure 10.3).

What provides the servants with the potential if not the reality of freedom is their work, their labour (*Arbeit*): they work on the earth, on the elements, and shape it with their hand, in accordance with their imagination. To put it in Hegel's terms:

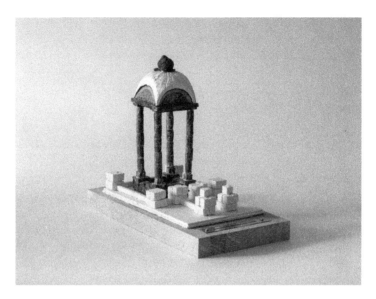

Figure 10.3. Paul Coldwell, *Scenes from the Kitchens – Tomb*, 2018. Painted bronze, plaster, wood and brass, 23 × 43 × 38 cm.

Credit: © Paul Coldwell. Photograph: Peter Abrahams.

> Labour forms and shapes the thing. [...] It is in this way, therefore, that consciousness, qua worker, comes to see in the independent being [of the object] its own independence. [...] In fashioning the thing, he becomes aware that being-for-self belongs to him, that he himself exists essentially and actually in his own right.
>
> (1977, 118)

As the servants form and shape things, anything could emerge: temples, sculptures, artworks, columns, arches, tombs. Soane has brilliant ideas, but he was always reliant on others to bring them to reality. This still holds true today, in all transformed and digitally refined power structures. Those who labour on the earth and the elements hold the true power; they just need to realise it.

Conclusion

Paradoxically, our bodies, which make us visible at the ordinary level of perception, are actually invisible in terms of what matters about them:

their ethical relevance and our exposure to the elements, which makes us dependent on others. Pregnancy is the paradigmatic case, which brings this dependence to the fore. But in fact, we always have others under our skin.

Despite all vulnerability and exposure, we will manage as long as we continue to carry each other and their worlds. Through joint labour and being there for each other, we can best realise our embodied existence. However, it is very difficult to admit our vulnerability, exposure and dependence. We tend to deny these features of our bodies to ourselves and to others. But if we do not manage to communicate the deep levels of our existence, which we tend to ignore, we cannot get better at being with each other. How can we communicate those deep and precarious truths, which we try to repress and for which we have no comfortable words?

Is there a way out? Yes: art. Art can reveal the truth about our bodies and our dependence on earth, elements and others. It can do so without immediately needing to judge; and to withhold judgement is crucial in those matters where we get under each other's skin, as we have also seen in our reflections on pregnancy and carrying. Art can reveal the hidden as hidden, can disclose the earth as that which keeps to itself, can let the elements shine and resound. The affinities between concepts like earth (Heidegger), flesh (Merleau-Ponty) and the elements (in Ancient Greek Philosophy and Levinas) are arguably so strong that they can indeed elucidate each other. The purpose of bringing these concepts together is, of course, to facilitate interpretation and invite the reader to follow that concept which speaks to them most.

My body, in turn, is earth/flesh/elements manifesting as a 'me', a separate individual, a situated being, endowed with something like spirit (which is another invisible crucial component of our existence). Being situated in the 'here' and 'now' as a spirited body, I become responsive to the call of the other person. Levinas is right: we can play Gyges and hide in our invisibility, denying our responsibility. But even if we were to be able to make ourselves properly invisible, like Griffin in Wells' novel, we would still be embodied and dependent on each other.

If art inspires us to communicate with each other more fully – where communication is an existential ability, which further affirms the significance of the invisible – we can learn to give each other the care that all of us need. Art also allows us to see what matters about human relations: our possibilities. Very important among these are our ways of engaging with earth and with elements. In this way, we can offer each other hospitality, provide each other with that which the labour of our hands shaped and formed out of elements. We can shape the elements to

which we are exposed yet which we also deeply enjoy, as in good food and, very differently, in art.

Notes

1 Some translations name Gyges as the main protagonist of the story, whereas others ascribe it to an ancestor of Gyges. This divergence is based on the fact that there are, in fact, two slightly different versions of the Greek text in circulation. Since my concern lies with the general idea of the myth, this difference is immaterial.
2 I have discussed elsewhere that, to my mind, the inconceivability and unpredictability (in terms of when, where, with whom, how, etc.) of giving birth causes our anxiety about birth on a much deeper existential level than specific dimensions of birth such as pain. See Tanja Staehler, 'Who's afraid of birth? Exploring mundane and existential affects with Heidegger' (2017).
3 https://www.birthsite.org

References

Coldwell, Paul. 2019a. 'A visual response to the siege of Sarajevo', *Journal of Visual Art Practice* 18(2): 145–59.

Coldwell, Paul. 2019b. *Picturing the invisible – The house seen from below*. London: Camberwell, Chelsea, Wimbledon Colleges of Arts.

Derrida, Jacques. 2000. *Of Hospitality*. Stanford: Stanford University Press.

Derrida, Jacques. 2005a. 'Rams: Uninterrupted dialogue. Between two infinities, the poem', In: *Sovereignties in Question. The poetics of Paul Celan*, edited by Jacques Derrida, Thomas Dutoit and Outi Pasanen, 136–63. New York: Fordham University Press.

Derrida, Jacques. 2005b. *On Touching: Jean-Luc Nancy*. Stanford: Stanford University Press.

Eliot, T. S. 1915. 'The love song of J. Alfred Prufrock'. In: *Poetry: A magazine of verse* (June 1915), 130–35.

Hegel, Georg Wilhelm Friedrich. 1977. *Phenomenology of Spirit*. Oxford: Clarendon Press.

Heidegger, Martin. 2002. 'The origin of the work of art'. In: *Off the Beaten Track*, translated and edited by Julian Young and Kenneth Haynes, 1–56. Cambridge: Cambridge University Press.

Herodotus. [425 BCE] 1996. *The Histories*. London: Penguin.

Hume, David. [1739] 1975. *A Treatise of Human Nature*. Oxford: Clarendon Press.

Levinas, Emmanuel. 1969. *Totality and Infinity*. Pittsburgh: Duquesne University Press.

Levinas, Emmanuel. 1981. *Otherwise Than Being or Beyond Essence*. Pittsburgh: Duquesne University Press.

Merleau-Ponty, Maurice.1964. 'The philosopher and his shadow'. In: *Signs*, edited by John Wild, 159–81. Evanston: Northwestern University Press.

Merleau-Ponty, Maurice. 1993. 'Eye and mind'. In: *The Merleau-Ponty Aesthetics Reader*, edited by Galen A. Johnson, 121–50. Evanston: Northwestern University Press.

Nancy, Jean-Luc. 2003. *A Finite Thinking*. Stanford: Stanford University Press.

Plato. 1997. *Complete Works*, edited by John Cooper. Indianapolis: Hackett.

Staehler, Tanja. 2017. 'Who's afraid of birth? Exploring mundane and existential affects with Heidegger'. *Janus Head* 16(1): 139–72. http://janushead.org/wp-content/uploads/2020/06/Staehler.pdf.

Wells, Herbert George. [1897] 2017. *The Invisible Man*. London: HarperCollins.

11
The aesthetics of silence, withdrawal and negation in conceptual art
Jo Melvin

Introduction

This essay explores two interweaving strands of ideas that came to prominence in the late 1960s and early 1970s, which inform a discussion of works by Barry Flanagan (1941–2009) and Christine Kozlov (1945–2005). These were the newly emerging concept of publication and distribution as a site for exhibition and the attitudes identified by Susan Sontag in her 1967 essay, 'The Aesthetics of Silence' (Sontag 1967). The focus here is on Anglo-American exchanges of this period (there is no attempt to address other national or international artistic dialogues) and a generation that experienced political upheaval and unprecedented technological advancement. Protests and campaigns for equal rights took place at the same time as the Vietnam War, the Cold War and the introduction of more affordable trans-Atlantic air travel. The inter-connectivity of life was scrutinised by and incorporated into art practice explicitly, seen in the attention artists gave to data analysis, information systems and documentation. Different systematic formations affected minimalist painting and sculpture, and much conceptual art emerged through a paring down of minimalism's preoccupation with geometric structures. The focus shifted to indexical networks, mapping devices, repetition and the economies of production. The Xerox copy enabled artists to take direct do-it-yourself control of the production and distribution of work, enabling them to bypass commercial galleries and cut costs. Coding systems of information networks lent themselves to

number patterns, while telegrams and postcards became a medium for making and distributing work.

Flanagan and Kozlov, absence and negation

The nuances of Flanagan and Kozlov's shared concerns have not been aired since the period, and then it was merely by inclusion in the same exhibitions or exhibitions devised around the 'new art practices'. The exhibitions they both participated in were *One Month*[1] (1969), *557,087*[2] (1969) in Seattle, which toured to Vancouver where its title changed to *955,000* (1970), and *Information*[3] at the Museum of Modern Art, New York, organised by Kynaston McShine (1935–2018). These four exhibitions provide crossover points.

Flanagan and Kozlov were students at the same time. Both likewise were expected to become dexterous in a range of skills via traditional art school teaching. In 1964 Flanagan enrolled as a full-time student of the Advanced Sculpture course at St Martin's School of Art. He became one of the number of artists emerging from St Martin's who were taught by Anthony Caro whose method of constructing sculpture out of industrial metal, steel and so on was a major influence. The move to get sculpture off the plinth was being investigated in many ways, some playful. Flanagan brought the relationship between the horizontal and vertical to the wall and the floor, invoking questions around medium – for instance, painting on the floor (a white circle) or on the ceiling (with hanging paper) or hung on the wall, is it then painting or sculpture?

Flanagan's work was shown in New York for the first time at the Theodoron Awards[4] exhibition at the Guggenheim Museum in May 1969. He was already respected in the United States by the group of artists around Seth Siegelaub (1941–2013) and Lucy R. Lippard (b. 1937). Joseph Kosuth (b. 1945) had written to *Studio International's* assistant editor, Charles Harrison (1942–2009) asking when they could expect to see Flanagan 'in New York as his arrival was anxiously awaited'.[5] Flanagan had met Lippard the previous year in London and they became friends immediately. She sent him a note to say how good the works looked in the Guggenheim; in reply he sent her the postcard announcement for 'a hole in the sea' (1969) and a copy of 'O for orange U for you : poem for the lips, jun0965' (1965) where the letters o and u were arranged alternately in a vertical line (this concrete poem will be referred to later). His vertical rather than horizontal layout of the poem's letters shows his critique of reading from left to right. It is a similar investigation to his placing

of canvases on the floor to be experienced horizontally rather than vertically. The repetition of the shapes of the letters o and u, formed in the mouth and to be uttered silently, echoes Flanagan's statement, 'sculpture is always going on', as even silent mouthing from the body's interior is sculptural.

Since his student days, Flanagan was preoccupied with language's formation and structure. This engagement took various forms; he made concrete poetry as stand-alone artworks – performances, as well as written on paper by hand, but sometimes typed. It can also be seen in his titles. Early on he began to use a system, like a type of shorthand, where he compressed words together. The titles are pragmatic. They are what they are and they reveal Flanagan's interest in 'pataphysics, begun serendipitously when a poet friend gave him a copy of the *Evergreen Review*, dedicated to 'pataphysics, defined as 'the science of imaginary solutions' by Alfred Jarry, the symbolist poet and playwright. Much of Flanagan's poetry, or rather his approach to it in the broadest sense of his practice, takes its instigation from this science of imaginary solutions. When, as an older man, he was asked who his father figure might be, his riposte was he had a perfectly good father, his anti-father was Jarry.

Flanagan and Kozlov met and socialised on several occasions in 1969, in New York City, London and Bern, Switzerland, for the opening of *When Attitudes Become Form*.[6] In this exhibition Flanagan presented '2 space rope sculpture 67' (1967) and the photographic documentation of his recent film 'a hole in the sea'. During the opening, Kozlov, who was not exhibiting, participated with Kasper König (b. 1943) to perform Franz Walther's 'Werksatz' (1963–9).[7]

Kozlov had studied at the School of Visual Arts in New York from 1963. There, she became friends with fellow student Kosuth who enrolled a year later and the pair would collaborate on a number of projects. American artist, Ad Reinhardt (1913–67), loomed large as a central figure for them.[8] For many of their contemporaries on both sides of the Atlantic, Reinhardt's painting, as well as his analysis of visual culture, was influential. Arguably, his practice sits outside the definition of 'abstract expressionism', which is how it is usually categorised. This is perhaps more to do with his association with those artists than a designation of his ideological concerns. His reflective, self-critical awareness of the parameters of painting in particular and cultural history in general was not part of gesture and self-expression, identifying preoccupations of the abstract expressionist. His use of humour to poke fun at Greenbergian formalism in his cartoons is a case in point. Reinhardt's now famous black paintings, shown at the Tate Gallery (as it was then called) in the

exhibition of American art, *Painting and Sculpture of a Decade, 54–64*,[9] provoked frustration and curiosity. The perceptive viewer became conscious of the processes, the physical and physiological processes of seeing. Flanagan remembered looking at the paintings, which were ostensibly black rectangular canvases, and wondered what they held in store for the viewer, beyond their apparent 'blackness'. For the eye to adjust to what it is looking at requires a time of looking, in effect for the eye to open up. During this process, he walked in front of the paintings from side to side, up close and moving back, as if the pupils in his eyes were becoming enlarged, so as to see each painting as a series of stages, of nuances and of gridded black. Reflecting in conversation with the author on this experience, Flanagan remarked that he 'felt and saw' the work as a means to demonstrate the way the eye functions, physiologically.[10] Reinhardt's lectures and statements on art held currency

Figure 11.1 Ad Reinhardt *Travel Slides* (1952–67). Video; colour, silent. Duration: 18 minutes (354 slides).

Credit: © Estate of Ad Reinhardt/Artists Rights Society (ARS), New York. Courtesy of David Zwirner Gallery, New York/London/Hong Kong.

among the younger artists who were questioning the critical impasse created by the acceptance of and dogmatic preoccupation given to Greenbergian formalism. When speaking on art, Reinhardt rearranged conventional historical chronologies and rethought approaches to representing ideas about the shape of time and duration, suggesting a form of pattern-making more akin to musical structures than art historical narrative (see figure 11.1).[11]

In parallel with his longstanding collaborators and friends, the poet Robert Lax and theologian Thomas Merton, his artistic judgements favoured ways of thinking visually around how to represent lack, negation and absence. Shortly after the Tate's large American survey exhibition, Reinhardt had a one-person show at the Institute of Contemporary Arts[12] and this time the work was hung according to his instructions (see figure 11.2).[13]

Kozlov and Kosuth set up the Lannis Gallery, dedicated to Reinhardt.[14] This short-lived space was perhaps the first gallery project generated by students to achieve attention beyond the school's community. Siegelaub, then a young dealer pioneering strategies for exhibiting and distributing work through publications, visited regularly,

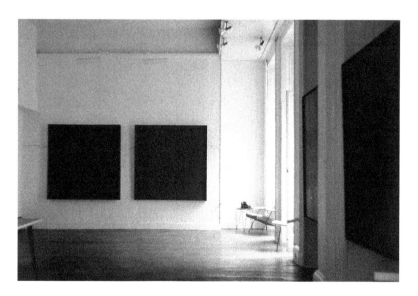

Figure 11.2 Ad Reinhardt, Installation view, Ad Reinhardt, Institute of Contemporary Art, London, 27 May – 27 June 1964.

Credit: © Estate of Ad Reinhardt/Artists Rights Society (ARS), New York. Courtesy of David Zwirner Gallery, New York/London/Hong Kong.

and he soon started working with Kozlov and Kosuth.[15] The first exhibition, held in February 1967, was titled *Non-Anthropomorphic Art by Four Young Artists*.[16] The catalogue, designed by Kosuth along with the invitation cards, presented artists' statements in place of illustrations, demonstrating an interest in information distribution. Kozlov's statement is a methodological account of a group of individually numbered works entitled *Sound Structures* (1965) that were hand-drawn on lined paper and photocopied in negative.[17] Each presents a sequence of short lines that are numbered and drawn across the page, referencing systems for musical notation and the black-and-white notes of the piano keyboard. The *Sound Structures* suggest a way of thinking about the representation of sound as a visual concept, emphasising sound's spatial, and therefore sculptural, qualities – like notation, or a performance score or dance movement, without enactment (see figure 11.3).[18]

Susan Sontag's influential text, 'The Aesthetics of Silence', was published in *Aspen* in 1967 alongside Roland Barthes' 'The Death of the Author' (1967), translated into English for the first time. The artist and critic, Brian O'Doherty (b. 1928), was the magazine's guest editor and the

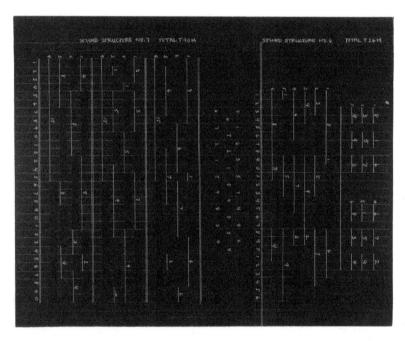

Figure 11.3 Christine Kozlov *Sound Structure No. 6, Sound Structure No. 7*, 1965. Photographic print.

Credit: © Estate of Christine Kozlov. Courtesy of Private Collection, Brussels.

issue was, in effect, an exhibition comprising various art forms: 45 rpm records, 35 mm film, art multiples and essays presented in a boxed set. The reader–viewer could unpack, peruse and display it however they wished. The essays and artworks propose a framework for the symposium and publication, *Picturing the Invisible*, and were evident in art practices emerging at the end of the 1960s and throughout the 1970s. These were prescient for what was to become a growing preoccupation with negation – a defined space of absence – in contemporary art practices. Significant to this discussion are two of Sontag's proposals. One, that the artist should cease production as 'exemplary renunciations of a vocation' (Sontag 1967, II), whereby she argued that the turn away from production undertaken by Ludwig Wittgenstein (1889–1951), Marcel Duchamp (1887–1968) and Arthur Rimbaud (1854–1891), 'doesn't negate their work. On the contrary, it imparts retroactively [*sic*], an added power and authority to what was broken off; disavowal of the work becoming a new source of its validity' (Sontag 1967, II). The other privileges the power of silence to define and to punctuate experience with meaning. She reminds us that it is 'the context and their parameters that define silence' (Sontag 1967, II).

'Silence', Sontag asserts, 'is the furthest extension of that reluctance to communicate, that ambivalence about making contact with the audience' (Sontag 1967, II), and with Kozlov, rather than an actual silence, it could be the experience for the viewer of a form of withdrawal that is more lacking than a deferral or a decision not to commit to an either/or situation. 'Silence remains, inescapably, a form of speech (in many instances, of complaint or indictment) and an element in a dialogue' (Sontag 1967, IV). Sontag points to the generative potential of silence because '[d]iscovering that one has nothing to say, one seeks a way to say that' (Sontag 1967, VI).

Just as Kozlov understood the sculptural qualities of sound in her *Sound Structures*, the experience of the inclusion of systems of notation and narration in three dimensions and constructions of spoken language were fundamental to Flanagan's concerns. Both considered how silence, denoted as a lack of sound, could be a sculptural phenomenon. This is silence as the space in-between sound, which punctuates time or measures duration between points. The inclusion of silence – to signify a gap, a lack, an absence, removal or withdrawal – extends the sculpture's fluidity as well as its parameters.

For Flanagan, sound and the absence of sound were important in his approach. He regarded sound as sculpture and its absence as much an articulation of space and an experience of how we perceive where we are

as a presence. A keen concrete poet, he participated in the *2nd International Exhibition of Experimental Poetry* at St Catherine's College, Oxford, in June 1965, where he presented 'O for orange U for you : poem for the lips', the silent performance of the lips' formation of the letters (see figure 11.4).[19]

The implication is the voice's projection of them, the throwing of these empty sounds through the mouth invoking their lack. A few years later, Flanagan placed the phrase 'No thing to say' across one of his pages in the catalogue for the Tokyo Biennale, *Between Man and Matter*, 1970[20]: each artist had been allocated three pages, for their biography, their plan for the Biennale and the third effectively as an artist's page with their own layout. This page is a collage of words, shapes and photographs. Using a rubber stamp, the words 'No' and 'thing' are placed above roughly shaped rectangles, parodying the idea of definitions of 'no thing', or nothing. These were set above an upside-down photograph of 'light on light on white on white' (1969), recently made for the exhibition *6 at the Hayward Gallery* and later titled 'Hayward 1'.[21]

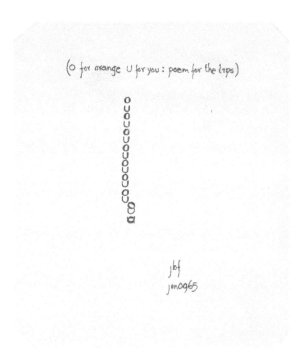

Figure 11.4 Barry Flanagan, *(O for Orange U for You : Poem for the lips) jun0965* (1965), Ink on paper, 23 cm × 20.2 cm.

Credit: © The Estate of Barry Flanagan. Courtesy of Plubronze Limited, 2020.

Also included on this page is a photograph of the artist in profile, his hand held up to his mouth, open as if speaking. The facing page bears an emblematic handwritten statement; 'eye, light, material, measurement', which occurs twice and is signed off both times with his signature. The statement proposes the elements required to constitute sculptural experience and a communication that does not depend on speech, but on speechlessness, and yet paradoxically, as the list of directives is signed and so claimed by its author, it leads to a strategic mode of experiencing the world, the eye sees and measures material through light.

As with sound, Flanagan presented light and the controls it can be subject to, including its removal, as a distinct sculptural element and identified it as a key component in many of his works. The first notable light piece was experienced at the exhibition *19:45–21:55 September 9th 1967* at Galerie Dorothea Loehr in Frankfurt. Flanagan's instructions culminated with the participants drawn from gallery goers, eating a loaf of bread, having completed a list of other actions: switching the lights on and off for 10 seconds at a time, standing in a queue, then a ring, lighting the gas, and so on. To form a line and then a ring, after being subjected to controlled light and dark, all followed by eating bread mixed with salt sounds like a curious way to precipitate aesthetic engagement (see figure 11.5).

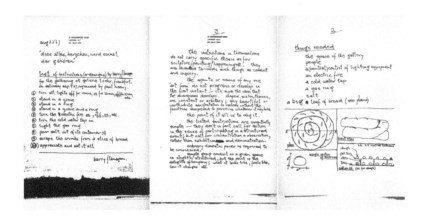

Figure 11.5 Barry Flanagan performance instructions, 'aug 22 '67 "dies alles, herzchen, wird einmal der gehören"' (1967), *19:45–21:55, September 9, 1967* organised by Paul Maenz at Galerie Dorothea Loehr, Frankfurt.

Credit: © The Estate of Barry Flanagan. Courtesy of Plubronze Limited, 2020.

However, the processes of orientation and disorientation, the recognition and subversion of identifiable systems are established strategies of aesthetic encounter, and the interplay of reversal and repetition are intrinsic to Flanagan's practice. For instance, in an artist's page in the October 1970 issue of *Studio International*, magazine readers may have puzzled over how to respond to the black advertisement facing the contents page, with white text that stated 'this advertisement will be blacked out for a fee of £2.25n.p.' (see figure 11.6).[22]

There would be nothing to stop the reader from subverting the offered transaction, to do the blackout themselves and so avoid the fee. In itself this dual and enigmatic possibility would be disconcerting for a reader who was invited to pay the artist and yet would realise the ease with which the task could be fulfilled.

For Kozlov, the student-led Lannis Gallery opened many networks and led to her participation in a number of publication exhibitions, such as Siegelaub's *One Month*[23] and Lippard's *557,087* in 1969. Lippard's was a citywide exhibition, presenting works in different places across a 50-mile radius. The catalogue was another site, with artists making work specifically for it. *One Month* existed solely as a publication. Siegelaub offered 31 artists the opportunity to create a text-based work on a single

Figure 11.6 Barry Flanagan, *Black Ad* (1970), Studio International vol. 180, no. 926, July/August 1970, shown here to indicate its position in the magazine.

Credit: © The Estate of Barry Flanagan. Courtesy of Plubronze Limited, 2020.

page, one for each day of the month. Kozlov was the only woman included. The book-exhibition was distributed via Siegelaub's worldwide mailing list. The first page reproduced the invitation letter he had mailed to each artist, including Flanagan. Seven artists did not submit work: their date pages are blank in the calendar. Kozlov's date was 19 March 1969. Her submission described a continuous recording, 'from 12am to 12am, a looped tape, duration one hour, sound recorded 24 hours with the actual amount of sound on the tape, 1 hour'. This conceptual work proposes the parameters for her work 'Information No Theory' (1970), included in the 1970 exhibition *Conceptual Art and Conceptual Aspects*.[24] The insertion of the word 'No' in the title is important, given Kozlov's concern with withdrawal. It is a pragmatic and practical negation that pokes fun at the attention given to 'information theory' at the time – typified by Robert Ash's popular book of the same name (Ash 1965). Flanagan's contribution for 11 March returned Siegelaub's invitation letter with annotations on copyright, ownership and circulation of the material requested.

In 1970 Charles Harrison, writing in *Studio International*, gave a tentative explanation for this emerging tendency with the remark that, 'some withdrawals are more effective than most engagements' (Harrison 1970). His article opened with a series of quotations by artists concerning negativity. Reinhardt claimed purity could be achieved through negation: 'You can only make absolute statements negatively.' Flanagan questioned: 'Is it that the only useful thing a sculptor can do, being a three-dimensional thinker and therefore one hopes a responsible thinker, is to assert himself twice as hard in a negative way?' Kozlov, the only woman artist referenced in the article, was actually misquoted, a fact that reflects the socio-economic dynamics of the period, then on the brink of the feminist movement. Harrison misremembered the title of Kozlov's work, which was a phrase used as one of the statements to identify withdrawal's power: '270 blank sheets of paper to represent 270 days of concepts rejected' (1968).[25] His version, 'A stack of several hundred blank sheets of paper – one for each day on which a concept was rejected', suggests the manner in which the idea of the work had lodged in his mind. The tentative phrasing of his article's title as 'notes', may suggest Kozlov's influence as much as the ways the various artists he was interested in were tackling absence, loss or negation, in other words 'invisible things'. They sought ways to focus on lack, making removal a form of action. Harrison's intention in writing had been to engage with the conceptual processes of producing this kind of work and to write in a manner that mirrored the procedural staking of an idea, demarcating territory, while allowing its uncertainty.

In various ways, Christine Kozlov's work is a barometer of her times, yet she continues to be underexposed. She was a central figure in the formation of early conceptual art practices in 1960s New York, being involved in a network of collaboration and friendships. Kozlov's work was based on a systematic participation in and drawing back from these networks until the early 1970s when she decided to stop actively making art. Kozlov did not position herself within the feminist discourse, although her practice drew attention to strategies for withdrawal, and disappearance. This strategy could be interpreted as a form of passive resistance to the more submissive role expected by female artists who were assumed to be 'pleased' if their work was considered to be on a par with that of their male colleagues by being selected for an exhibition. More compelling and subversive is the possibility that to declare a production predicated on either an apparent removal of something redacted, or by simply not having anything there in the first place gives a power to silence. This is alluded to in Sontag's perhaps slightly ironic assertion on how it is that 'Wittgenstein, with his scrupulous avoidance of the psychological issue, doesn't ask why, when, and in what circumstances someone would want to put into words "everything that can be thought" (even if he could), or even to utter (whether clearly or not) "everything that could be said"' (Sontag 1967, XII). Wittgenstein's famous quotation became a mantra for some younger artists in the 1960s. His writing was referenced frequently, for instance by Kosuth, as a rationale for non-figuration to precipitate the mode of an artwork's focus on the slippery ellipsis of grappling with meaning: 'everything that can be thought at all can be thought clearly. Everything that can be said at all can be said clearly' (Wittgenstein [1921] 1993, 26), necessarily suggests its counter position; not everything that can be thought can be said.

The fact that in 1967 Sontag draws attention to the negative effect on our psychological wellbeing brought on by a push to reveal what may more readily have been passed over, or set aside – which blurs the private and intimate with the public in the notion 'everything that can be said …' back to the daily bustle of 'an overpopulated world being connected by global electronic communication and jet travel at a pace too rapid and violent for an organically sound person to assimilate without shock, people are also suffering from a revulsion at any further proliferation of speech and images' (Sontag 1967, XIII) – more than 50 years later, during the Covid-19 lockdown the prescience of these words becomes even more salient.

Articulating, pronouncing, announcing in language determines the status of an event. This articulation takes place in time, a voice speaking which points to the 'before' and to what comes 'after' an utterance: silence.

(Sontag 1967, XIII)

Kozlov set out to represent 'nothing', to reject concepts and to consider the parameters of silence. Her work points to the margins, to a liminal space where perceptions are in the process of becoming defined. Carl Andre (b. 1935), who was a friend of hers, remarked that he made art 'because it is not there' and climbed mountains 'because they were' (Andre and Sharp 1970). Andre sent Kozlov a postcard in 1975 on which he wrote, 'Sculpture is fat silence'.[26] In the context of considering Kozlov's work as sculpture, this is an important statement. The idea of creating something because it is 'not there' is a way of thinking about practice; to make artwork that denotes what is 'not there' is to provide a framework for nothing; it tautologically articulates an idea of nothing, making it become something.

A prime example of Kozlov's tactical approach is her index card contribution to Lucy Lippard's exhibition in Seattle, *557,087* (1969). This and the Vancouver show *955,000* (1970) were named after the official population figure of each city at the time they took place. Lippard asked artists to submit either proposals or instructions for the realisation of their works on index cards. These became the publication. The cards included writing by Lippard, cited statements by philosophers, a list of participating artists and information about the exhibition. The reader could order the cards as they wished. Kozlov's card is devoid of an obvious statement, instruction or proposal. Written in capitals by hand, precisely replicating typeface, it simply states her name followed by 're: Seattle Show, September, 1969 catalogue card cc: R. Barthelme, O. Kawara and J. Kosuth'.[27] In Lippard's planning files for the exhibition she lists artists alongside the titles of their work and in Kozlov's case her name appears with a gap beside it and the word 'nothing' alongside her name.[28] Once again, Kozlov's nomination empowers 'nothing' and the act negation as productive. Taking a cue from the 'cc' – carbon copy – on Kozlov's card, it is pertinent to observe that there is one blank card in the catalogue, presumably Barthelme's contribution as all the other artists' submissions are clearly identifiable.

Kozlov's work consistently addresses difficult and even slippery problems on what constitutes art and art practice. This ambiguity is in part created by the working situation that she chose to follow. Her friends

and colleagues recall that she withdrew from pronouncements and the rumbustious interaction required for successful art world careers – for example, the influential gallerist Paul Maenz wrote to Kosuth and Kozlov inviting them both to be affiliated with his new gallery in Cologne, but Kozlov did not pursue the offer.[29] Her removal from the growing professionalisation of artists was perhaps even some form of mockery of the art world conventions. Early on, she took the decision not to push herself forward into the milieu of artists jostling for position and career. Lippard referred to Kozlov's 'social/conceptual withdrawal',[30] and in 1970 described her as 'a specialist in the reduction of complex intentions to rejection' and placing her alongside artists exploring 'nothing', from Duchamp and Francis Picabia (1879–1953) to Yves Klein (1928–62) and Robert Barry (b. 1936).[31]

Kozlov's elusive practice addresses ethical problems that continue to require consideration, and the contradiction between artistic exposure and recognition is something that her work raises through manifestations of negation – and, it must be noted, this approach is also humorous. Despite her tactics that caused frustration etc., Kozlov's work attracted attention outside the USA – the connections between like-minded artists in Europe and the UK were particularly facilitated through publication networks. In 1969 Konrad Fischer (1939–96), then a young dealer with a gallery in Düsseldorf, invited Kozlov to participate in *Konzeption/Conception* at the Städtisches Museum Leverkusen,[32] which included many artists from her circle. In common with other younger curators, Lippard, Siegelaub and Yusuke Nakahara (1931–2011), Fischer saw the exhibition publication as a site for artists. Interestingly, however, Kozlov is not present in the catalogue. This absence is significant: she responded to Fischer's request with a Deutsche Bundespost telegram (see figure 11.7) which read,

> I will send you a series of cables during the exhibition these will supply you with information about the amount of concepts that I have rejected during that time this cable and the ones following will constitute the work.[33]

The following year Kozlov represented herself through an inventory of her work. She submitted the list for the exhibition catalogues of *Information*[34] and later Lippard's *c. 7,500* (1973–74).[35] The *Information* catalogue takes the form of an artist's book. Alongside Kozlov's list is a photostat of a Western Union telegram sent to Kynaston McShine on 16 April 1970, which states:

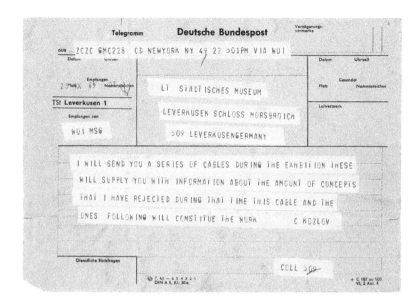

Figure 11.7 Christine Kozlov, Untitled ['I will send you a series of cables during the exhibition ...'], 1969 telegram addressed to Konrad Fischer.

Credit: Photographer unknown. Courtesy of Collection Eric Fabre, Brussels.

Particulars related to the information not contained herein constitute the form of this action.[36]

Notes

1 *One Month*, organised by Seth Siegelaub (also referred to as *March 1969*).
2 *557,087*, Seattle Art Museum Pavilion, Seattle, 5 September–5 October 1969; *955,000*, The Vancouver Art Gallery, Vancouver, 13 January–8 February 1970, organised by Lucy R. Lippard.
3 *Information*, Museum of Modern Art, New York, 2 July–20 September 1970.
4 *Nine Young Artists: The Theodoron Awards*, Solomon R. Guggenheim Museum, New York, 23 May–29 June 1969.
5 Charles Harrison personal papers, letter dated 3 March 1969. Tate Gallery Archive TGA 200826.
6 *Live in Your Head: When Attitudes Become Form (Works – Concepts – Processes – Situations – Information)*, Kunsthalle Bern, Bern, 22 March–27 April 1969, curated by Harald Szeemann.
7 Photographic documentation shows Christine Kozlov and Kasper König performing Franz Walther's 'Werksatz', in *When Attitudes Become Form: Bern 1969/Venice 2013*, Progetto Prada Arte, Milan, 2013, p. 177. The performers were invited by the artist, not the curator, Harald Szeemann.
8 Joseph Kosuth and Christine Kozlov. 'Ad Reinhardt: Evolution into darkness – the art of an informal formalist; negativity, purity, and the clearness of ambiguity'. Unpublished typescript, School of Visual Arts, New York, May 1966. Lucy R. Lippard papers, Joseph Kosuth File 1 (c. 1960s–c. 1970s), Archives of American Art, Smithsonian Institution.

9 *Painting and Sculpture of a Decade, 54–64,* The Tate Gallery, London, 22 April–28 June 1964.

10 Flanagan in conversation with Jo Melvin, 14 November 2008.

11 Ad Reinhardt lecture sound files and slides, Ad Reinhardt Archive, David Zwirner Gallery, New York.

12 *Ad Reinhardt,* Institute of Contemporary Arts, London, 27 May–27 June 1964. Charles Harrison was a postgraduate student at the Courtauld Institute at the time. He did not recall seeing the Reinhardt exhibition, in conversation with the author (28 March 2008), but shortly afterwards he became attentive to the concerns of Reinhardt's practice.

13 Ad Reinhardt Archive, David Zwirner Gallery, New York, ICA London correspondence.

14 The Lannis Gallery, in premises rented by Kosuth's cousin, Lannis Spencer, later renamed Museum of Normal Art.

15 Siegelaub's signature is in the sign-in book for the Lannis Gallery (Joseph Kosuth Archive, NYC). Kosuth and Kozlov changed its name later that year to the Museum of Normal Art but used the same sign-in book. Siegelaub's signature indicates his presence at several exhibitions (Joseph Kozlov Archive, NYC).

16 *Non-Anthropomorphic Art by Four Young Artists,* Lannis Gallery, New York, opened 19 February 1967 (end date not listed), organised by Joseph Kosuth and Christine Kozlov and included their work with those of fellow students Michael Rinaldi and Ernest Rossi. Kozlov Archive, London. Lippard papers, Kosuth File, Archives of American Art, Smithsonian Institution.

17 Kozlov referred to these as *Audio Structures.* 'Compositions for audio structures', *Non-Anthropomorphic Art,* Lannis Gallery, New York, 1967 (not paginated). Christine Kozlov Archive, London.

18 Kozlov made numerous drawings on graph paper using Tipp-Ex to erase the lines of geometric shapes in serial repetitions of form. She applied the same process to music manuscript stave paper. Christine Kozlov Archive, London.

19 Barry Flanagan Archive, London, Barbara Reise Archive, Tate, London and Lucy R. Lippard, Smithsonian, Archives of American Art.

20 *Between Man and Matter,* sponsored by Mainichi Newspapers, Metropolitan Art Gallery, Tokyo, 10–30 May; Municipal Art Museum, Kyoto, 6–28 June; Aichi Prefectural Art Gallery, Nagoya, 15–26 July. Yusuke Nakahara, the curator, spent two years planning, visiting studios and exhibitions in Europe, the USA and Japan. The exhibitions he cited as precedents were *When Attitudes Become Form,* Bern Kunsthalle, *Op Losse Schroeven,* Stedelijk Museum, Amsterdam, and *Anti-Illusion: Procedures/Materials,* Whitney Museum of American Art, New York.

21 *6 at the Hayward Gallery,* Hayward Gallery, London, 13 November–21 December 1969. The installation comprised various elements, about a hundred lengths of rope each between three and seven feet long covered the floor, a white painted dado around the wall, one vertical light projection and in one of the corners 'light on light on sacks' (1969).

22 *Studio International,* October 1970, vol. 180, no. 926, p. xix.

23 *One Month (March 1969),* exists in book form. Barry Flanagan Archive, London.

24 *Conceptual Art and Conceptual Aspects,* New York Cultural Center, New York, 10 April–25 August 1970, organised by director Donald Karshan, ghost curated by Ian Burn and Joseph Kosuth. This was first institutional exhibition to focus solely on conceptual art. A telegram announcing the exhibition was made as a poster and distributed across billboards in the city. It is illustrated in Ann Stephen's 'The New York art strike', *On Looking at Looking,* pp. 132–55, p. 132.[2006]

25 Kozlov's work had been included in *Number Seven,* Paula Cooper Gallery, New York, 18 May–17 June 1969, curated by Lucy R. Lippard.

26 Carl Andre. Postcard to Kozlov, October 1975 [postmark not clear], Christine Kozlov Archive, London.

27 Kozlov, '557,087' (1969), index card catalogue, Seattle, 1969. Copied in, alongside Kosuth, are fellow artists and exhibitors Rick (Frederick) Barthelme (b. 1943) and On Kawara (1932–2014).

28 Lucy R. Lippard lists, Seattle planning files, Archives of American Art, Smithsonian Institution.

29 Letter dated 24 September 1970, Joseph Kosuth File 1, Series 1, Galerie Paul Maenz Köln records, Special Collections and Visual Resources, The J. Paul Getty Trust.

30 Lucy R. Lippard, email to author, 21 May 2015.

31 Lucy R. Lippard, unpublished review of *Idea Structures,* Camden Town, London, 24 June–19 July 1970, organised by Charles Harrison, in Lucy R. Lippard, *Six Years,* p. 172. See also Lucy R. Lippard papers, Charles Harrison correspondence file, Archives of American Art, Smithsonian Institution.

32 *Konzeption / Conception,* Städtisches Museum Leverkusen, 24 October–23 November 1969, curated by Konrad Fischer.
33 *Konzeption / Conception,* Städtisches Museum Leverkusen, 24 October–23 November 1969. Telegram sent to Konrad Fischer.
34 Kozlov, *Information,* exhibition catalogue, MoMA, New York, 1970, p. 70.
35 *c. 7,500,* Gallery A-402, The California Institute of the Arts (CalArts), Valencia, California, 14–18 May 1973, curated by Lucy R. Lippard. Touring North America to February 1974.
36 Christine Kozlov Archive, London. Kozlov sent the same text in a telegram to Athena Spear for the exhibition *Art in the Mind* at Allen Art Museum, Oberlin College, Oberlin, Ohio, 17 April–12 May 1970.

References

Andre, Carl and Willoughby Sharp. 1970. 'Interview: Carl Andre', *Avalanche* Fall, 1 (1970): 18–27.
Ash, Robert B. 1965. *Information Theory.* New York: Interscience Publishers.
Barthes, Roland. 1967. 'The death of the author', *Aspen 5+6 (The Minimalism Issue)* (Fall/Winter 1967) New York: Roaring Fork Press.
Harrison, Charles. 1970. 'Notes towards art work', *Studio International* 179(919): 42–3.
Lippard, Lucy R. (1973) 1997. *Six Years: The dematerialization of the art object from 1966 to 1972: a cross-reference book of information on some esthetic boundaries.* Praeger: New York. Reprint, Berkeley, Los Angeles and London: University of California Press.
Sontag, Susan. 1967. 'The aesthetics of silence', *Aspen 5+6 (The Minimalism Issue)* (Fall/Winter 1967) New York: Roaring Fork Press.
Stephen, Ann. 2006. *On Looking at Looking: The art and politics of Ian Burn.* Carlton Victoria: Miegunyah Press, Melbourne University Publishing.
Wittgenstein, Ludwig. (1921) 1993. *Tractatus Logico-Philosophicus.* Trans. D.F. Pears and B. F. McGuinness. London: Routledge & Kegan Paul Ltd.

Looking forward

12
The dictionary of invisible meanings
Roberto Trotta

A momentous discovery ... or is it?

On 4 July 2012, Professor Joseph Incandela, the spokesperson for the Compact Muon Solenoid (CMS) experiment at the Large Hadron Collider, the largest particle accelerator in the world, announced to a packed auditorium: 'If we combine the ZZ and gamma-gamma, in the region of 125 GeV they give a combined significance of 5 standard deviations!' (CMS Collaboration 2012). As everybody cheered (and Peter Higgs shed a few tears), it was not immediately obvious to anybody but the particle physicists in the room what the significance of this was. What Incandela was saying was that they had discovered the Higgs boson, the 'God particle' that gives mass to all other particles. For the public at large, nothing short of a translation would do.

Jargon is the number one enemy to a clear communication to anybody outside a restricted circle of cognoscenti. As the astronomer Percival Lowell put it: 'technical phraseology, useful as shorthand to the cult, becomes meaningless jargon to the uninitiated and is paraded most by the least profound' (Lowell 1906, viii–ix). Whether scientists talking about their work to non-specialists, or experts in different fields coming together to share their viewpoints on a topic of common interest, we are all guilty of slipping back into jargon, often without noticing it.

As an astrophysicist with a passion for communicating with the public, for the last two decades I have been looking for novel ways of engaging new audiences with my science. All this time, I now realise, what I was searching for was a language to translate in a more pictorial, immediate way the often complex and abstruse cosmological concepts my research is about: dark matter, dark energy, the Big Bang and the fundamental nature of the universe. A language capable of overcoming the barrier that is the technical knowledge gap between the science

professionals and the public. The same invisible gap that often still divides the sciences and the humanities (Snow [1959] 2001).

Saying it in just a few words

One day in January 2013, I stumbled across the Ten-Hundred Words of Science challenge on the internet – a website collecting people's descriptions of their job written using only the most common one thousand words in English (https://tenhundredwordsofscience.tumblr. com). The challenge was inspired by a cartoon by Randall Munroe, the creator of the XKCD website, who would later go on and write a popular illustrated book using the same format (Munroe 2015). XKCD is a humorous site with stick-like cartoons, often concerned with physics, maths, computer science and other technical subjects. Randall had drawn a picture of the Saturn V moon rocket (or 'Up-Goer Five'), and labelled its parts using only the one thousand words list. This made me think that perhaps this was the new language I had been looking for! I found myself struggling to compose a few paragraphs describing my job as a cosmologist using only the allowed words – and 'universe' was not on the list!

The technique of 'constrained writing' has been long used to many different effects in literature and poetry, and pushed to the extreme by the Oulipo group. Founded in 1960 by French writers Raymond Queneau and François Le Lionnais, Oulipo (*Ouvroir de littérature potentielle*) was a loosely connected society of writers who experimented with various constrained writing techniques. Works by members of the group included *La disparition* (Perec 1969), a novel without the letter *e* centring about the mystery of characters disappearing as they near the truth of the letter's absence. Another famous constrained writing method went under the name of 'flash fiction' – a story narrated in a small, pre-determined number of words. The six-words flash fiction format is often, apocryphally, attributed to Ernest Hemingway.

I was fascinated by the potential of the format, and suspected that perhaps it could be used to address about everything in the universe, not just my job, if only I could build a sufficiently imaginative dictionary to translate jargon terms into simpler, and hopefully more poetic, expressions. *The Edge of the Sky: All you need to know about the all-there-is* (Trotta 2014) is the result of that small *Eureka* moment: a short book that follows a female scientist ('Student-Woman') as she spends one night at one of the largest telescopes ('Big-Seer') on Earth ('Home-World'), and

recounts the tale of how we got to understand the universe ('All-There-Is') and of its many outstanding mysteries. The whole book was written using only 707 words out of the allowed one thousand.

In the simple, yet slightly unusual language of the book, this is the way I describe how the Higgs boson was discovered:

> There is a city in a land full of safe places to put your money in. People there know how to make sweet, dark bars that make your mouth water. They build tiny wood houses that tell the time with the song of a little flying animal, also made of wood.
>
> Near that city, student-people have built a large ring under the ground. It would take you over five hours to walk around that Big Ring.
>
> Student-people take normal matter drops and make them fly around the Big Ring almost as fast as light.
>
> Then they pick a point where they make the normal matter drops hug each other, and they look at what kind of other drops come out of their hot kisses.
>
> This way, student-people have already found a new type of drop that no one had seen before, but that doctor Higgs had a long time ago said should be there.
>
> Mr Higgs was very happy about this.
>
> (p. 46)

One thing I learnt from my experiment is that limiting our lexicon to such a drastic extent forces us to re-think concepts and ideas we thought we were familiar with. The result was for me a refreshingly new perspective on my subject – and one that has opened the door to cosmology to many readers who would have otherwise not been interested in a 'traditional' book on the subject.

The benefits of junking jargon

One of the main hurdles to interdisciplinary research today is poor communication between team members coming from different perspectives. Rick Szostak, economics professor at Canada's University of Alberta and former president of the Association for Interdisciplinary Studies, maintains that 'research teams fall apart by not getting the basic communication in place at the start' (Bothwell 2020). This is not only a language barrier, but it actually betrays more profound and engrained

hurdles due to the different disciplinary *forma mentis*. Simple but effective strategies to overcome this difficulty include conversations in which each team member repeats in her own words what the other has said.

In my experience, the communication gap is even wider between scientists, artists and humanities specialists (e.g. Leach 2005). This is because each brings often polarly opposite perspectives on a topic – the very reason why a synthesis can be greatly satisfying and enhance a holistic understanding of the phenomenon being considered (Eldred 2016; Kneebone et al. 2018). However, there is a substantial risk of missing each other's arguments because of the lack of a common ground to which to anchor ideas. In art and science collaborations, for example, it often happens that the artist provides a mere 'artist impression' of the science, or that the scientist is called upon to sprinkle a layer of scientific interpretation on an artwork. Neither of these approaches are truly dialogic, nor truly collaborative. The only outcome that is more than the sum of its parts is one in which both the scientist and the artist engage in an act of co-creation that leaves the safety of their own domain of expertise and established practice behind.

The dictionary of invisible meanings project

As I was listening to the many fascinating contributions by fellow 'Picturing the Invisible' network members during our first gathering (held at the Sir John Soane's Museum, London in March 2019. See list of those present in acknowledgements), the question of finding a common language was very present in my mind. The network presented us with the rather uniquely stimulating opportunity to interact with outstanding thinkers and practitioners in an exceptionally wide range of disciplines. At the same time, this created an equivalently substantial problem: how were we to build bridges across such wide swaths of knowledge and experience?

The Dictionary of Invisible Meanings project grew out of the need to make each other aware of the discipline-specific colourings that our language takes on – both from a point of view of communication and as a reflection of our way of thinking about the world. Stimulated by the gathering of so many different disciplinary experts, I asked fellow network members to participate in a group project, articulated over three phases.

The first phase aimed at eliciting discipline-specific terms that each network member felt were of importance and relevance for their practice.

Figure 12.1 Words with discipline-specific meaning provided by *Picturing the Invisible* network members.

Credit: Roberto Trotta.

I asked each member to select between three and five terms, which are shown in figure 12.1.

In the second phase, network members were invited to contribute a short definition of terms that they felt had a discipline-specific meaning for them (this included the opportunity to write about terms that had been suggested by others). Among the many definitions provided, I selected a few that I found particularly intriguing:

Model:

1. A representation of reality.
2. A test piece.
3. A subject of representation.
4. A theory of understanding a psychological phenomenon.
5. (colloquial) A three-dimensional representation of something.

Proof:

1. A mathematical conclusion showing the truth value of a proposition.
2. A trial work on route to completion, i.e. a state.
3. A convincing heuristic line of arguments: a link between theoretical model and clinical reality.

Experiment:

1. A measurement of a physical quantity.
2. What happens if I do this?
3. What reductionist 'biological' and 'psychological' empirical researchers do.

Matrix:

1. A 2-dimensional arrangement of numbers.
2. The woodblock, or metal plate, or lithography stone, or screen from which an image is printed.
3. The material or code that holds information.
4. The network of interlinked factors that shape a psychological development or the coming into being of a personality.
5. (The —) A sci-fi trilogy that began in 1999.

Error:

1. Instrumental uncertainty.
2. An expression of an unconscious motivation that might be contrary to the conscious efforts.
3. Subconscious bias.
4. (colloquial) A mistake.

Theory:

1. A well-defined model of the physical world.
2. A melange of Frankfurt School and French deconstructionist dogma.
3. A cognitive and logically sound way to understand psychological and/or interpersonal phenomena.
4. (colloquial) A wild guess.

Law:

1. A fundamental premise of science that cannot be broken.
2. Something to be broken by the avant-garde.
3. Something groups define to control their libidinal and aggressive drives within their co-existence.
4. A paternal principle.
5. (colloquial) A legal rule that can be broken.

From this second phase there are some striking examples of how a common term can be very differently connotated in different disciplines, sometimes at polar opposites. 'Law' is interpreted from being a 'fundamental premise that cannot be broken' (in physics) to a rule that must be infringed to create novel forms of art. 'Error' for the physicist describes the uncertainty arising from noise in the instrumental device used for an observation, while it becomes an expression of the unconscious for the philosopher or the psychoanalyst. 'Theory' is not too different across physics and psychoanalysis, but it often has negative connotations in common parlance. 'Proof' has a definitive mathematical character in physics, while being a transient state in the creative arts and meeting only a threshold of heuristic plausibility on psychoanalysis. 'Experiment' is a controlled, repeatable measurement of a physical quantity for the scientist; a playful and unique gesture for the artist.

These examples, while merely scratching the surface of what a true cross-disciplinary dictionary would look like, vividly illustrate the depth and complexities of meanings attached to words within a disciplinary context. Strikingly, such significations are often divergent from the common usage of the word (e.g. as in 'model'). With such a depth of disciplinary-specific meaning, it is a minor miracle that we understand each other at all at any level!

Towards an interdisciplinary perspective

The third and final phase of the project experimented (in the artistic sense) with the notion that reducing the available lexicon to a minimum common denominator would short-circuit the difficulty of disciplinary-specific meanings. I thus asked each network member to describe their job using only the most common one thousand words in English, with the same set of rules that I had used for my book. Specifically, all the words on the list of the one thousand most common words in English were allowed (figure 12.2; for a complete list of the thousand words, see Appendix to this chapter). The 1000-word list comes from a Wikipedia entry, which claims to have derived them from over 9 million words of 'contemporary fiction' gathered online.

Also allowed were words obtained from the list by adding the following suffixes: -(e)s, -er, -ed, -ing (possibly in sequence. So -ers is also allowed). For adjectives, comparatives (-er) and superlatives (-est) can be formed from the adjective given. Adverbs could only be used if present in the list; for example, 'completely' was allowed because it appears as such

Figure 12.2 The 707 words used in *The Edge of the Sky: All you need to know about the all-there-is*, arranged according to how frequently they occur in the book.

Credit: John Pobojewski/Thirst for Foreign Policy Magazine.

in the list, but 'deeply' was not because only 'deep' appears on the list. In addition, possessive forms were also allowed.

My hope was that this exercise in constrained writing would generate reflection on the unconscious assumptions behind the usage of disciplinary words. By forcing each participant to present their specialty using a set of common, simple, everyday words, I wanted to draw them closer together and nudge them to assume a non-disciplinary perspective on their field. The unexpected difficulty of this very same exercise was profoundly illuminating for me when I first did it in 2013, and I was hopeful that my colleagues would be similarly challenged. My own attempt from 2013 was provided as an example of the format to other network members:

> I study tiny bits of matter that are all around us but that we cannot see, which we call dark matter. We know dark matter is out there because it changes the way other big far-away things move, such as stars, and Star Crowds. We want to understand what dark matter is made of because it could tell us about where everything around us came from and what will happen next.

To study dark matter, people like me use big things that have taken lots of money, thought and people to build. Some of those things fly way above us. Some are deep inside the ground. Some are large rings that make tiny pieces of normal matter kiss each other as they fly around very, very fast – almost as fast as light. We hope that we can hear the whisper of dark matter if we listen very carefully. We take all the whispers from all the listening things and we put them together in our computers. We use big computers to do this, as there are lots and lots of tiny whispers we need to look at.

I go to places all over the world to talk to other people like me, as together we can think better and work faster. Together, perhaps we can even find new, better ways to listen to dark matter.

These are the submissions that were received in response:

In my work I try to draw and make things that seem like the thoughts that I have in my head. Ideas are without form so it's only by making them or drawing pictures that I am able to make them real and then they can be shared with others.

While a writer uses words, I use matter to give my thoughts form. To begin with, the idea is far away but through all the changes it slowly becomes in focus and appears true and close.

(Paul Coldwell, artist and Professor of Fine Art)

I use deep red light to take pictures of people who are not well. Red light gets stopped by blood, so if we use deep red light and find the dark parts, we can know where the blood is. We can even see where the blood is in the brains of people who are well, and this can tell us what people are thinking.

In my other job I take pictures of old books and writing. We still use deep red light, but also use normal red, green and blue light, and deep blue light. Using different kinds of light lets us see if old writing is under new writing, or lets us read writing that we cannot usually see.

(Adam Gibson, Professor of Medical Physics)

I study pictures made by people, sometimes long ago, to figure out why they made them and also why we like to look at them now. It is interesting because sometimes we like to look at them for the same reasons, but sometimes what we like about them is very different from what people liked when they made them. I go to lots of

different places to look at pictures, and I also read lots of books and letters in big book-houses and on my computer. Then I try to write a true story about those people and those pictures. Sometimes there are pictures that have very few written words to help us understand them. Sometimes we have words but the pictures have been lost. Then the questions are very big and very fun to try to answer.

(Susan Tallman, art historian and editor in chief of *Art in Print*)

I work with people who make sick people better. I also study how people who are very good at things have become so good at what they do. Many of these people dance, draw pictures, play music or do hard things with their hands. Finding out what these people do is not as easy as it sounds because often they do not know how good they really are.

My job is to make stories that show other people things they haven't noticed and make them see what they do every day in a new way.

(Roger Kneebone, Professor of Surgical Education and Engagement Science)

I am a teacher of the love of knowing things. This means I am not a teacher of things to know, but of the love to know them. I try to make people think about the world and what we can (and cannot) know about it, and what is good to know about the world, and why.

I also like to ask questions about how we come into this world, and how we leave it, and what happens in between. I think about the ways in which we do things with other people, and how others make us feel, and why. I like to talk and write about life and what matters to us. I also like to write about paintings and dance.

(Tanja Staehler, Professor of European Philosophy)

When bad things happen it is important to find out what, how, where and when they happened, and who was there. I search for different pieces of different types of stuff to put together a picture of what happened. Finding tiny pieces of stuff can change what we thought happened, like who was there at the time.

I teach students about these tiny pieces of stuff and how we can piece together the pictures that tell us what happened. I also talk to world leaders to tell them how important this is. I get to go to places all over the world to talk with other people like me, because

together we can find better ways of finding out what happened so we can help to stop bad things happening in the first place.

(Ruth Morgan, Professor of Crime and Forensic Science)

Conclusion

I enjoyed the freshness of these description, their 'otherness', as well as their playfulness. Using a given set of simple words has the effect of reducing the complexity of the sentences, while often increasing the metaphorical depth. The resulting language is at the same time transparent and indirect, childlike and sophisticated, a representation of its object and a hint at something quite out of reach. The 1000 words format makes us wonder whether the unique, objective, inter-personal meanings we entrust to our language are ever quite so common as we like to believe. As a reviewer of my book remarked, the 1000 words dictionary creates a language that feels 'like a translation of ancient storytelling' (Popova 2014) or perhaps post-apocalyptic: the language of a civilisation that, far in the future, has lost the 'proper' words for things, and is making do with myths and tales around the fire. It simultaneously connects us with a mythological past, and with a possible – if dystopic – future.

The Dictionary of Invisible Meanings, like Borges' book of sand (Borges 1975), is a never-ending project. This small experiment drew upon the exceptional gathering of experts across widely different disciplines, enabled by the network, to shine a light on the barriers and opportunities of cross-disciplinary thinking. I hope that this first step will be followed by further work together and that it might help to illuminate the path towards novel cross-disciplinary approaches.

Acknowledgements

I am very grateful to the network members who participated in this project:

Professor Stephan Doering (Medical University of Vienna), Professor Mark Emberton (UCL), Professor Adam Gibson UCL, Professor Paul Goodwin (UAL), Owen Hopkins (Sir John Soane's Museum), Professor Roger Kneebone (Imperial College, London), Professor Tanja Staehler (University of Sussex), Susan Tallman (School of the Art Institute Chicago) and Professor Irene Tracey (University of Oxford).

Appendix

The most common thousand words in English used in *The Edge of the Sky* (Trotta, 2014) and adopted for this project:

a able about above accept across act actually add admit afraid after afternoon again against age ago agree ah ahead air all allow almost alone along already alright also although always am amaze an and anger angry animal annoy another answer any anymore anyone anything anyway apartment apparently appear approach are area aren't arm around arrive as ask asleep ass at attack attempt attention aunt avoid away baby back bad bag ball band bar barely bathroom be beat beautiful became because become bed bedroom been before began begin behind believe bell beside besides best better between big bit bite black blink block blonde blood blue blush body book bore both bother bottle bottom box boy boyfriend brain break breakfast breath breathe bright bring broke broken brother brought brown brush build burn burst bus business busy but buy by call calm came can can't car card care carefully carry case cat catch caught cause cell chair chance change chase check cheek chest child children chuckle city class clean clear climb close clothes coffee cold college colour come comment complete completely computer concern confuse consider continue control conversation cool corner couch could couldn't counter couple course cover crack crazy cross crowd cry cup cut cute dad damn dance dark date daughter day dead deal dear death decide deep definitely desk did didn't die different dinner direction disappear do doctor does doesn't dog don't done door doubt down drag draw dream dress drink drive drop drove dry during each ear early easily easy eat edge either else empty end enjoy enough enter entire escape especially even evening eventually ever every everyone everything exactly except excite exclaim excuse expect explain expression eye eyebrow face fact fall family far fast father fault favourite fear feel feet fell felt few field fight figure fill finally find fine finger finish fire first fit five fix flash flip floor fly focus follow food foot for force forget form forward found four free friend from front frown fuck full fun funny further game gasp gave gaze gently get giggle girl girlfriend give given glad glance glare glass go God gone gonna good got gotten grab great green greet grey grin grip groan ground group grow guard guess gun guy had hadn't hair half hall hallway hand handle hang happen happy hard has hate have haven't he he'd he's head hear heard heart heavy held hell hello help her here herself hey hi hide high him himself his hit hold home hope horse hospital hot hour house how however hug huge huh human hundred hung hurry hurt I I'd I'll I'm I've

ice idea if ignore imagine immediately important in inside instead interest interrupt into is isn't it it's its jacket jeans jerk job join joke jump just keep kept key kick kid kill kind kiss kitchen knee knew knock know known lady land large last late laugh lay lead lean learn least leave led left leg less let letter lie life lift light like line lip listen little live lock locker long look lose lost lot loud love low lunch mad made make man manage many mark marry match matter may maybe me mean meant meet memory men mention met middle might mind mine minute mirror miss mom moment money month mood more morning most mother mouth move movie Mr Mrs much mum mumble music must mutter my myself name near nearly neck need nervous never new next nice night no nod noise none normal nose not note nothing notice now number obviously of off offer office often oh okay old on once one only onto open or order other our out outside over own pack pain paint pair pants paper parents park part party pass past pause pay people perfect perhaps person phone pick picture piece pink piss place plan play please pocket point police pop position possible power practically present press pretend pretty probably problem promise pull punch push put question quick quickly quiet quietly quite race rain raise ran rang rather reach read ready real realise really reason recognise red relationship relax remain remember remind repeat reply respond rest return ride right ring road rock roll room rose round rub run rush sad safe said same sat save saw say scare school scream search seat second see seem seen self send sense sent serious seriously set settle seven several shadow shake share she she'd she's shift shirt shit shock shoe shook shop short shot should shoulder shouldn't shout shove show shower shrug shut sick side sigh sight sign silence silent simply since single sir sister sit situation six skin sky slam sleep slightly slip slow slowly small smell smile smirk smoke snap so soft softly some somehow someone something sometimes somewhere son song soon sorry sort sound space speak spend spent spoke spot stair stand star stare start state stay step stick still stomach stood stop store story straight strange street strong struggle stuck student study stuff stupid such suck sudden suddenly suggest summer sun suppose sure surprise surround sweet table take taken talk tall teacher team tear teeth tell ten than thank that that's the their them themselves then there there's these they they'd they're thick thing think third this those though thought three threw throat through throw tie tight time tiny tire to today together told tomorrow tone tongue tonight too took top totally touch toward town track trail train tree trip trouble true trust truth try turn television twenty two type uncle under understand until up upon us use usual usually very visit voice wait wake walk wall want warm warn was wasn't watch water wave way we we'll

we're we've wear week weird well went were weren't wet what what's whatever when where whether which while whisper white who whole why wide wife will wind window wipe wish with within without woke woman women won't wonder wood word wore work world worry worse would wouldn't wow wrap write wrong yeah year yell yes yet you you'd you'll you're you've young your yourself

References

Borges, Jorges Luis. 1975. *El libro de arena*. Buenos Aires: Emecé Editores.

Bothwell, Ellie. 2020. 'Is interdisciplinary research really the best way to tackle global challenges?' *Times Higher Education*, 13 February 2020. https://www.timeshighereducation.com/features/interdisciplinary-research-really-best-way-tackle-global-challenges.

CMS Collaboration. 2012. 'Observation of a new boson at a mass of 125 GeV with the CMS experiment at the LHC', *Physics Letters B* 716(1): 30–61.

Eldred, Sheila. 2016. 'Art–science collaborations: Change of perspective', *Nature* 537: 125–6.

Kneebone, Roger, Claudia Schlegel and Alan Spivey. 2018. 'Science in hand: How art and craft can boost reproducibility', *Nature* 564: 188–9.

Leach, James. 2005. '"Being in between": Art-science collaborations and a technological culture', *Social Analysis: The International Journal of Social and Cultural Practice* 49(1): 141–60.

Lowell, Percival. 1906. *Mars and Its Canals*. New York: The MacMillan Company.

Munroe, Randall. 2015. *Thing Explainer: Complicated stuff in simple words*. London: John Murray Press.

Perec, Georges. 1969. *La disparition*. Paris: Gallimard.

Popova, M. 2014. The Best Science Books of 2014 available at https://www.brainpickings.org/2014/11/24/best-science-books-2014/.

Snow, Charles Percy. (1959) 2001. *The Two Cultures*. Cambridge: Cambridge University Press.

Trotta, Roberto. 2014. *The Edge of the Sky: All you need to know about the all-there-is*. New York: Basic Books.

13
Postscript
Paul Coldwell

This work came out of the AHRC-funded network *Picturing the Invisible* that began in early 2019 and spanned a period of one year. During this time the network held workshops, exhibitions, seminars, a conference and prepared the material for this book. Social interaction, dialogue and exchange were at the centre of all these activities.

The aim of the project was to initiate and conduct a cross-disciplinary investigation into how different disciplines picture the invisible, or that which is unknown. Through this investigation, we sought to develop a better understanding of how languages are used within a variety of disciplines to identify and express concepts and anxieties that have commonality. The objectives were: to explore how concepts are expressed within differing disciplines, looking for similarities and divergence; to examine the use of language within disciplines and provide a testing ground for cross disciplinary dialogue; to explore common themes, common approaches and what can be learnt from a diverse range of disciplines, experiences and perspectives in order to facilitate problem solving; and to foster flexible and creative thinking that can address complex issues faced within different disciplines that transcends traditional disciplinary boundaries.

On 12 March 2020, the final event of the network was staged in the form of a public presentation at Chelsea College of Arts (University of the Arts London) in which we reflected back on the activities of the network and looked forward to the publication of the resulting chapters for this book. It was one of those memorable occasions in academia where serious and indeed profound ideas were discussed and freely exchanged in an atmosphere of conviviality and genuine inquiry. It drew a broad audience of students, academics and the general public and the structure of the event allowed for break-out meetings and conversations during the course

of the day over coffee and cakes. New contacts were made as well as consolidating and refreshing old ones.

The evening concluded with a meal in a restaurant in Pimlico for all the speakers where the conversation turned to COVID-19 and the potential impact of the virus. Professor Mark Emberton prophetically suggested that this might be the last social occasion for a while, putting in mind Captain Oates tragic last words, *I am just going outside and may be some time.* For most of us, the full implications of the virus could not have been fully realised.

A few days later, on 16 March, with the rapidly rising death toll, the Secretary of State for Health and Social Care, Matt Hancock, announced in Parliament that all unnecessary social contact should cease. This message was endorsed a week later when the prime minister, Boris Johnson, declared that the country was now to enter a period of lockdown.

The question posed by the project, 'how we picture the invisible?' takes on an added significance in the light of the COVID-19 pandemic. H. G. Wells had imagined the terror from an unseen source in his novella of 1924, *The Invisible Man*, where the protagonist of the story Griffin declares 'This is day one of year one of the new epoch, – the epoch of the invisible man. ... he may lock himself away, hide himself away, get guards around him, put on armour if he likes; death, the unseen death, is coming' (H. G. Wells, *The Invisible Man*).

As in the novella, the unseen virus was only made visible by the trace of its passing, the numbers of infections those admitted to hospital and, of course, the tragedy of the rising death toll. There was, of course, physical evidence of change in the form of the rapid building of the Nightingale hospitals in anticipation of the NHS needing to increase its capacity and the retreat into our homes, leaving the streets deserted. Home now functioning as a place of work, teaching and learning as well as living space.

While scientists were at work to develop a viable vaccine, a raft of practical solutions to slowing the spread were promoted, from personal hygiene, washing hands regularly, to wearing face masks, social distancing and lockdown. In an attempt to communicate and help picture this existential threat, bar graphs and projected curves were used, as well as the government forming a trinity with scientists and the medical profession on regular early evening briefings. New concepts were explained, the R rate of transmission, social distancing, bubbles, lockdown, furloughing, etc., while numerous slogans were coined to communicate changing policy. Stay Safe, Stay Home, Save the NHS, Eat Out to Help Out and the Rule of Six, among many.

To contain the virus, while awaiting the development of a vaccine, we have been compelled to modify and change how we behave both in our private and public spaces including how we work, shop, do business, even how we conduct rituals such as weddings, births and funerals. All our social interaction has become viewed through the need to act in order to safeguard ourselves, our families and our wider communities, including those sectors of society most at risk. Wider, it has also forced us to reflect on the relationship between nation states and our obligation to the world as a whole.

The pandemic arguably has imposed the biggest change on our daily lives since the Second World War. In the UK its effect has arguably been greater than the imposition of the three-day week in 1974, the Aids epidemic of the 1980s, and the great recession of 2007–9 resulting in the subsequent austerity programme. Its impact has affected and continues to affect, every aspect of our lives, with no section of society left untouched.

One striking aspect is how this pandemic has highlighted the need for cross-disciplinary dialogue. Every discipline has been impacted upon and the deepening problems, many unforeseen, have made apparent the complexity of our society and how interdependent each sector is upon the other.

While the disciplines of science and medicine have been at the forefront of addressing the more 'seen' impact of the pandemic and finding a vaccine and the means of mitigating the spread of the virus, other disciplines have been quick to remind us of their importance and the implications and indeed dangers of ignoring them. The closure of concert halls, music and dance venues, museums and art galleries has had a profound effect on the artists and support staff but also more widely in society in terms of wellbeing and mental health for the public as a whole. The arts also have a vital role in both helping us to understand what we are experiencing now as well as, once we emerge from the pandemic, of helping to reflect and understand what we have gone through. In concurrence, there has been renewed prominence given to the application of technologies that can address social challenges that have emerged from this time of lockdown, such as the use of augmented and virtual reality technologies to emulate sensory experiences to build human connections where physical spaces for traditional interaction and community are increasingly restricted.

As we hopefully emerge from the pandemic, the interrelated nature of our society has been brought into sharp focus. The issues that are facing our world are increasingly complex and it has never been more clear that

it is impossible to attempt to solve issues from the position of a single discipline. At its simplest, we need to further understand both the priorities and the languages of those working in other disciplines in order to better understanding how each impacts upon the other.

Post-COVID-19 provides an important opportunity to reflect on the kind of society we wish to construct and all disciplines have a role in contributing to that debate. *Picturing the Invisible* has been a small contribution in seeking understanding across disciplines and adding to that process of learning about how each discipline thinks and expresses those thoughts, in order that we might all share in shaping the future.

Reference

Wells, H. G. 2005. *The Invisible Man*. London and New York: Penguin,

Index

CPSIA information can be obtained
at www.ICGtesting.com
Printed in the USA
BVHW021937290822
645320BV00015B/122